WILLIAM DUNLAP

AND THE CONSTRUCTION

OF AN AMERICAN

ART HISTORY

WILLIAM DUNLAP

AND THE CONSTRUCTION

OF AN AMERICAN

ART HISTORY

Maura Lyons

University of Massachusetts Press

Amherst & Boston

Library of Congress Cataloging-in-Publication Data

Lyons, Maura.
William Dunlap and the construction of an American art history / Maura Lyons.
p. cm.
Includes bibliographical references and index.
ISBN 1-55849-475-8 (cloth : alk. paper)
1. Dunlap, William, 1766–1839. History of the rise and progress of the arts of design in the United States.
2. Art, American—Historiography.
I. Title.
N7483.D82L96 2005
709' .73—dc22 2004018193

British Library Cataloguing in Publication data are available.

For my parents

CONTENTS

ILLUSTRATIONS

ACKNOWLEDGMENTS

It is a pleasure to recognize the people who made this book possible and the organizations that helped sponsor it. Numerous scholars, librarians, and archivists aided me in my research. I thank Patricia Hills for her expert early direction of my work and for her continued encouragement of this project as well as for her professional example. Special thanks are also due to Janice Chadbourne and the other reference librarians at the Fine Arts Department of the Boston Public Library, and to Brenda Madore and Diane Collett, who secured interlibrary loans for me in Maine and Iowa, respectively. And I wish to acknowledge Julian Mates of Long Island University for graciously responding to an early query about his research on Dunlap.

I am grateful for the generous financial support offered to this project. A Henry Luce Foundation/American Council of Learned Societies dissertation fellowship in American art sustained my early research, as did a Robert C. Vose Jr. Scholarship in American Art History from the Copley Society of Boston and the Edwin and Ruth M. White Prize from the Humanities Foundation at Boston University. The crucial assistance of the Friends of Drake Arts and Drake University's Center for the Humanities made the illustrations for this book possible.

I also thank the museums and libraries that have given permission to reproduce the illustrations in this volume as well as the Archives of American Art, Smithsonian Institution; Rare Books Department, Boston Public Library; the Historical Society of Pennsylvania; the New-York Historical Society; Manuscripts and Collections, New York State Library; and Manuscripts and Archives, Yale University Library, for allowing me to quote from manuscript material in their possession.

I have been extremely fortunate to find a congenial environment at Drake University since I joined its faculty. I thank my colleagues in the Department of Art and Design, including Robert Craig, its chairman, for their encouragement of this project. In addition, an American Studies faculty workshop at Drake during the summer of 2002 aided my refocusing of the book, Vibs Petersen provided wise counsel during its completion, and Hope Donovan served as an able research assistant during 2002–3.

I have presented portions of this research in a number of forums. Each opportunity helped me to sharpen my arguments. In particular, I thank Johannes Nathan from the Institut für Kunstgeschichte, Bern, for selecting my paper as part of the session he organized on art historical literature at the 2000 meeting of the College Art Association.

I am indebted to a number of perceptive readers of this manuscript. Interlocutors of an earlier version included Keith Morgan, David Hall, Theodore E. Stebbins Jr., and Jonathan Ribner. In addition, Amy Ellis, Nancy Gruskin, Catherine Lyons, and Lenore Metrick offered criticism at crucial points of the study, and the two anonymous readers for the University of Massachusetts Press prompted me to make many clarifications. The book is much stronger as a result of all of the readers' suggestions. I am also grateful to the staff of the University of Massachusetts Press, especially Paul Wright, who initiated this project and was instrumental in sustaining it, and Carol Betsch, for her capable oversight of the many details involved in the book's production, and to Joel Ray, for his careful editing of the final manuscript.

It would be impossible to list all of the friends and family members who inquired about the state of this project and encouraged me over the years. I owe the longest-standing debts to early mentors: Elizabeth Prelinger as well as Joseph Murphy and Jane Hurst, and to Catherine and Tom Lyons, Tara Lyons, Dan and Christine Lyons, Kendra Hansis, and Christine Lepoutre.

WILLIAM DUNLAP

AND THE CONSTRUCTION

OF AN AMERICAN

ART HISTORY

INTRODUCTION

When William Dunlap published his *History of the Rise and Progress of the Arts of Design in the United States* in 1834 it became the first book to trace the emergence of an independent visual art tradition in the United States. Although scholars specializing in American art have long acknowledged Dunlap's book as the founding text of their field and continue to cite its contents, they have never subjected it to rigorous analysis. In this book I transform the *History* from a static biographical register of artists, familiar only to specialists, to a charged partisan tract shaped by competing professional, regional, and commercial interests. I effect this shift in perspective by examining, among other issues, who stood to benefit from Dunlap's account, how the *History* positioned its author and potential readers, and what vision of U.S. society informed its creation and distribution. This enlarged frame of reference reveals the *History* as a point of intersection for several systems of cultural meaning; the book's explication offers insight into other nationalist projects of the early nineteenth century and subsequent narratives of American art.[1]

The routes by which information is gathered, analyzed, and disseminated as well as the ways information confers meaning and power are among the principal concerns of the twenty-first century, particularly with the rise of the Internet. Current debates in the United States surrounding the Internet—about its effect on users, the practices of content providers, the role of the market, issues of access, and so forth—are relevant for thinking about the construction and dissemination of knowledge in previous periods. For example, as it bypasses local, regional, and national concerns to create a worldwide cyber-community, the Internet is said to be a principal agent of globalization. As many have pointed out, however, western (largely U.S.) government-sponsored agencies and corporations developed much of

1. The use of the term "American" to describe persons, activities, or characteristics of the United States is fraught with political and ideological implications. As residents of non-U.S. regions of the Americas rightly point out, they have as much claim to the term as citizens of the United States do. The label was used, however, to designate regions within the current United States during the colonial period, and it seems misleading to attach a U.S. label to something that predated the founding of the nation. I therefore have retained the term where it seemed that not to do so would cause greater confusion.

the technology creating the Internet, and English remains the dominant language online.[2] The growing links between the World Wide Web and established media conglomerates supply another example of the way in which the West continues to shape the values and interests defining the Internet.[3] Many of the critical questions posed in this book regarding Dunlap's *History* resemble those being asked of the Internet—such as, what does any source of information present as transparent or self-evident to its users or readers and what does it obscure? Just as the (western) rhetoric surrounding the Web posits the equivalence of experience around the globe, the *History* imbued local (and in some cases parochial) concerns with national implications in a period when what constituted the national was very much contested. These metonymic sleights of hand function on a number of levels in Dunlap's book. Without much explanation, Dunlap presented his autobiography as typical of the lives of other American citizens of the period as well as of his fellow artists' experiences. He found in the professional struggles of visual artists in the United States—an admittedly minuscule segment of the population—evidence of the triumph of republicanism over aristocracy. Perhaps most important for scholars interested in the historiography of American art, the book offered an extremely localized art scene—that of New York City—and a small coterie of friends and acquaintances as the standard-bearers for a national art tradition.

The *History* was not alone in its efforts to conjure the national from the local. It joined other contemporary accounts attempting to establish a shared history for the United States. The literary scholar Priscilla Wald, who has distinguished between official and unofficial national stories in her study of U.S. literature during the nineteenth and early twentieth centuries, writes that the authors of official narratives during this period "sought to create memories of forgotten origins, to transform contestable geopolitical boundaries and plural ethnic and racial peoples into a community with origins that predate those contests."[4] Dunlap performed such an act of creation by initiating an official story about the genesis and nature of the visual arts in the United States. The book shifted the frame of reference for U.S.

 2. John Carlos Rowe, "Post-Nationalism, Globalism, and the New American Studies," in *Post-Nationalist American Studies*, ed. John Carlos Rowe (Berkeley: University of California Press, 2000), p. 33.

 3. See Robert McChesney, "So Much for the Magic of Technology and the Free Market: The World Wide Web and the Corporate Media System," in *The World Wide Web and Contemporary Cultural Theory*, ed. Andrew Herman and Thomas Swiss (New York: Routledge, 2000), pp. 5–35, as well as the other essays in this anthology.

 4. Priscilla Wald, *Constituting Americans: Cultural Anxiety and Narrative Form* (Durham, N.C.: Duke University Press, 1995), p. 2. Wald argues that although these official and unofficial narratives exist on separate tracks, they had a shaping influence on each other (see p. 10).

artists, removing them from the history of British art and placing them in a new narrative.

Surviving contemporary responses to the *History* indicate resistance to Dunlap's version of events; in some cases this resistance inspired counternarratives, or unofficial stories in Wald's terminology. Yet the *History*'s presumption that American art could constitute an isolated subject of study has been a compelling and persistent idea since 1834, as the eight-part television series and accompanying book entitled *American Visions* (1997) by Robert Hughes, the Australian-born art critic for *Time* magazine, testified.[5] There are fascinating parallels and differences between Hughes's project and Dunlap's.[6] Both men established an overriding narrative theme for their chronological accounts of U.S. art: Dunlap referred to the "Rise and Progress of the Arts of Design" in his title and Hughes subtitled his account "The Epic History of Art in America." But whereas Dunlap created a chronicle that looked forward to future triumphs, Hughes presented a tale of aesthetic and conceptual decline, culminating in his portrait of a contemporary U.S. art world in crisis.[7] The two accounts function almost as bookends, presenting contrasting views of historical development that are both, in their own ways, indebted to Edward Gibbon's *The History of the Decline and Fall of the Roman Empire* (1776–88).[8] Both projects also targeted general audiences—Hughes wrote that his book was "meant for that creature who, American academics often profess to believe, no longer exists: the general intelligent reader"[9]—and both authors promoted their respective histories in the contemporary media. (*American Visions*, however, had the backing of the BBC and Time Warner for the television program and the publisher Alfred A. Knopf for the book whereas Dunlap self-published the *History* at great financial risk.) Even the

5. In the United States, *American Visions* premiered on PBS from May 28 to June 18, 1997. Robert Hughes, *American Visions: The Epic History of Art in America* (New York: Alfred A. Knopf, 1997).

6. The parallels include the emergence of a villain in each account. I propose John Trumbull as the villain of Dunlap's *History*; Jeff Koons seems to play that role in *American Visions*, most vividly in an interview with Hughes from the final episode of the television series.

7. Carter Ratcliff once labeled Hughes as an "art-world Cassandra," and Hughes has been both vocal and consistent in his characterization of the contemporary art world, and U.S. culture more generally, as destructively self-indulgent. Ratcliff's label appeared in his article "Dramatis Personae, Part I: Dim Views, Dire Warnings, Art-world Cassandras," *Art in America* 73 (September 1985): 9–15. For a sample of Hughes's foray into the culture wars, see his *Culture of Complaint: The Fraying of America* (New York: Oxford University Press, 1993).

8. In a letter to James Fenimore Cooper, Dunlap revealed that his reversal of Gibbon's title was intentional ("William Dunlap to James Fenimore Cooper," July 24, 1833, Za Cooper 230x, Beinecke Rare Book and Manuscript Library, Yale University). Dunlap never contemplated the possibility of an American decline.

9. Hughes, p. viii.

critical reception surrounding the accounts is eerily similar in a number of respects: reviewers were not quite sure how to categorize either project, although they perceived both as didactic in intent. Both authors also drew criticism for providing what was described as gratuitous personal information about artists and for their free use of sources.[10] When watching Hughes on television or reading his book the pull of a national narrative seemed as powerful in the late nineties as it had been for readers of the *History* in 1834.

The analysis of Dunlap's subscription and distribution network for the *History* offers another way of understanding the rhetorical claims driving the book's narrative. The *History* appeared at the beginning of an information revolution in the United States, when the number of newspapers, magazines, and books in print was increasing exponentially. As his discussions of the artistic profession reveal, Dunlap was confident that an independent art market would replace traditional systems of patronage for visual artists, and he entertained similar expectations for his publishing venture. He entered into the selling of the *History* certain that an educated populace would buy his book if it were promoted adequately. Yet this projected model of its distribution to a wide cross section of the American reading public presupposes a very specific form of cultural diffusion, one in keeping with the version of republican theory circulating in the early years of the United States that warned of the absolute necessity of an informed citizenry and included the belief that "natural" not inherited elites were responsible for educating the populace. The *History*'s limited commercial success suggests that Dunlap misjudged contemporary social and economic realities.

The form chosen by William Dunlap shaped the text's meaning in as consequential a way as the information the *History* included or the means of its distribution. Although dominated by profiles of individual artists, the book made use of a mixture

10. The critical reactions to Dunlap's *History* are analyzed in chapter 5 herein. On the nature of Hughes's didacticism, see David Rieff, "One Leg in History," *Modern Painters* 9 (Autumn 1996): 38, and Dave Hickey, "Bob and Wendy Teach Art," *Art Issues* 52 (March/April 1998): 10–13. For complaints that Hughes's approach to his subject was gossipy or sometimes blatantly mean-spirited, see Patricia Hills, "Half the Story," *Los Angeles Times*, April 27, 1997, p. 3; William Jaeger, "American Visions," *Art New England* 19 (February/March 1998): 7; and Martica Sawin, "Robert Hughes's Hat Trick," *Art Journal* 57 (Spring 1998): 79. Hughes came under fire after the publication of *American Visions* for not having properly credited the scholarship of art historians; for the debate, see Suzaan Boettger, "Partial Vision," *Art in America* 85 (October 1997): 39–43; "Hot Type," *Chronicle of Higher Education* 43 (June 27, 1997): A17; and Peter Plagens, "The Provenance of Ideas in Art History," *Chronicle of Higher Education* 44 (October 17, 1997): A68. Robert Hughes and *American Visions* were also the subject of a session at the 1999 conference of the College Art Association entitled "American Re-Visions: Evaluating Robert Hughes's Media Blitz." Like Dunlap's *History*, Hughes's account provoked a debate about the responsibilities of exercising cultural authority.

of writing genres. Dunlap hinted at this eclecticism when he refused to characterize his account in any definitive way, announcing, "The author calls this work a history, without presuming to place himself in the rank of professional historians. His history shall be given by a chain of biographical notices, with all the discursiveness and license of biography."[11] The heterogeneous nature of the book might strike many current readers as a clear signal of the amateur intentions of its author, yet it reflected the contemporary vogue for compendia of knowledge. Nineteenth-century readers found cultural value in publications ranging from popular magazines to multivolume biographical surveys that gathered as much information in as many different forms as possible.[12] The *History* broke new ground among U.S. publications on the visual arts by steering a middle course between the learned and traditional form of the academic discourse, as presented by Samuel Morse (1791–1872), then president of New York's National Academy of Design, and the emerging field of professional art criticism being practiced with great wit by John Neal (1793–1876).[13] Neither theoretical nor strictly topical, the *History* billed itself as an openended historical storehouse from which other surveys could draw.

One form in which the *History* does not present information to its readers is visually. Dunlap left no evidence that he ever considered illustrations for his account, probably because of their prohibitive cost. Despite his own background as a painter, Dunlap also did not analyze artworks created by the artists he included. In fact, his language often distances the reader from the visual realm, substituting generalized description for more sustained investigation. One scholar has suggested that the level of abstraction found in much American art writing from the beginning of the nineteenth century derives from its origins in neoclassical and associationist theory. Eventually, the critical balance would tip in favor of romanticism,

11. William Dunlap, *A History of the Rise and Progress of the Arts of Design in the United States*, ed. Rita Weiss (repr., New York: Dover, 1969), vol. 1, p. 9. Although the original edition of the *History* did not include the article "A" in its title, both the 1918 and 1969 editions did. As I explore in subsequent chapters, an eclectic approach to literary genres characterized much writing of the eighteenth and nineteenth centuries, particularly in magazines of the period.

12. On the nineteenth-century genre of the art historical survey text, see Hubert Locher, "The Art Historical Survey Narratives and Picture Compendia," *Visual Resources* 17 (2001): 165–78, and Dan Karlholm, "Reading the Virtual Museum of General Art History," *Art History* 24 (September 2001): 552–77.

13. See Samuel F. B. Morse, *Lectures on the Affinity of Painting with the Other Fine Arts*, ed. Nicolai Cikovsky Jr. (Columbia: University of Missouri Press, 1983). For more information on Morse as an art theorist, see Cikovsky's essay " 'To enlighten the public mind . . . to make the way easier for those that come after me': Samuel Morse as a Writer and Lecturer," in National Academy of Design, *Samuel F. B. Morse: Educator and Champion of the Arts in America* (New York: NAD, 1982). John Neal's art criticism has been collected as *Observations on American Art: Selections from the Writings of John Neal (1793–1876)*, ed. Harold Edward Dickson (State College: Pennsylvania State College, 1943).

prompting writers in the United States to produce written equivalents for the visual effects they observed.[14] A reader of the *History*, though, is much more likely to be able to recall a humorous anecdote told about an artist than summon up a vivid mental picture of a work of art.

Information does not flow in a closed circuit; it is always subject to reuse, revision, and recontextualization over time. After a period of neglect, the *History* entered into U.S. scholarship on the eve of World War I and has served various discursive functions in the years between its rediscovery and the present day. My study is yet one more installment in the critical uses to which the book has been put. When Dunlap embarked on his account, the American public was beginning to take pride in the productions of the country's artists. The *History* both reflected and stimulated this trend. Although the immediate press attention to the book was substantial, the *History* fell quickly from notice. One factor in its precipitous decline surely was the number of historical surveys that succeeded Dunlap's. Readers throughout the nineteenth century could find other, updated accounts of American art.

Another reason for the decline in interest was the changing definition of history itself. As Peter Novick demonstrated in his study of the historical profession in the United States, late nineteenth-century historians adopted "scientific" approaches to their subject matter in reaction to the narrative and didactic style of their predecessors.[15] In a passage that could describe the reorientation of histories of American art away from the Dunlap model, Novick writes of the first generation of American historians: "The combination of the 'intrusive' authorial presence, the explicit moralizing, and overt partisanship, made their work unacceptable to the historical scientists."[16] A more significant cause of the *History*'s eclipse during the nineteenth century was the waning taste for early American art.[17] The *History*'s critical fortunes have always been directly linked to contemporary appraisals of its subject matter— American art created during the colonial and early national periods. As American artists grew in number and technical proficiency in the period after the Civil War,

14. Stephanie Wasielewski Fay, "American Pictorial Rhetoric: Describing Works of Art in Fiction and Art Criticism, 1820–1875," Ph.D. diss., University of California, Berkeley, 1982, pp. 24–25. Profuse illustrations were crucial to the contemporary success of periodicals such as the *New-York Mirror* as well as to that of gift books. On the latter, see Isabelle Lehuu, *Carnival on the Page: Popular Print Media in Antebellum America* (Chapel Hill: University of North Carolina Press, 2000), chap. 4.

15. Peter Novick, *That Noble Dream: The "Objectivity Question" and the American Historical Profession* (Cambridge: Cambridge University Press, 1988).

16. Ibid., p. 46.

17. See Elizabeth Johns, "Histories of American Art: The Changing Quest," *Art Journal* 44 (Winter 1984): 339–40.

they viewed antebellum artworks as the embarrassing evidence of a provincial past best forgotten. For much of the later nineteenth century, the *History* could be condemned both for its literary style and for its content.

Amid many comparable rediscoveries, several publications directed attention to William Dunlap and the *History* during the 1910s. The Centennial Exposition in Philadelphia had begun the task of rehabilitating early American culture in 1876. Displays at the fair showcased historical American art and architecture and helped to spark the colonial revival that would continue well into the twentieth century. The surge of patriotism accompanying World War I and attempts to codify a shared national culture in the face of record immigration further intensified this interest in the artistic past.[18] Dunlap's descendent Theodore Woolsey provided the first modern study of his forebear in a 1914 article for the *Yale Review*.[19] Although Woolsey presented Dunlap as something of a Renaissance man of arts and letters, he focused primarily on his roles as a painter and a historian of the visual arts. Titling his essay "The American Vasari," Woolsey concluded with an appeal for a new edition of the *History*: "We study the silver and the furniture of our forefathers and their makers with eager interest; we gather the portraits and paintings of our early artists with enthusiasm. But we neglect the source of information about them nearest to hand and fullest of detail."[20] Four years later Oral Sumner Coad supplemented Woolsey's cursory biographical outline with a full-length monograph on Dunlap based on his doctoral dissertation.[21]

In 1918, the same year that Van Wyck Brooks made his influential call for American literary culture to "discover [and] invent a usable past," a revised edition of the *History* appeared.[22] In their editorial preface, Frank W. Bayley and Charles Eliot

18. See William B. Rhoads, "The Colonial Revival and the Americanization of Immigrants," in *The Colonial Revival in America*, ed. Alan Axelrod (New York: W. W. Norton for the Henry Francis du Pont Winterthur Museum, 1985), pp. 341–61, and William H. Truettner and Roger B. Stein, eds., *Picturing Old New England: Image and Memory* (Washington, D.C.: National Museum of American Art, Smithsonian Institution/New Haven: Yale University Press, 1999).

19. Theodore S. Woolsey, "The American Vasari," *Yale Review* 3 (July 1914): 778–89. At the time of this article's publication, Woolsey had six of Dunlap's diaries in his personal possession. He later bequeathed them to Yale University; see Oral Sumner Coad, "The Dunlap Diaries at Yale," *Studies in Philology* 24 (1927): 403–12.

20. Woolsey, p. 789.

21. Oral Sumner Coad, *William Dunlap: A Study of His Life and Works and of his Place in Contemporary Culture* (New York: Dunlap Society, 1917).

22. Van Wyck Brooks, "On Creating a Usable Past," *Dial* 64 (April 11, 1918): 337–41. In an attempt to reinvigorate American literature, Brooks urged his contemporaries to renounce academic interpretations of historical writers in favor of personal encounters with their works. He observed, "The past is an inexhaustible storehouse of apt attitudes and adaptable ideals; it opens of itself at the touch of desire; it yields up,

Goodspeed enumerated the limitations they found in the original text and outlined their decision to alter rather than reprint it *"verbatim et literatim* as a historical document."[23] Bayley and Goodspeed not only abridged but corrected the text—removing the more conspicuous evidence of Dunlap's authorial presence by eliminating his preface and many of his editorial comments. They also expanded Dunlap's list of supplementary artists and the book's original index, incorporated 174 illustrations, and appended a substantial "Bibliography of American Art and Artists before 1835" compiled by Frank Chase. A subsequent *History* editor noted that Bayley and Goodspeed had "transformed the work into the indispensable tool it has become" through these additions.[24] Their editorial changes, however, also provide insight into contemporary ideas about the proper way to approach American history. Following Dunlap's lead, Bayley and Goodspeed viewed the *History* as a work in progress, one that could ultimately be corrected and completed once the appropriate research had been conducted and sufficient information compiled.[25] Similar to the colonial period rooms that began to appear at the turn of the century, the 1918 edition of the *History* offered an edited and somewhat sanitized view of the past.

During the same period that a series of influential museum exhibitions began showcasing American art of the previous century, two publications brought William Dunlap more clearly into focus.[26] In 1930, the New-York Historical Society published the eleven extant volumes of Dunlap's diaries, covering the years between 1786 and 1834 (these remain divided between the collections of the Historical

now this treasure, now that, to anyone who comes to it armed with a capacity for personal choices" (p. 339). Later Brooks would devote a chapter to "William Dunlap and His Circle" in *The World of Washington Irving* (New York: E. P. Dutton, 1944), pp. 152–75.

23. Frank W. Bayley and Charles E. Goodspeed, "Editor's Preface" to *A History of the Rise and Progress of the Arts of Design in the United States* by William Dunlap (Boston: C. E. Goodspeed, 1918), vol. 1, p. v. Frank W. Bayley (1863–1932) wrote several books on John Singleton Copley and colonial portraiture and ran the Copley Galleries in Boston. Bayley was later charged with having passed off European portraits as works by Copley and other colonial artists; see Richard H. Saunders, "The Eighteenth-Century Portrait in American Culture of the Nineteenth and Twentieth Centuries," in *The Portrait in Eighteenth-Century America*, ed. Ellen G. Miles (Newark: University of Delaware Press, 1993), pp. 146–50. Charles Eliot Goodspeed (1867–1950) was a noted Boston bookseller and publisher.

24. Alexander Wyckoff, "Preface" to *History of the Rise and Progress of the Arts of Design in the United States* by William Dunlap, ed. Alexander Wyckoff (New York: Benjamin Blom, 1965), p. xxxvii.

25. See Bayley and Goodspeed, vol. 1, p. v.

26. William H. Truettner illuminated many of the historical and cultural forces driving interest in nineteenth-century American art during the 1920s and 1930s in his historiographic essay "Nature and the Native Tradition: The Problem of Two Thomas Coles," in *Thomas Cole: Landscape into History*, ed. William H. Truettner and Alan Wallach (New Haven: Yale University Press/ Washington, D.C.: National Museum of American Art, Smithsonian Institution, 1994), pp. 137–58. See also Elizabeth Johns, "Scholarship in American Art: Its History and Recent Developments," *American Studies International* 22 (October 1984): 11–16.

Society and Yale University). It quickly became clear that Dunlap used his diaries as a primary source for many of his published writings, including the *History*.[27] To mark the centennial of Dunlap's death in 1939, the Addison Gallery of American Art presented the exhibition *William Dunlap, Painter and Critic: Reflections of American Painting of a Century Ago*.[28] This display and its accompanying catalogue considered Dunlap's dual roles as an artist and historian. Winslow Ames, the guest curator, exhibited a selection of Dunlap's oil paintings, miniatures, and landscape sketches as well as works by his contemporaries that were accompanied by relevant passages from the *History*. Although in her catalogue essay Jane T. Johnson noted the differences between Dunlap's methods of analysis and modern art criticism, the exhibition made an implicit case for the prescience of Dunlap's critical assessments. As a reviewer for *Art Digest* observed, the display "gives [Dunlap], in the matter of selecting winners whose names would endure, a percentage that is far above average."[29] The Addison exhibition received extensive press coverage and represented the first time that the art historical community claimed Dunlap as one of its own.

Occurring against the backdrop of the cold war, the growth of American studies as an academic discipline during the 1950s and 1960s and the contemporary rise of American art as a specialized field within art history further energized scholarship relevant to Dunlap's *History*.[30] Walter Muir Whitehill's essay *The Arts in Early American History: Needs and Opportunities for Study*, published in 1965 with an annotated bibliography by Wendell D. Garrett and Jane N. Garrett, surveyed studies on art produced before 1826 while highlighting research topics that had yet to be addressed.[31] In their analyses of the development of the American artistic community

27. *Diary of William Dunlap*, ed. Dorothy C. Barck (New York: Benjamin Blom, 1969 [orig. pub., New York, 1930]).

28. Addison Gallery of American Art, Phillips Academy, *William Dunlap, Painter and Critic: Reflections on American Painting of a Century Ago* (Andover, Mass.: AGAA, 1939). This, 1939, was also the year of the influential *Life in America* exhibition at the Metropolitan Museum of Art that chronicled the history of the United States through painting (see Truettner, "Nature and the Native Tradition," p. 137). A recent exhibition organized by Hirschl & Adler Galleries followed a similar strategy as the Addison Gallery's, presenting examples of early American art seen through the lens of William Dunlap; see "The American Vasari: William Dunlap and His World," with essay by Arlene Katz Nichols (New York: Hirschl & Adler Galleries, 1998).

29. "Dunlap, the American 'Vasari,' and His Age," *Art Digest* 14 (October 1, 1939): 10. Other art journals also carried notices of the Addison exhibition, including *Antiques*, the *Magazine of Art*, and *Art News*.

30. For the connection between midcentury explorations of historical American art and the international critical acclaim being showered on Abstract Expressionism, see Truettner, "Nature and the Native Tradition," pp. 148–50, and Johns, "Histories of American Art," pp. 342–43.

31. Walter Muir Whitehill, *The Arts in Early American History: Needs and Opportunities for Study* (Williamsburg, Va.: Institute of Early American History and Culture/ Chapel Hill: University of North Carolina

between the Revolution and the Civil War, both Neil Harris and Lillian Miller contributed to a more comprehensive portrait of the fine arts during this period.[32] As if following Whitehill's call, Harold Dickson used William Dunlap as the focal point of his scholarship on early American artists, most notably in the 1968 exhibition *Arts of the Young Republic: The Age of William Dunlap* held at the Ackland Art Center at the University of North Carolina.[33]

Two new editions of the *History* were issued in 1965 and 1969, each with a modern introduction.[34] The 1965 edition attempted a compromise approach to the text, restoring all portions excised by Bayley and Goodspeed but relegating them to an appendix. Alexander Wyckoff, the editor, preserved the book's layers of historical accretion by retaining the footnotes from the 1918 version of the *History* as well as adding his own. A planned volume of accompanying illustrations was never published. The 1969 edition represented a shift in approach to the *History*. Dover Publications issued a facsimile copy of the original 1834 text, edited by Rita Weiss, in which the only additions were illustrations, keyed more closely to the text than those accompanying the 1918 edition; an enlarged index; and the marginal notation of each artist's complete name and life dates. The editorial decision to remove all scholarly additions to the *History* and treat it as a documentary source reflects the contemporary interest in discovering primary material on American art.[35] This approach restored the integrity of the text, and also encouraged art historians to view Dunlap's book as an exact mirror of its times, a transparent "period document."

During the subsequent decade, a number of cultural historians also rediscovered William Dunlap. Several used the circumstances of his biography to explore the

Press, 1965). Whitehill called for a new, annotated edition of the *History* (p. 26). He also offered a warning against the "budding chauvinism of American studies programs" which, he wrote, courted the "danger of isolating the early American arts, which should be studied in terms of their European roots and of their relationship to the West Indies and the Maritime Provinces" (p. 8).

32. Neil Harris, *The Artist in American Society: The Formative Years, 1790–1860* (New York: George Braziller, 1966), and Lillian B. Miller, *Patrons and Patriotism: The Encouragement of the Fine Arts in the United States, 1790–1860* (Chicago: University of Chicago Press, 1966).

33. Harold E. Dickson, *Arts of the Young Republic: The Age of William Dunlap* (Chapel Hill: University of North Carolina Press, 1968).

34. William Dunlap, *History of the Rise and Progress of the Arts of Design in the United States,* with an introduction by William P. Campbell, ed. Alexander Wyckoff (New York: Benjamin Blom, 1965), and William Dunlap, *A History of the Rise and Progress of the Arts of Design in the United States,* with an introduction by James Thomas Flexner, ed. Rita Weiss (New York: Dover, 1969).

35. After being founded in 1954, the Archives of American Art, a national research collection including original manuscript material related to American art, became a part of the Smithsonian Institution in 1970 (a year after the last edition of the *History* appeared).

social trends of the period. In her 1974 dissertation, Sarah Elizabeth Williams developed a case study on the rise of professionalism in the arts during the early American republic by scrutinizing Dunlap's various careers as a playwright, theater manager, biographer, painter, and historian.[36] Joseph Ellis chose William Dunlap as one of the four subjects of his book *After the Revolution: Profiles of Early American Culture* (1979).[37] In a chapter that focused on Dunlap's involvement with the American theater, Ellis found Dunlap's lack of commercial success representative of the disillusionment facing an entire post-Revolutionary generation. Although the biographical approach to William Dunlap practiced during the 1970s produced a richer portrait of the early national period, it also seemed to portray Dunlap as a passive conduit for larger historical forces.

The 1980s witnessed, in Wanda Corn's words, a "coming of age" in scholarship on American art.[38] One symptom of this maturation was the stirrings of interest in developing a historiography of the field. In two articles that appeared in 1984, Elizabeth Johns emphasized the influence of published histories on the development of American art scholarship, tracing the genre from Dunlap's *History* to Joshua Taylor's *The Fine Arts in America* (1979).[39] More recently, other historians have begun to flesh out the details of selected historical accounts surveyed by Johns, thereby particularizing their authors' use of narrative. Charles Colbert has argued persuasively that spiritualism was the driving force behind the art criticism of James Jackson Jarves, author of *Art Hints* (1855) and *The Art-Idea* (1864), while Alan Wallach has traced the connections between Oliver Larkin's Pulitzer Prize–winning

36. Sarah Elizabeth Williams, "William Dunlap and the Professionalization of the Arts in the Early Republic," Ph.D. diss., Brown University, 1974. Williams discusses the *History* briefly and summarizes the known information about its publication.

37. Joseph J. Ellis, *After the Revolution: Profiles of Early American Culture* (New York: W. W. Norton, 1979). Unlike many other writers, Ellis created a psychological portrait of Dunlap. He also profiled Charles Willson Peale, Hugh Henry Brackenridge, and Noah Webster.

38. Wanda M. Corn, "Coming of Age: Historical Scholarship in American Art," *Art Bulletin* 70 (June 1988): 188–207. As this book went to press, John Davis published a comprehensive article updating Corn's review of the state of the field; see "The End of the American Century: Current Scholarship on the Art of the United States," *Art Bulletin* 85 (September 2003): 544–80.

39. Johns, "Scholarship in American Art," pp. 3–40, and "Histories of American Art," pp. 338–44. Johns's research is one example of the growing contemporary self-consciousness within the discipline of art history. Surveys of the art historical past include Michael Podro, *The Critical Historians of Art* (New Haven: Yale University Press, 1982); David Carrier, *Principles of Art History Writing* (University Park: Pennsylvania State University Press, 1991); Udo Kultermann, *The History of Art History* (New York: Abaris Books, 1993); Vernon Hyde Minor, *Art History's History* (Englewood Cliffs, N.J.: Prentice Hall, 1994); and Keith Moxey, *The Practice of Persuasion: Paradox and Power in Art History* (Ithaca: Cornell University Press, 2001).

Art and Life in America (1949) and Popular Front ideology.[40] In addition, numerous books and exhibitions analyzing early American artists, and the growing ranks of textbook surveys of art produced in the United States, testify to the expansion of the field during the 1980s and 1990s.[41]

In this book I explore the process by which an art tradition "spoke itself into existence."[42] My work joins a number of investigations of the antebellum period that have probed the various means by which Americans constructed, maintained, revised, and challenged the "imagined community" of the nation, to use Benedict Anderson's phrase.[43] Many of the interrelated trends that have been identified by other scholars as defining the early nineteenth century reappear in this book: the expansion of the market economy, the continued importance of the print medium as a social force, the tension between republican and liberal ideologies, and the challenge to traditional authorities. William Dunlap found himself in the midst of many of these cultural shifts—in some cases embracing the new possibilities they allowed, such as targeting a new middle-class constituency for his book, and in others, attempting to retain the ideals of the late eighteenth century that helped to form his worldview, such as the necessity of civic, professional, and moral responsibility. Despite the celebratory tone of Dunlap's *History*, a number of pressing questions hover around his account, questions that were of particular concern for the nineteenth-century art world and remain relevant in modified form today: What is the role of the visual arts in a democracy and what are the implications for the art world of democratizing trends in the promotion and criticism of the visual arts? To

40. Charles Colbert, "A Critical Medium: James Jackson Jarves's Vision of Art History," *American Art* 16 (Spring 2002): 18–35, and Alan Wallach, "Oliver Larkin's *Art and Life in America*: Between the Popular Front and the Cold War," *American Art* 15 (Fall 2001): 80–89.

41. For a brief history of textbook surveys of American art as well as the comments of recent authors working in this genre, see David Bjelajac, Frances K. Pohl, and Angela Miller, "Textbooks for a New Generation," *American Art* 16 (Summer 2002): 2–15.

42. Wald, p. 2. See also Edmund S. Morgan, *Inventing the People: The Rise of Popular Sovereignty in England and America* (New York: W. W. Norton, 1988).

43. Benedict Anderson, *Imagined Communities: Reflections on the Origin and Spread of Nationalism* (London: Verso, 1986). The scholarship on early American nationalism has investigated, among other topics, the relationship between the regional (or increasingly, sectional) and the national, constructions of American identity that countered the dominant model, the rites by which a nation constitutes itself, and the use of the print medium to bind Americans together. See, for example, Harlow W. Sheidley, *Sectional Nationalism: Massachusetts Conservative Leaders and the Transformation of America, 1815–1836* (Boston: Northeastern University Press, 1998); Cheryl Walker, *Indian Nation: Native American Literature and Nineteenth-Century Nationalisms* (Durham, N.C.: Duke University Press, 1997); and David Waldstreicher, *In the Midst of Perpetual Fetes: The Making of American Nationalism, 1776–1820* (Chapel Hill: University of North Carolina Press for the Omohundro Institute of Early American History and Culture, Williamsburg, Va., 1997).

whom should artists address their works? Who is best qualified to define and judge artistic standards? What influence should patrons and audiences have over the content and appearance of works of art? As will become clear, Dunlap laid claim to an expanded, exemplary role for visual artists within U.S. society through his book, yet a number of the contemporary artists he chronicled expressed ambivalence about this position. They both courted and distrusted the viewing public.

As this book focuses on the significance of the *History* as a text, it details the strategies used by Dunlap to construct, position, and circulate his book, as well as analyzes its critical reception. The methods of the discipline known as the "history of the book" provide a fruitful point of departure in this endeavor, given that scholars in the field treat "the material text as a nexus in the intersection of literature, culture, and history."[44] It is also important to remember that the insistence of the *History* on the reader's *textual* encounter with artists and artworks is historically significant; what has yet to be written is a comprehensive account of the visual culture of the early republic.

In chapter 1, I argue that a comprehensive understanding of the *History* demands an investigation of the man at the center of its creation—William Dunlap. The first chapter details the personal, professional, and geographic ambitions that shaped his account of American art. The resulting *History* manifests a tension between Dunlap's belief in the honors and rewards of the academic art tradition, observed firsthand while he was abroad, and his experience of the tenuous state of the visual arts in the United States. In chapter 2, I tackle the subject of the growing attention to the visual arts found in nineteenth-century newspapers and magazines. I contend not only that the print culture of serials encouraged the reading public to develop a greater familiarity with the art world, but that this coverage injected the notion of topicality

44. Michele Moylan and Lance Stiles, eds., introduction to *Reading Books: Essays on the Material Text and Literature in America* (Amherst: University of Massachusetts Press, 1996), p. 12. Useful introductions to the "history of the book" include David D. Hall, "On Native Ground: From the History of Printing to the History of the Book," *Proceedings of the American Antiquarian Society* 93 (1983): 313–36, as well as Cathy N. Davidson, "Toward a History of Books and Readers," and Robert Darnton, "What Is the History of Books?," both in *Reading in America: Literature and Social History*, ed. Cathy N. Davidson (Baltimore: Johns Hopkins University Press, 1989), pp. 1–26 and 27–52. For other anthologies highlighting scholarship in this field, see William L. Joyce et al., eds., *Printing and Society in Early America* (Worcester, Mass.: American Antiquarian Society, 1983); David D. Hall and John B. Hench, eds., *Needs and Opportunities in the History of the Book: America, 1639–1876* (Worcester, Mass.: American Antiquarian Society, 1987); Michael Hackenberg, ed., *Getting the Books Out: Papers of the Chicago Conference on the Book in 19th-Century America* (Washington, D.C.: Center for the Book, Library of Congress, 1987); and Scott E. Casper, Joanne D. Chaison, and Jeffrey D. Groves, eds., *Perspectives on American Book History: Artifacts and Commentary* (Amherst: University of Massachusetts Press, 2002).

into considerations of art. Emphasizing the speculative nature of the *History* in chapter 3, I trace the circumstances of its research and writing, publication, and promotion, maintaining that the eclectic nature of Dunlap's book results from the multiple aims of the *History*. The book attempted to build upon the legacy of previous art literature, thus establishing a professional history for U.S. artists, while also referencing other writing genres in order to make the book attractive to a general audience. Chapter 4 examines Dunlap's influential biographies of Benjamin West and John Trumbull—two possible "fathers" of American art—within the context of his bid to construct a lasting genealogy of American artists. It reveals that the contrast drawn in the *History* between the two painters enacts larger contemporary debates about the role of visual art and artists within U.S. society. Scrutinizing surviving reactions to the book by artists as well as published reviews, chapter 5 gauges contemporary responses to the *History*. It elucidates the various limitations of Dunlap's appeal to a popular audience, demonstrating that the book existed on the cusp of competing visions of cultural authority. The epilogue presents a little-known benefit exhibition held in Dunlap's honor in 1838 as the embodiment of the *History*'s interpretative strengths and weaknesses.

This book has intentional parameters; it suggests, however, several directions for further research. For example, it provides an alternative to the artist monographs and genre studies that have dominated contemporary scholarship on American art of the early republic.[45] Although these explorations have contributed greatly to an understanding of individual artists and the cultural resonance of subject types such as landscape and genre scenes, the field is in need of more synthetic studies about early patronage, art institutions, and artistic culture in the United States.[46] Recent exhortations and preliminary attempts by U.S. scholars to take a more global perspective and to broaden the scope of research done in the fields of American history and American studies suggest another crucial line of inquiry for examinations of the

45. For an overview of the early American republic, see Gordon S. Wood, "The Significance of the Early Republic," in *New Perspectives on the Early Republic: Essays from the* Journal of the Early Republic, *1981–1991*, ed. Ralph D. Gray and Michael A. Morrison (Urbana: University of Illinois Press, 1994), pp. 1–20.

46. Some exceptions to the emphasis on monographic and genre studies within scholarship on art of the early nineteenth century include Vivien Green Fryd, *Art and Empire: The Politics of Ethnicity in the United States Capitol, 1815–1860* (New Haven: Yale University Press, 1992); David R. Brigham, *Public Culture in the Early Republic: Peale's Museum and Its Audience* (Washington, D.C.: Smithsonian Institution Press, 1995); and Alan Wallach, "Long-Term Visions, Short-Term Failures: Art Institutions in the United States, 1800–1860," in his *Exhibiting Contradiction: Essays on the Art Museum in the United States* (Amherst: University of Massachusetts Press, 1998).

art world of the late eighteenth and early nineteenth centuries.[47] Analysis of the *History* suggests many areas of overlap between art historical writing in the United States and Europe—including nationalist agendas, links to contemporary art academies, and the role of the publishing market—while comparative studies of art literature in the United States and other parts of the Americas offer an untapped subject. A more general question is how have constructions of the visual arts played a role in forging cultural identities in emerging nations around the world. A careful reading of the *History* offers valuable insights into only one of many attempts to make normative a provisional view of history and cultural practice.

47. See Thomas Bender, ed., *Rethinking American History in a Global Age* (Berkeley: University of California Press, 2002), and John Carlos Rowe, ed., *Post-Nationalist American Studies* (Berkeley: University of California Press, 2000). Barbara Groseclose draws attention to the growing internationalization within the study of art of the United States in "Changing Exchanges: American Art History on and at an International Stage," *American Art* 14 (Spring 2002): 2–7.

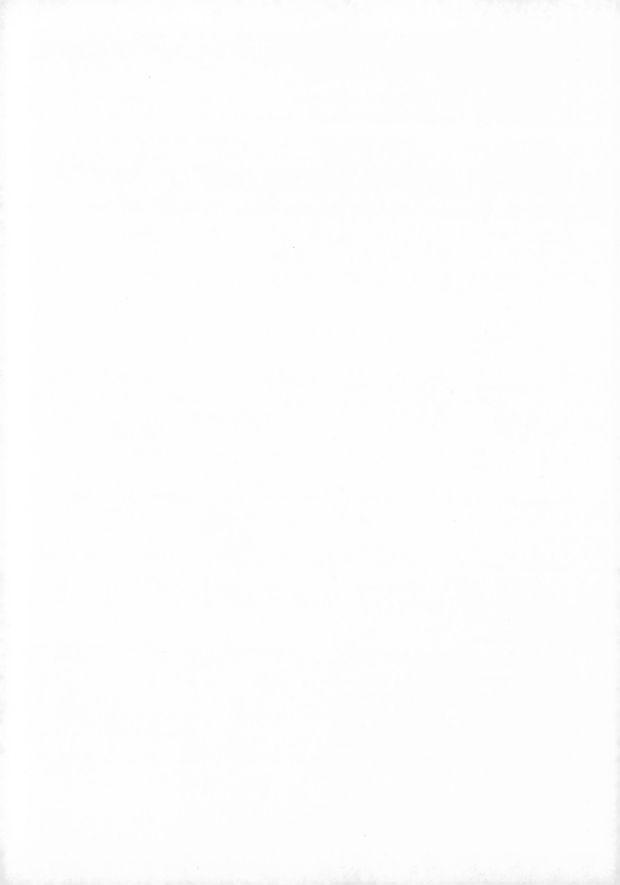

ONE

The Historian: William Dunlap, "The American Vasari"

The subject of the following sketch has been before the public as an author and an artist for nearly half a century. . . . Engaged for so many years in pursuits so various, active and exciting, in which he was not always kindly treated by fortune, and which brought him into conflict with so many interests, it might almost be deemed impossible that Mr. Dunlap should have escaped occasions of slander and enmity. Yet, few men have passed through life so free from reproach, and few are so universally beloved. Mr. Dunlap, by general consent, bears that noblest of titles—an honest man. His manners are unassuming and kind; his conversation full of knowledge and anecdote; his moral judgment true and delicate; and his feelings warm and generous. One proof of the excellence of his heart, and the elevation of his character above every thing sordid and envious, is the instant, warm and liberal commendation which he bestows upon the works of his brethren in the art of painting, wherever he discovers in them the marks of genius and skill.

William Cullen Bryant (1833)

To begin an analysis of the *History of the Rise and Progress of the Arts of Design in the United States* with a consideration of William Dunlap's biography may seem a methodological risk, but there are compelling reasons why the details of Dunlap's life merit attention. As the art historian Elizabeth Johns observed, "Dunlap's *History* had at its center his own biography."[1] This is true both in the indirect sense that Dunlap's account reflects his expertise and prejudices, and in the literal sense that the book includes a lengthy autobiographical passage midway through its historical survey. Indeed, as Dunlap revealed in the *History*'s conclusion, his life span was the defining framework for the account. Having just traced the rise of the visual arts in

1. Elizabeth Johns, "Histories of American Art: The Changing Quest," *Art Journal* 44 (Winter 1984): 338.

the United States, he summarized: "Within the short space of one man's life we see arts which were unknown, successfully taught and practised throughout the wide extent of the republic, and in regions which were unexplored by civilized man within half a century."[2] Dunlap could thus conflate the history of American art with his personal frame of reference, begging the question: what did his life prepare him to see—and miss—when writing about a century of art activity?

 Another incentive to investigate Dunlap's life stems from his claim that his first-hand knowledge of the art world legitimized his authorship of the *History*. This assertion operates on two levels. In its most direct manifestation, Dunlap presented his own experiences as a painter as typical of the biographies of his fellow artists, suggesting that he could render their lives in an accurate way because he was one of them. An examination of his life, therefore, should seek to identify the areas in which his professional life was representative. It is equally important, however, to gauge Dunlap's cultural position outside the art world in order to understand the ways in which his background distinguished him from other artists. As the epigraph to this chapter discloses, Dunlap was a familiar figure within the cultural world of New York City, having established strong ties not only to its artists but to its literary, theatrical, and publishing communities.[3] Readers of the *History* should not mistake the book for an idiosyncratic project by a minor artist; the account was possible because of Dunlap's varied background and connections. Any analysis of the book should thus acknowledge Dunlap's double vision—his professional ambition to present the art world as an independent, self-governing entity, and yet his tacit admission that its survival depended on an ongoing dialogue with society at large. An investigation of Dunlap's artistic training and professional career as well as his lifelong residence in New York reveals the terms of this balancing act.

Dunlap's Biography in Brief

Dunlap's autobiography in the *History* is the source for much of the known information about his life.[4] He structured this profile as a morality tale, tracing the path

 2. William Dunlap, *A History of the Rise and Progress of the Arts of Design in the United States*, ed. Rita Weiss (New York: Dover, 1969), vol. 2, p. 465. Unless otherwise noted, all subsequent citations refer to this edition.
 3. [William Cullen Bryant], "American Authors and Artists. William Dunlap," *New-York Mirror*, February 23, 1833, pp. 265–66. Dunlap identifies Bryant as the author of this sketch in his diaries; see *Diary of William Dunlap*, ed. Dorothy C. Barck (New York: Benjamin Blom, 1969 [orig. pub., New York, 1930]), pp. 655 and 658. All subsequent citations refer to this edition of the *Diary*.
 4. Dunlap, *History*, vol. 1, pp. 243–311. Dunlap also included some autobiographical material in his *History of the American Theatre* (New York: Burt Franklin, 1963 [repr. of 1833 London ed.]) and *History of*

from his sheltered childhood to his mildly dissipated youth and chastened adult-hood. The manner in which the so-called American Vasari interpreted his own life reveals much about his priorities in writing the biographies of his fellow artists.[5]

Dunlap (figure 1) was born in Perth Amboy, New Jersey, on February 19, 1766, to Samuel Dunlap and Margaret Sargent Dunlap. His father, a native of Ireland, came to America as a soldier in the British army and served in General Wolfe's regiment during the French and Indian War. Samuel Dunlap eventually resigned his commission, married a woman from Perth Amboy, and set himself up as a merchant in that town. Remaining loyal to the crown, Dunlap's father moved his family to British-held New York City in 1777 when conditions became dangerous in New Jersey.

Curiously, William Dunlap never commented directly on his father's status as a Loyalist in any of his autobiographical writings. He presented himself, though, as an ardent patriot—one who met and painted George Washington in 1783 and who always favored political and cultural independence from England. Many pages of the *History* bristle with disparaging comments about the British monar-chy or condemnations of aristocratic society. Samuel Dunlap's success in adapting to postcolonial America probably made further justification on his son's part un-necessary; after settling in New York permanently after the war, Dunlap's father was able to build a thriving mercantile career despite his prior allegiance to the king.[6]

By his own account, Dunlap spent his youth "as the only and indulged child of

the New Netherlands, Province of New York, and State of New York to the Adoption of the Federal Constitution (New York: Burt Franklin, 1970 [repr. of orig. 1839–40 ed.]). As mentioned in the introduction, two monographs have been published on Dunlap: Oral Sumner Coad, *William Dunlap: A Study of His Life and Work and His Place in Contemporary Culture* (New York: Dunlap Society, 1917), and Robert H. Canary, *William Dunlap* (New York: Twayne Publishers, 1970).

5. Samuel Isham is the earliest writer I have found to apply this epithet to William Dunlap; see Isham's *The History of American Painting* (New York: Macmillan, 1927 [orig. pub., New York, 1905]), p. 72.

6. Even though local authorities began inquisition proceedings against the elder Dunlap in 1778, they apparently never confiscated his property in Perth Amboy. See A. Van Doren Honeyman, "Appendix III—Additional New Jersey Loyalists," in E. Alfred Jones, "The Loyalists of New Jersey in the Revolution," *Proceedings of the New Jersey Historical Society* 12 (April 1927): 167. Several newspaper advertisements of Samuel Dunlap's New York store can be found reproduced in Rita Susswein Gottesman, *The Arts and Crafts in New York, 1777–1799. Advertisements and News Items from New York City Newspapers* (New York: New-York Historical Society, 1954), pp. 100, 138, and 201. In chapter 4, I discuss Dunlap's attacks on the patriotism of the painter John Trumbull in the *History*, which seem anomalous given Dunlap's own vulner-ability in this area and given the obvious patriotic credentials of Trumbull's father, who served as the Revolutionary governor of Connecticut.

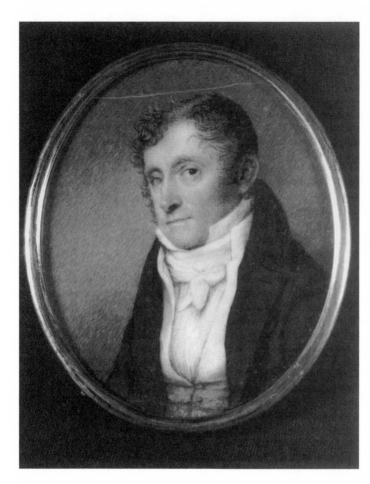

FIGURE 1.
William Dunlap,
Self-Portrait, c. 1812.
Watercolor on ivory,
3 × 2 ½ in.
Yale University Art
Gallery. Gift from the
estate of Geraldine
Woolsey Carmalt.

my parents."[7] Because of the dislocations of the war, various childhood illnesses, and the loss of his right eye in an accident at the age of twelve, he never received a formal education. When Dunlap demonstrated an early interest in art, however, his parents secured him lessons, bought him art supplies, and agreed to subsidize a trip to London to study with Benjamin West after the Revolution ended. Within the larger narrative trajectory of his autobiography, Dunlap presented his three-year sojourn in London as the period of his temptation and fall. In the first sentence of the sketch of his life, Dunlap characterized his experience in the British capital as a cautionary tale for all young artists: "As I have endeavored, by the examples of West and Copley, to show the road to eminence which a painter ought to follow, and

7. Dunlap, *History*, vol. 1, p. 251. Dunlap also blamed his weakness of character on his early exposure to slavery. His father owned a number of slaves, as did most of his New Jersey neighbors (see ibid., p. 244).

shall hereafter exhibit Trumbull, Sully, Allston, Morse, Leslie, and others, as examples of industry, when students, my desire is to exhibit my own conduct when placed in that situation, and *its results*—as a beacon to be avoided by all."[8] Dunlap described himself as an inattentive pupil while in London, more concerned with socializing and frequenting the theater than prosecuting his studies as a painter. News of his truancy apparently reached his father, who called him home in 1787. Dunlap summarized his time abroad succinctly: "Thus ended a residence in London of sufficient length to have made a man of abilities feebler than mine a painter."[9]

Upon his return to New York, Dunlap set up a portrait studio in his father's house. His experiment was short-lived. Although he had little artistic competition at that time in New York—he mentions only Joseph Wright in the *History*—Dunlap admitted that "by degrees my employers became fewer, my efforts were unsatisfactory to myself. I sought a refuge in literature, and after a year or two abandoned painting, and joined my father in mercantile business."[10]

Soon dissatisfied with commercial life, however, Dunlap sought new social and creative outlets during the 1780s and 1790s. As a result of his marriage to Elizabeth Woolsey in 1789, Timothy Dwight—the future president of Yale College—became his brother-in-law, and he made further ties to New York's mercantile community.[11] Backed by the resources of his father's business, he began to write for the New York stage, and found intellectual support for this venture through membership in a series of influential literary clubs. His first play to be produced, a comedy entitled *The Father; or American Shandyism*, debuted at the John Street Theatre in 1787. Dunlap became increasingly involved with this theater, first acquiring partial interest in its Old American Company and then becoming its sole proprietor, manager, and director in 1798. During his seven-year tenure as manager, he produced both his own plays and his translations of contemporary French and German drama. He

8. Ibid., p. 243. Joseph J. Ellis observes that Dunlap presented his life as a melodrama—punctuated by early immaturity, crisis, and later reform; see *After the Revolution: Profiles of Early American Culture* (New York: W.W. Norton, 1979), pp. 117–18.

9. Dunlap, *History*, vol. 1, p. 265.

10. Ibid., p. 266. In his historical survey of art in New York City, Frank Weitenkampf records that a number of painters were active there during the 1790s in addition to Wright and Dunlap; these included miniaturists such as Benjamin Trott and Alexander Robertson as well as Gilbert Stuart; "The Fine Arts in New-York City," in *The Memorial History of the City of New-York*, ed. James Grant Wilson (New York: New-York History Company, 1893), vol. 4, pp. 344–45. For more information on this period, see Gottesman.

11. For information on the Woolsey family, see Walter Barrett [Joseph A. Scoville], *The Old Merchants of New York City* (New York: Carleton, 1862), pp. 379–87; and Benjamin W. Dwight, "The Descendants of Rev. Benjamin Woolsey, of Dosoris (Glen Cove), L.I.," *New York Genealogical and Biographical Record* 4 (July 1873): 143–55, continued in ibid., 5 (January 1874): 12–25.

detailed his failed experiment as a theater manager in his *History of the American Theatre* (1832).[12] Despite his heavy personal investments and desperate efforts to attract an audience through diverse offerings, the theater consistently lost money. In 1805 these financial reverses forced Dunlap to declare bankruptcy; he lost all of his property with the exception of his mother's farm in Perth Amboy.

Dunlap's bankruptcy was a turning point in his life. Sarah Williams, one of the few historians to link Dunlap's social class to his activities and critical outlook, argued that his financial crisis brought about a fundamental change in his approach to the arts; he ceased to be a dilettante and began to view himself as a professional.[13] Although never traveling in the wealthiest circles of New York society, Dunlap was financially secure enough initially to bypass his father's business and involve himself in a number of unpaid or low-paying activities. After 1805, he returned to his painting career in earnest, becoming an itinerant portraitist. Dunlap's willingness to remake his life can be read as one example of the growth in character emphasized in his autobiography. Thinking of his misspent youth, Dunlap wrote in the *History*, "I am so dissimilar to what I was, that I can with difficulty recognize *sameness*. I am *not* what I was; but the knowledge of what I was produces the conviction of identity."[14] This narrative of personal redefinition also contributes to one of the other thematic threads running throughout the *History*: the growing self-consciousness of American artists. Once a gentleman-amateur, Dunlap joined the ranks of artists who were just beginning to challenge the public view of them as mechanical craftsmen. Dunlap's own shifting social position made him particularly sensitive to the artist's changing status in American society, and his writings reveal the tensions and contradictions that accompanied the process of their professionalization.[15]

Although he subsequently became an advocate for artists' professional dedication,

12. See also Coad, *William Dunlap*; George C. D. Odell, *Annals of the New York Stage* (New York: Columbia University Press, 1927); David Grimsted, "William Dunlap: The Corruption of an Enlightened Age," in *Melodrama Unveiled: American Theater and Culture 1800–1850* (Chicago: University of Chicago Press, 1968); Canary, *William Dunlap*; and Robert Alexander Grinchuk, "The Plays of William Dunlap: A Study of Dramatic Failure and the Shift in Popular Taste, 1795–1805," Ph.D. diss., University of Minnesota, 1972.

13. Sarah Elizabeth Williams, "William Dunlap and the Professionalization of the Arts in the Early Republic," Ph.D. diss., Brown University, 1974. Williams describes Dunlap as traveling in genteel but not aristocratic social circles before his bankruptcy (p. 42). Robert Grinchuk has suggested that Dunlap's social insulation was the primary reason for the failure of his theater (Grinchuk, p. 37).

14. Dunlap, *History*, vol. 1, p. 243.

15. Joseph Ellis presents these tensions as being characteristic of Dunlap's generation (those who came of age after the Revolution). He describes this group as being caught between the Revolutionary dream of a republican society and the emerging conditions of liberal capitalism (Ellis, *After the Revolution*, intro.). For the shift in the professional identity of artists, see Neil Harris's classic study *The Artist in American Society: The Formative Years, 1790–1860* (New York: George Braziller, 1966), esp. chap. 3.

Dunlap was often willing to interrupt his own painting career in order to take advantage of other sources of income. During the ten years after his financial failure he published two biographies—one of the actor George F. Cooke and another of his friend, the novelist Charles Brockden Brown—and a short-lived magazine, worked for nearly five years as the assistant manager of the New York theater that he had once directed, and spent two years traveling throughout New York as assistant paymaster-general for the state militia.

The period from late 1816 through the 1820s marks Dunlap's most sustained activity as a painter. During these years he traveled widely in search of portrait commissions, executed several large-scale exhibition paintings, and involved himself with two New York art institutions—the American Academy of the Fine Arts and the National Academy of Design.

Bad health caused Dunlap to turn his attention to writing projects during the 1830s. In addition to making regular contributions to several newspapers and magazines, he published his histories of the American theater and American art, a temperance novel, a history of New York for children, and the first volume of his history of New York state (the second volume appeared posthumously). Dunlap died in New York City on September 28, 1839, at the age of seventy-three.

Dunlap as a Professional Artist

As a theater manager and as an itinerant artist, Dunlap confronted the unpredictability of popular taste; in particular, his career as a painter forced him to qualify the high-flown rhetoric of traditional art literature in light of the frequently brutal realities of the art market. This accommodation helped shape the content of the *History*, sharpening Dunlap's insistence in the book that formal training and institutional support were crucial to a contemporary artist's survival, and giving resonance to those biographies in which he demonstrated that necessity rather than choice made resourceful entrepreneurs of early American artists.

Unlike many of his fellow artists of the period, Dunlap had access to regular instruction during his stay in London. Not only was Benjamin West willing to act as his teacher, the Royal Academy admitted him based on a drawing he submitted after a cast of an ancient sculpture, the *Fighting Gladiator*. The professional difficulties Dunlap faced after his return to the United States lend poignancy to his condemnations in the *History* of his immature behavior when abroad. Having struggled with technical limitations throughout his painting career, he expressed tremendous re-

gret at not having made more use of his educational opportunities. Fifty years after the fact, this omission appeared to him to have been not just a moral failing, but a costly professional miscalculation. Still, Dunlap undoubtedly profited throughout his lifetime from his early association with Benjamin West. The credentials he acquired while in London set him apart from many artist competitors and helped him to assume leadership positions within the early American art world.[16]

In the *History* Dunlap acknowledged the assistance he received during the course of his career from fellow artists. For example, he extended a grateful tribute to Edward Malbone for instructing him in the preparation of ivory—the material on which most miniatures were painted—when the two met in Boston in 1805.[17] As Dunlap was trying to make his living at the time as an itinerant miniaturist, this advice was timely if not overdue. He credited Gilbert Stuart, as well, with his decision to add oil painting to his artistic repertoire when he returned to painting in 1811.[18] These instances of collegial support explain his particular attention in the *History* to mature artists, including West, Stuart, and Thomas Sully, who were willing to dispense instruction.[19]

Dunlap's challenges as an artist included not only his inadequate training but also the financial constraints imposed by a limited art market. Despite his residence in a major metropolitan area, inadequate local commissions forced him into sustained periods of itinerancy.[20] As did his contemporaries, Dunlap sought

16. The most comprehensive analysis of Dunlap's artistic production can be found in Charles H. Elam, "The Portraits of William Dunlap (1766–1839) and a Catalogue of His Works," M.A. thesis, Institute of Fine Arts, New York University, 1952.

17. Dunlap, *History*, vol. 1, pp. 269–70. In another example of his belated search for technical instruction, Dunlap copied Thomas Sully's palette into his diary for 1819–20 (vol. 24).

18. Dunlap, *History*, vol. 1, p. 273. In his capacity as an artistic mentor, Gilbert Stuart once offered a candid assessment of Dunlap's artistic limitations. After Dunlap confessed that several Connecticut patrons had expressed dissatisfaction with his miniature portraits of them, Stuart reportedly remarked: "Friend Dunlap, it appears to me the good people of New Haven may have had some cause." Cited in Harry B. Wehle, *American Miniatures, 1730–1850* (New York: Da Capo Press, 1970 [orig. pub., Garden City, N.Y., 1927]), p. 80.

19. Dorinda Evans analyzes West's legacy as a teacher in *Benjamin West and His American Students* (Washington, D.C.: Smithsonian Institution Press, 1980). For Stuart as a teacher, see John Hill Morgan, *Gilbert Stuart and His Pupils* (New York: New-York Historical Society, 1939); this volume also publishes a manuscript recording instructions that Stuart gave to Matthew Jouett in 1816. Monroe H. Fabian considers Sully as an instructor briefly in *Mr. Sully, Portrait Painter* (Washington, D.C.: Smithsonian Institution Press, 1983), pp. 18–19.

20. For information on Dunlap as an itinerant artist, see Leah Lipton, "William Dunlap, Samuel F. B. Morse, John Wesley Jarvis, and Chester Harding: Their Careers as Itinerant Portrait Painters," *American Art Journal* 13 (Summer 1981): 34–50.

FIGURE 2.
William Dunlap,
John Adams Conant,
1829. Oil on wood,
30 1/8 × 25 in.
Metropolitan Museum
of Art. Gift of John A.
Church, 1913
(13.217.1).

out portrait commissions along the eastern seaboard; figure 2 is a portrait of John Conant painted by Dunlap on a trip through Vermont. Artists (or their agents) used local newspapers to announce their arrival in a city and to inform the populace where they could be found. An artist's stay in a city or town could last a few days or a period of months. A surviving clipping from an unidentified Montreal newspaper records Dunlap's 1820 visit and illustrates the hyperbole (and erratic spelling and punctuation) often used in these notices. Readers were advised not only that Dunlap was soliciting portrait commissions, but that he brought the skills of an Old Master to the task: "Mr. D. In the bold full light of his painting, follows his great master Reynold's; and in delicacy of colouring we believe their is no artist of the present day will exceed him. In this he appears to retain the purity and soft blending Tints of Ruben; and while the boldness of

his outlines, and depth of shade approximate the style of West, they appear to mix with more softness and give a greater freedom that we have observed in some of the earlier productions of that eminen[t] painter."[21]

In the absence of established museums or commercial galleries, artists during the early nineteenth century desperately needed to find venues for presenting their works formally to the public.[22] Annual review exhibitions organized by newly founded art academies provided one regular opportunity. Although Dunlap showed a few times at the annual exhibitions of the Pennsylvania Academy and the Boston Athenaeum, he made most of his submissions to art institutions in New York City.[23] He was an active participant in the annual shows at the American Academy of the Fine Arts until 1826, exhibiting twelve works in its inaugural exhibition of 1816.[24] As a founder of the National Academy of Design, Dunlap became a mainstay of its exhibitions, contributing works every year until his death, with the exception of 1834 and 1837.[25] He also sent works to the fledgling Apollo Gallery's exhibitions of 1838 and 1839, and three of his works were shown by that organization posthumously in 1841.[26] Though portraits made up the bulk of Dunlap's entries to these exhibitions, their catalogues also record copies after Old Masters as well as original religious, allegorical, and literary compositions.

Since art academies did not compensate exhibitors for their submissions to

21. The clipping is preserved in volume 24 of Dunlap's diaries, now in the possession of the New-York Historical Society.

22. The largest public displays of Dunlap's paintings were at an exhibition of sixty works he organized in Norfolk, Virginia, which opened in December of 1820 (Dunlap, *Diary*, p. 573), and at the auction held in New York City in 1839 dispersing the contents of his studio after his death. Elam reproduces the catalogue from this auction as figure 231 of his thesis; both Dunlap's own works and his print collection were offered for sale.

23. Anna Wells Rutledge, *The Annual Exhibition Record of the Pennsylvania Academy of the Fine Arts, 1807–1870*, ed. Peter Hastings Falk (Madison, Conn.: Sound View Press, 1988 [repr. of Rutledge's 1955 *Cumulative Record of Exhibition Catalogues, 1807–1870*]), p. 66. Dunlap sent one painting to the Pennsylvania Academy's 1812 exhibition and three paintings to its annual exhibition of 1818. He also submitted three paintings to a special exhibition held at the Academy in 1818 and three paintings to Philadelphia's Artist's Fund Society exhibition of 1835. Dunlap had five works in the Boston Athenaeum show of 1828; see Robert F. Perkins Jr. and William J. Gavin III, compilers and eds., *The Boston Athenaeum Exhibition Index, 1827–1874* (Boston: Library of the Athenaeum, 1980), p. 52.

24. See Mary Bartlett Cowdrey, ed., *American Academy of Fine Arts and American Art-Union. Exhibition Record 1816–52* (New York: New-York Historical Society, 1953), pp. 118–19.

25. Mary Bartlett Cowdrey, ed., *National Academy of Design Exhibition Record, 1826–1860* (New York: New-York Historical Society, 1943), pp. 130–33.

26. Cowdrey, *American Academy*, p. 120. The Apollo Gallery, organized by James Herring in 1838, was the precursor to the American Art-Union. For more information on the Art-Union, see the notes to the epilogue.

annual review shows, many artists—even those who distinguished themselves by their European training—needed to find alternative ways to supplement their incomes, particularly during the lean years of the early republic.[27] Following the lead of John Singleton Copley, who began exhibiting his paintings outside the auspices of the British Royal Academy in 1781, a number of U.S. painters, including Dunlap, John Trumbull, Rembrandt Peale, Thomas Sully, Samuel F. B. Morse, and John Vanderlyn, adopted the same entrepreneurial tactic in the United States.[28] Most of their ambitious, and often large-scale, exhibition paintings were created without a specific commission, as speculative experiments to draw the admission-paying public. Between 1822 and 1828 Dunlap painted four such paintings based on the life of Christ: *Christ Rejected* (1821–22), *The Bearing of the Cross* (1823–24), *Death on the Pale Horse* (1825), and *Calvary* (1825–28). In promotional material for their exhibition, he openly acknowledged that he had based both the *Christ Rejected* and *Death on the Pale Horse* on compositions by Benjamin West.[29] Unfortunately, all of these large-scale works have been lost and are now known only through contemporary descriptions and one surviving study (see figure 3). When the four works were shown together in New York in 1832, a critic calculated that "this series of subjects from the Evangelists, occupies nearly one thousand square feet of canvas, displaying seven or eight hundred figures."[30]

Dunlap exhibited these paintings in cities throughout the United States ranging from Portland, Maine, to Urbana, Illinois.[31] Although he hired agents to supervise the transportation, unpacking, and hanging of the works and to collect admission fees, he often made the preliminary arrangements to engage appropriate exhibition

27. Harold E. Dickson, "Artists as Showmen," *American Art Journal* 5 (May 1973): 4–17. Dunlap and others turned to independent exhibitions in the years following the financial panic of 1818–19. In "The Artist's Profession in the Early Republic," *Art Quarterly* 8 (Autumn 1945): 262 and 265, Dickson observes that this depression reduced artists' commissions drastically until the late 1820s.

28. Dickson makes the point that three of Copley's major exhibition paintings were on view in London when Dunlap arrived in 1784. See his "Artists as Showmen," p. 6.

29. Elam records that Dunlap executed a fifth large-scale religious painting—*Christ with the Doctors in the Temple*—that disintegrated without ever having been exhibited (p. 42). Dunlap also showed a large contemporary history painting titled *The Attack on the Louvre of July 1830* (1831) in New York during the early 1830s; see *New-York Mirror*, March 19, 1831, pp. 294–95. Elam provides a comprehensive catalogue of Dunlap's known works in appendix A of his thesis.

30. "Painting. Mr. Dunlap's Historical Pictures," *New-York Mirror*, March 24, 1832, p. 299.

31. Coad, *William Dunlap*, p. 102. For a valuable index of the myriad display spaces available in New York City alone, see appendix A to Carrie Rebora Barratt's essay "Mapping the Venues: New York City Art Exhibitions," in *Art and the Empire City: New York, 1825–1861*, ed. Catherine Hoover Voorsanger and John K. Howat (New York: Metropolitan Museum of Art/ New Haven: Yale University Press, 2000), pp. 66–74.

FIGURE 3. William Dunlap, *Christ Rejected*, 1822. Oil on canvas, 70.5 × 91.2 cm. The Art Museum, Princeton University. Museum purchase, Caroline G. Mather Fund, ©2001 Trustees of Princeton University.

spaces himself. The *History* records the complexity of these arrangements; Dunlap noted that in 1826 he "had the bearing of the cross on exhibition at Charleston, the Death on the Pale Horse at Norfolk, and the Christ Rejected at Washington."[32]

Through his experience on the exhibition circuit, Dunlap acquired firsthand knowledge of the uncertainties that met American artists as rising professional expectations and increased competition complicated an already volatile market.[33] By necessity he became remarkably well informed about other artists' activities in order

32. Dunlap, *History*, vol. 1, p. 296.
33. Dickson, "The Artist's Profession in the Early Republic."

to avoid saturating any one location. He also gained extensive knowledge of the independent exhibition spaces around the country. Though his paintings were often shown in makeshift quarters, Dunlap exhibited a number of works at more substantial public galleries, including the one opened by Thomas Sully and James Earle in Philadelphia, Charles Bird King's gallery in Washington, D.C., and Doggett's Repository of Art in Boston.[34] During his travels he extended his range of acquaintances beyond the New York area, meeting both artists and collectors. This crucial network was not only necessary to his survival as a professional artist but became a rich source for the *History*.

Dunlap's struggles as an artist help account for his close affiliation with the art academies in New York. After being elected an academician, Dunlap became a stalwart supporter of the American Academy of the Fine Arts, serving as one of its directors as well as holding the position of Keeper and Librarian from 1818 to 1819, a salaried post that paid him a much-needed $200 per year and allocated him studio space.[35] The American Academy was the second art academy established in the United States, following the short-lived Columbianum of Philadelphia organized by Charles Willson Peale in 1794. A group of New York politicians, merchants, doctors, and other professionals led by Robert R. Livingston, the United States minister to France, and his brother Edward Livingston, the mayor of New York, founded the American Academy in 1802 to serve as the city's cultural leader in the visual arts.[36]

34. Fabian, p. 20. Dunlap's surviving correspondence with Charles Bird King documents his use of King's Washington gallery: "William Dunlap to Charles Bird King," January 14, 1826, and October 1, 1829, Charles Roberts Autograph Collection, Haverford College Library, available through the Archives of American Art, Smithsonian Institution, roll P88, frames 36–38; and "William Dunlap to Charles Bird King," December 21, 1829, Harvard Theatre Collection, Harvard College Library. For more information on King's gallery, see Andrew J. Cosentino, *The Paintings of Charles Bird King (1785–1862)* (Washington, D.C.: Smithsonian Institution Press, 1977), pp. 37–50. The *History* identifies John Doggett as a Boston framemaker and the purchaser of Thomas Sully's *Washington Crossing the Delaware* (Dunlap, *History*, vol. 2, p. 134). Doggett also ran the gallery where Dunlap showed his *Christ Rejected* in the summer of 1822 (*History*, vol. 1, p. 290); a surviving catalogue from this exhibition is located at the Boston Athenaeum.

35. Dunlap, *Diary*, p. 461. Dunlap, *History*, vol. 1, p. 277. Also see William Kelby, *Notes on American Artists 1754–1820, Compiled from Advertisements Appearing in the Newspapers of the Day* (New York: Burt Franklin, 1970 [orig. pub., New York, 1922]), pp. 51–52.

36. Originally known as the New York Academy of Arts, the organization changed its name to the American Academy of the Fine Arts in 1817. The most comprehensive account of the history of the American Academy can be found in Carrie Rebora, "The American Academy of the Fine Arts, New York, 1802–1842," Ph.D. diss., City University of New York, 1990. This section relies on her chronology and analysis of events. Rebora has returned to the topic of the Academy in two subsequent publications: see her "History Painting at the American Academy of the Fine Arts" in *Redefining American History Painting*, ed. Patricia M. Burnham and Lucretia Hoover Giese (Cambridge: Cambridge University Press, 1995), pp. 229–41, and Rebora Barratt, "Mapping the Venues," in Voorsanger and Howat. Discussions of the American

It was not until the founding of the National Academy of Design that Dunlap broke
with the American Academy.

In 1826, a group of artists led by Samuel Morse defected from the American
Academy, protesting the lack of representation for professional artists on its board
of directors, the institution's lack of concern for students, and the self-interested
leadership of its president, John Trumbull. They went on to establish a rival, artist-
run institution, the National Academy, that aimed to be more responsive to the
concerns of working artists. Morse was the leading spirit behind the genesis and
early organization of the National Academy of Design, and William Dunlap became
one of its key early supporters. Dunlap's subsequent appointments at the National
Academy, as at the American Academy, confirm his status as one of the elder states-
men of the New York art community. In addition to being elected to the National
Academy's council, he was appointed Professor of Historical Composition and
elected Vice President.[37] During part of the time that Morse spent in Europe during
1829–32, Dunlap effectively functioned as the institution's president, giving the
annual address to the Academy's students in 1831.[38] He also represented the Na-
tional Academy on each of the three negotiating committees appointed to discuss
possible union with the American Academy during the late 1820s and 1830s. To
commemorate his years of service, the National Academy commissioned Charles C.
Ingham to paint Dunlap's portrait at the time of his resignation from office in 1838
(figure 4).

The National Academy was instrumental in developing Dunlap's sense of mission
to define and promote the aims of the artistic profession, and the organization must

Academy can also be found in "The Early Institutions of Art in New York," an introduction to Winifred E.
Howe's study, *A History of the Metropolitan Museum of Art* (New York: Metropolitan Museum of Art, 1913),
and Theodore Sizer, "The American Academy of the Fine Arts," in Cowdrey, *American Academy*, pp. 3–93.

37. Cowdrey lists Dunlap's various positions by year in *National Academy of Design*, pp. 130–33. Dunlap
may also have served as a visiting instructor in the early years of the National Academy when its teachers
were drawn from the ranks of the academicians on a rotating basis. For information on art instruction at
the National Academy, see Donald Ross Thayer, "Art Training in the National Academy of Design, 1825–
35," Ph.D. diss., University of Missouri, 1978; Lois Marie Fink and Joshua C. Taylor, *Academy: The Academic
Tradition in American Art* (Washington, D.C.: Smithsonian Institution Press, 1975); and Fink and Taylor's
exhibition catalogue, *Academy: The Academic Tradition In American Art* (Chicago: University of Chicago
Press, 1978), in addition to the sources on the National Academy cited above.

38. Paul J. Staiti, "Ideology and Politics in Samuel F. B. Morse's Agenda for a National Art," in National
Academy of Design, *Samuel F. B. Morse: Educator and Champion of the Arts in America* (New York: NAD,
1982), p. 38. William Dunlap, *Address to the Students of the National Academy of Design at the Delivery of
Premiums, Monday, the 18th of April, 1831* (New York: Clayton & Van Norden, 1831). This speech, in which
Dunlap laid out his ideas about the function of an art academy, the artist's role in American society, and the
proper relationship between artists and patrons, is discussed in more detail in chapter 4.

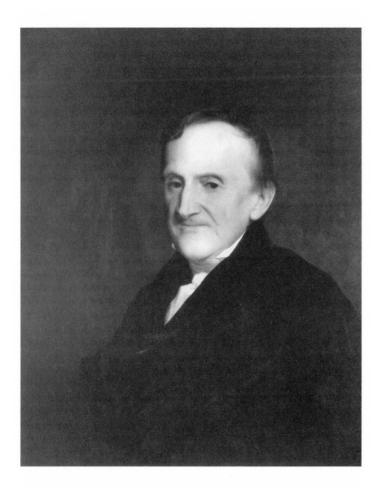

FIGURE 4.
Charles Cromwell
Ingham,
William Dunlap,
1838–39.
Oil on canvas,
30 × 25 in.
National Academy of
Design, New York.

have seemed to him to offer a necessary bulwark against the vagaries of the art market. Although the National Academy did not commission the *History*, its members encouraged the project and provided the author with information as well as subscriptions. In addition, their break with the American Academy represented the beginning of a new era for many members of the artistic profession. Having allied himself with a younger generation of artists, Dunlap was confident that the visual arts would create a new place for themselves in American society. The *History* reveals this historical perspective and reflects the National Academy's emphasis on egalitarianism, professionalism, and national mission.[39] Dunlap's relationship with the National Academy affected not only the general framework and conception of

39. As Paul Staiti points out in his writings on Morse, these were the precepts laid out by the Academy president.

the *History* but also its contents. The allegiances and rivalries among artists during the wars between the two New York art institutions would resurface in the text. When he sat down to write his account as a champion of the National Academy, Dunlap had unique access to inside information on the American Academy's dealings and was able to construct damning arguments about its policies. The negative assessment of the American Academy that appears in the *History* holds sway even today.[40]

Dunlap and New York City

The genesis, writing, and publication of the *History* occurred at the same time that New York City was remaking itself into the commercial capital of the United States. Although the city had suffered extensive destruction during the Revolution, it was the site of tremendous physical and economic growth during the early nineteenth century.[41] Production in the visual arts was dependent on this burgeoning economy. Artists and artisans experienced transformations in their working practices that paralleled the changes being effected in other sectors of the economy as New York began to distinguish itself for the luxury goods it provided to a local and a growing national market.[42] If New York presented Dunlap with a stimulating venue in which to work and write, he returned the favor in the pages of the *History*. His account joined contemporary efforts to establish the city not just as the leading commercial

40. Carrie Rebora Barratt observes that subsequent historians have considered the American Academy a failure because they have viewed it from the perspective of the disgruntled professional artists. She argues, however, that the American Academy was founded first and foremost as an organization for art patrons and, in that capacity, succeeded by providing New York elites with an influential cultural platform (Rebora, "American Academy," pp. 4–5). In a more recent essay, she contends that although the American Academy has been faulted for not exhibiting contemporary American art, it was designed under Trumbull's leadership as a venue for Old Masters and contemporary European art (Rebora Barratt, "Mapping the Venues," in Voorsanger and Howat, pp. 50–55). Although Rebora Barratt's writings supply a more nuanced picture of the artists' and patrons' diverging motives than has previously been available, I suspect that she overstates the Academy's impact on its gentleman-directors.

41. For more information on New York during the post-Revolutionary years, see Sidney I. Pomerantz, *New York: An American City, 1783–1803; A Study of Urban Life* (New York: Columbia University Press, 1938); Robert I. Goler, *Capital City: New York After the Revolution* (New York: Fraunces Tavern Museum, 1987); Elizabeth Blackmar, *Manhattan for Rent, 1785–1850* (Ithaca: Cornell University Press, 1989); and Edwin G. Burrows and Mike Wallace, *Gotham: A History of New York City to 1898* (New York: Oxford University Press, 1999), esp. pt. 3.

42. Mike Wallace, "The City the Artisans Made," a lecture given on November 4, 2000, at a symposium sponsored by the Metropolitan Museum of Art, New York, to accompany the exhibition *Art and the Empire City: New York, 1825–1861*.

center of the United States, but as the nation's undisputed source of cultural authority.

When Dunlap published his *History* in 1834, more of the nation's finances, trade, and publishing were based in New York than ever before, making it a magnet for young and ambitious professionals. Artists were among those attracted to the city since New York's growing concentration of wealth was creating a large group of potential patrons. Samuel Morse predicted this benefit for artists as early as 1823 in a letter to his wife. Weighing the advantages of settling in New York, Morse identified the Erie Canal (completed two years later) as one of the principal causes of the city's transformation: "The more I think of making a push at New York as a permanent place of residence in my profession, the more proper it seems that it should be pretty soon. . . . New York does not yet feel the influx of wealth from the Western [Erie] canal but in a year or two she will feel it, and it will be advantageous to me to be previously identified among her citizens as a painter."[43] But New York promised more to artists than growing ranks of wealthy citizens. The American Academy of the Fine Arts and the National Academy of Design supplied them with regular exhibition venues while the growing number of newspapers and magazines originating in the city offered valuable publicity and the chance to reach a national audience.

Dunlap had decided to tie his professional fortunes to those of New York more than thirty years before Morse made his own career calculations. The city presented him with an immediate audience in his varied roles as playwright, theater manager, artist, and author, and it also supplied him with a network of friends and colleagues who were helpful to his professional development. During the 1790s Dunlap found encouragement and intellectual stimulation in the clubs for which the city was famous.[44] In addition to joining several social clubs, Dunlap became a member of the Philological Society, joining Noah Webster, among others, in a group he described in the *History* as "a literary society formed by young men for mutual instruction and improvement."[45] Dunlap read his first play, *The Modest Soldier; or, Love in*

43. "Samuel F. B. Morse to Mrs. Morse," August 27, 1823, in *Samuel F. B. Morse, His Letters and Journals*, ed. Edward Lind Morse (Boston: 1914), vol. 1, pp. 248–49, cited in Harris, p. 111.

44. Williams covers this period in her chap. 3, pp. 46–73. See also Eleanor Bryce Scott, "Early Literary Clubs in New York City," *American Literature* 5 (1933–34): 3–16.

45. Dunlap, *History*, vol. 1, p. 267. In her introduction to Dunlap's *Diary*, Dorothy Barck records that the Philological Society's purpose was to promote knowledge of the English language (p. xvi). According to Robert Canary, Dunlap was first introduced to the club by Samuel Latham Mitchell, a rising New York physician and an old acquaintance of his (Canary, p. 20); the two had been companions abroad, making a

New York, to the society in 1788.[46] A number of the Philologians went on to found the Friendly Club in 1793, an organization whose members included the leading lights of the contemporary medical, literary, legal, business, and scientific communities. They provided Dunlap, in his words, with "a more regular course of study than I had ever known."[47] In fact, New York City became one of the few centers of Enlightenment thought in the United States because of such organizations as the Friendly Club.[48] Through their reading and discussions of works by David Hume, Mary Wollestonecraft, William Godwin, and the Marquis de Condorcet, club members attempted to remain abreast of intellectual currents in Europe. They were willing to explore radical social and religious positions while remaining politically conservative.[49]

In a pattern that is evident throughout his career, Dunlap's friendships brought him not only intellectual stimulation but an outlet for publication, as a number of his associates from the 1790s were involved with contemporary journals. These magazines presented club members with the opportunity to circulate their ideas among a somewhat larger but still sympathetic audience. Noah Webster edited the *American Magazine* during 1787–88, while the members of the Friendly Club were frequent contributors to the *New-York Magazine* and established the *Monthly Magazine and American Review* in 1797.[50] Though most submissions to the latter remained anonymous, Mary Rives Bowman identified Dunlap as the author of the *Monthly Magazine*'s "Theatrical Register" column from 1794 to 1796.[51]

During the same period that Dunlap was forging links with other professional artists active in New York, he became associated with an influential group of local

walking tour of Oxford together in 1786. For a recent summary of Mitchell's career, see Kenneth T. Jackson, ed., *The Encyclopedia of New York City* (New Haven: Yale University Press, 1995), p. 765.

46. Dunlap, *Diary*, p. xvi.

47. Dunlap, *History*, vol. 1, p. 267. Members of the Friendly Club with whom Dunlap was particularly close included Elihu Hubbard Smith, a physician and poet; the novelist Charles Brockden Brown; and William Johnson, a lawyer (Williams, pp. 50–53).

48. Henry F. May, *The Enlightenment in America* (New York: Oxford University Press, 1976), p. 233–34, and Thomas Bender, *New York Intellect: A History of Intellectual Life in New York City, from 1750 to the Beginnings of Our Own Time* (Baltimore: Johns Hopkins University Press, 1987), pp. 28–36. For a description of the Friendly Club's meetings, see Barrett, pp. 335–36.

49. May, p. 234, and Bender, p. 31. Both Barrett and Williams contend that the Friendly Club broke up because of political divisions (p. 335; p. 60). Williams adds that by the early nineteenth century many of the club's members had died or moved from New York (p. 129).

50. Frank Luther Mott, *A History of American Magazines*, vol. 1: *1741–1850* (New York: D. Appleton, 1930), pp. 104–7; 114–16; and 218–22. Charles Brockden Brown edited the *Monthly Magazine*.

51. Mary Rives Bowman, "Dunlap and the 'Theatrical Register' of the *New York Magazine*," *Studies in Philology* 24 (July 1927): 413–25.

novelists and journalists. Knickerbocker writers and artists developed a symbiotic creative relationship during the first half of the nineteenth century, and writers including Washington Irving and James Fenimore Cooper who had achieved greater initial success than their artist counterparts found themselves in a position to help advance the cause of the visual arts.[52] Dunlap was a member of two of the clubs that facilitated these artistic-literary exchanges: the Bread and Cheese Club, organized by Cooper in 1822, and the Sketch Club established around 1827.[53] Despite his sporadic attendance at their meetings, the clubs strengthened Dunlap's ties with a number of prominent New York writers. These relationships would prove fruitful when Dunlap embarked upon the *History*; subscription proposals name Cooper, Irving, and the New York essayist and politician Gulian C. Verplanck as contributors of information to the text.[54]

As many of Dunlap's contemporaries noted, New York had traditionally been more interested in commerce than in the fine arts.[55] But, as the city grew in

52. James T. Callow, *Kindred Spirits: Knickerbocker Writers and American Artists, 1807–1855* (Chapel Hill: University of North Carolina Press, 1967).

53. In addition to Callow (pp. 11–12), see Albert H. Marckwardt, "The Chronology of the Bread and Cheese Club," *American Literature* 6 (January 1935): 389–99. Details of the meetings of the Bread and Cheese Club, or "The Lunch" as it was sometimes called, are unclear. Many of the "Lunch" members later became affiliated with the National Academy of Design and the Sketch Club. Not all New York artists had the opportunities afforded club members to interact with other artists, writers, and patrons. Kathleen D. McCarthy observes that women artists were denied access to the social clubs available to their male counterparts; see McCarthy, *Women's Culture: American Philanthropy and Art, 1830–1930* (Chicago: University of Chicago Press, 1991), chap. 1.

The Sketch Club, also known as XXI (because of the number of original members), was the forerunner to the Century Association. Members took turns hosting meetings, which occurred every two weeks during the season from November to April. After being given a topic selected by the host, members would write or sketch something on that theme; see Callow, pp. 11–29. The club also established a literary annual, *The Talisman* (1828–30). Although there is a ten-year gap in Dunlap's diaries between 1822 and 1832, he does record attending Sketch Club meetings regularly during 1832–33. He also reports hosting the club's meetings twice during this period (Dunlap, *Diary*, pp. 626 and 759). For further information on the Sketch Club, see Howe, pp. 84–85, and Ralph Thompson, *American Literary Annuals and Gift Books, 1825–1865* (New York: H. W. Wilson, 1936), pp. 56–64.

54. Dunlap and Cooper first become acquainted in 1823 and were to remain friends until Dunlap's death in 1839. In his article "*Satanstoe*: Cooper's Debt to William Dunlap," James H. Pickering provides a brief summary of their relationship as part of his argument that Cooper depended on Dunlap's *History of the American Theatre* and *History of New Netherlands* for his novel *Satanstoe* (1845); see *American Literature*, 38 (January 1967), n. 5, p. 469. Pickering notes that Cooper helped to arrange the British edition of Dunlap's *History of the American Theatre* while he was abroad; Dunlap had dedicated the earlier American edition to him. The two were also investment partners in a frontier land deal (Canary, p. 39). Cooper's correspondence at Yale University preserves numerous letters from Dunlap from the mid-1830s requesting advances on his share of the investment, as well as letters from Dunlap's son John trying to sort out his father's estate.

55. See Wayne Craven, "Painting in New York City, 1750–1775," in *American Painting to 1776: A Reappraisal*, ed. Ian M. G. Quimby (Winterthur, Del.: Henry Francis du Pont Winterthur Museum/Charlottesville: University Press of Virginia, 1971), pp. 251–97.

economic might, attempts were made to rectify this imbalance. During the first half
of the nineteenth century, a local elite was instrumental in linking the success of
the city to its achievements in the arts and sciences.[56] New York formally acknowl-
edged this connection in 1815 when the city council voted to provide municipally
subsidized space for a number of organizations in the newly vacated city almshouse.
Renamed the New York Institution of Learned and Scientific Establishments, the
building ultimately housed the New-York Historical Society, the Literary and Phil-
osophical Society, the American Academy of the Fine Arts, John Scudder's American
Museum, and the Lyceum of Natural History. The New York Institution, as it was
known, served as the city's cultural center until the council terminated the leases in
1830.[57] Thus in the early nineteenth century, as encouragement of the visual arts
became a municipal priority, it appeared that cultural aspirations galvanized by the
Revolution would flower in New York.

Thomas Bender has argued that New Yorkers' vision of a civic culture began to
break down by 1830. Artisans challenged the patrician definition and leadership of
local culture, and the increased specialization and professionalism that the founding
of learned societies had helped to inspire led to divisions among elites. The war
between the American Academy of the Fine Arts and the National Academy of
Design revealed parallel fractures dividing the visual arts community. On the basis
of their emerging professional self-consciousness, artists sought to replace the social
elite as the city's cultural arbiters.

Although New Yorkers often regarded their city's culture as representing that of
the United States as a whole, the local nature of the conflicts just described indicates
that the idea of a national culture remained ambiguous during the early nineteenth
century. New York's eventual success as the uncontested center of the U.S. art world
has preempted any acknowledgement that this outcome was not inevitable, thereby
obscuring the city's active bid for cultural leadership of the nation. Revisionist
studies have begun to rectify this omission. In her investigation of antebellum land-
scape painting, for example, Angela Miller has argued that it was New York's in-
creased commercial might that enabled promoters of the Hudson River School to

56. Thomas Bender believes that the ideal of a "civic culture," which he distinguishes from subsequent
"literary" and "academic" definitions of culture, flourished between the 1780s and 1840s; see *New York
Intellect*. For the encouragement given to learned societies in other U.S. cities, see Annie V. F. Storr, "Ut
Pictura Rhetorica: The Oratory of the Visual Arts in the Early Republic and the Formation of American
Cultural Values, 1790–1840," Ph.D. diss., University of Delaware, 1992, chap. 6.

57. For a more complete account of the chronology of the founding and various tenants of the New York
Institution, see Rebora, "American Academy," n. 94, p. 54, and Bender, pp. 64–66 and 76–77.

present an essentially regional vision of the American landscape as a national standard.[58] Similarly, in her examination of northern nationalism during the antebellum period, Susan-Mary Grant has demonstrated that the North was as active as the South in defining a sectional version of U.S. nationalism, yet after the Civil War northern ideology disappeared from view, becoming synonymous with the national. Grant's analysis serves as a reminder that the ability to naturalize one perspective among competing viewpoints is evidence of cultural power.[59] Seen in this light, Dunlap's *History* reveals itself as one of the means by which New York consolidated its national position, for the book shows a decided regional bias. Dunlap's identification with New York history, for example, probably caused him to underplay art created during the British colonial period since arguably more significant developments took place in Boston and Philadelphia than New York. Through his choice of emphasis in the *History*, Dunlap suggested that U.S. art history really came into its own only when New York became a viable center for artists. During a period in which many U.S. citizens expressed a desire for a shared national culture but were uncertain about its existence, Dunlap moved to fill the vacuum by advancing the ambitions of New Yorkers and artists simultaneously. Just as he threw his lot in with the nascent National Academy of Design, and promoted it as the leading art academy in the United States, Dunlap accelerated the perception of New York as the artistic center of the United States.

58. Angela Miller, *The Empire of the Eye: Landscape Representation and American Cultural Politics, 1825–75* (Ithaca: Cornell University Press, 1993), chap. 2. Miller argues persuasively that "previous scholarship has taken for granted both the nationalist function of the landscape genre and its northeastern bias" (p. 3).

59. Susan-Mary Grant, *North over South: Northern Nationalism and American Identity in the Antebellum Era* (Lawrence: University Press of Kansas, 2000).

TWO

Sketching History: Coverage of the Visual Arts in Early Nineteenth-Century American Serials

It is very certain we shall never have arts or sciences or literature, unless we know and reward those who devote themselves to their promotion. There is no excuse for apathy among us. Our country is flourishing, our people are free, peaceful, and happy. . . . We have neither tyrants, nor revolutions, nor want; our public coffers are overflowing. When shall we reach a more proper period for cherishing those elegant embellishments of civilization, among which the art of painting holds such a prominent rank? A good painter here in *want*, unless from his own idleness or extravagance, is a rebuke to the taste and liberality of the whole city . . . an exhibition like the present, comprising the works of so many talented men, and not noticed by the editors, visited by the community, and honored with ample encouragement, is a proof that we are progressing much more slowly towards the real refinements of cultivated life than we are willing to allow.

"National Academy of Design" [exhibition review], *New-York Mirror* (1832)

During the course of the nineteenth century, the number of American serial publications increased exponentially. Art historians have long marked the emergence of journals at midcentury including the *Crayon* as the beginning of a professional art literature in the United States, yet they have ignored the larger links between the publishing boom and the developing American art world. It is not simply that the serials' shift toward a popular audience during the period had direct implications for the visual arts, or that art coverage in newspapers and magazines was extensive years before the *Crayon*'s appearance, but also that artists used the press as a forum for defining and debating the place of art in U.S. culture.[1]

1. Scholarship on the coverage of the visual arts in serial publications during the early republic is limited. David B. Dearinger's essays in *Rave Reviews: American Art and Its Critics, 1826–1925* (New York: National

The central role of print in the development of a discourse on the visual arts will come as no surprise to students of early American history. Scholars have long argued for the decisive impact of the printed word on Revolutionary politics, for example, and more recently on constructions of U.S. nationalism after independence.[2] David Waldstreicher has concluded from his study of group rituals including Fourth of July celebrations that their reporting in the press was crucial to the meaning of such events, with the written accounts becoming both documentary records of particular occasions and templates for future ones.[3] Yet, unlike the nationally occurring political rituals that Waldstreicher describes, which included ceremonial toasts and parades, cultural traditions surrounding the visual arts had much shallower roots in the United States (or in the history of Great Britain for that matter).[4] Parallel with the link that Waldstreicher describes between political ritual and its representation, art coverage in contemporary newspapers and magazines taught large numbers of readers the terms under which visual art could be experienced in person and debated in the abstract.

The rapid increase of new serials and their expanding circulation provided a

Academy of Design, 2000), represent a recent attempt to map this subject. Dearinger links the emergence of art criticism in the United States to the annual exhibitions sponsored by art academies in various cities. A number of thematic studies preceded Dearinger's efforts; see James T. Callow, *Kindred Spirits: Knickerbocker Writers and American Artists, 1807–1855* (Chapel Hill: University of North Carolina Press, 1967), chap. 3, apps. 2 and 3, and William H. Gerdts, "American Landscape Painting: Critical Judgments, 1730–1845," *American Art Journal* 17 (Winter 1985): 28–59. In addition, Carrie Rebora's thesis bibliography provides an admirably thorough index of articles on the fine arts in New York publications during the early nineteenth century; see "The American Academy of the Fine Arts, New York, 1802–1842," Ph.D. diss., City University of New York, 1990. For a consideration of art criticism in earlier and later periodicals, see Jack F. Schoof, "A Study of Didactic Attitudes on the Fine Arts in America as Expressed in Popular Magazines during the Period 1786–1800," Ph.D. diss., Ohio University, 1967, and Janice Simon, "*The Crayon*, 1855–61: The Voice of Nature in Criticism, Poetry, and the Fine Arts," Ph.D. diss., University of Michigan, 1990. Trevor Fawcett and Clive Phillpot, eds., provide an international perspective in *The Art Press: Two Centuries of Art Magazines* (London: Art Book Company, 1976).

2. The literature on the impact of the print culture on colonial America and during the early national period is voluminous and growing. See, for example, Michael Warner, *The Letters of the Republic: Publication and the Public Sphere in Eighteenth-Century America* (Cambridge: Harvard University Press, 1990); Larzer Ziff, *Writing in the New Nation: Prose, Print, and Politics in the Early United States* (New Haven: Yale University Press, 1991); Scott E. Casper, *Constructing American Lives: Biography and Culture in Nineteenth-Century America* (Chapel Hill: University of North Carolina Press, 1999); and Isabelle Lehuu, *Carnival on the Page: Popular Print Media in Antebellum America* (Chapel Hill: University of North Carolina Press, 2000).

3. David Waldstreicher, *In the Midst of Perpetual Fetes: The Making of American Nationalism, 1776–1820* (Chapel Hill: University of North Carolina Press for the Omohundro Institute of Early American History and Culture, Williamsburg, Va., 1997). Waldstreicher sees nationalism and regionalism as being in "creative tension" during the early national period (p. 250).

4. There is some overlap between the ritualistic orations described by Waldstreicher and those detailed by Annie V. F. Storr in "Ut Pictura Rhetorica: The Oratory of the Visual Arts in the Early Republic and the Formation of American Cultural Values, 1790–1840," Ph.D. diss., University of Delaware, 1992.

broader public forum for the visual arts than had ever existed in the United States.[5] Each of the most significant early publications to report on the visual arts, however, exhibited a strong regional outlook, including the Philadelphia magazine the *Port Folio* (1801–27), which published a number of important articles during the first quarter of the nineteenth century, and the *New-York Mirror* (1823–57) and *Knickerbocker Magazine* (1833–62), which predominated during the 1830s when the center of the art world shifted to New York.[6] The growing concentration in New York of artists and publications covering the arts is no coincidence. As I noted in chapter 1, New Yorkers attempted during the period to equate their immediate local context with the national scene; a slippage of this nature is evident in the chapter epigraph where the author shifts almost imperceptibly from an analysis of the state of the arts in the United States to a consideration of their place in New York. Such assertions of New York's legitimacy to speak for the nation, when expressed by either visual artists or writers and publishers, were premature in the 1830s since the cultural consolidation that both groups posited had yet to occur.

A review of William Dunlap's contributions to New York serials (see appendix A) illustrates the visual arts discourse that developed in the 1820s and 1830s.[7] His submissions included promotional articles publicizing his own exhibitions and

5. In order to be useful, future studies of the readership of these early nineteenth-century periodicals must set individual publications within a precise geographical and historical context. David Paul Nord provides one model for such a case study in his analysis of subscribers to the *New-York Magazine; or Literary Repository* in "A Republican Literature: Magazine Reading and Readers in Late-Eighteenth-Century New York," in *Reading in America: Literature and Social History*, ed. Cathy N. Davidson (Baltimore: Johns Hopkins University Press, 1989), pp. 114–39. Nord found that this magazine had a more varied audience than had been thought previously, numbering not only professionals and merchants but also small businessmen and artisans among its readers. He used this evidence to propose "the importance of reading as a form of [republican] participation in the new social order of post-revolutionary America" (p. 115).

6. For example, the *Port Folio* published Benjamin Henry Latrobe's "Anniversary Oration Pronounced Before the Society of Artists of the United States, on the 8th of May, 1811," n.s. 5 (June 1811). On the *Port Folio*, see Frank Luther Mott, *A History of American Magazines*, vol. 1: *1741–1850* (New York: D. Appleton, 1930), pp. 223–46. For the *Knickerbocker*, see ibid., pp. 606–14. Sources on the *New-York Mirror* will be discussed below. According to Mott, during the late 1830s and 1840s *Burton's Gentleman's* (Philadelphia, 1837–40), the *Whig Review* (New York, 1845–52), and the *Union Magazine* (New York, 1847–52) also provided regular coverage of the arts (ibid., p. 435).

7. Scholars have directed some critical attention to Dunlap's histories of the American theater and art, his biographies of George F. Cooke and Charles Brockden Brown, his temperance novel, and local histories, but his contributions to serial publications remain largely unexplored. This is partly because of the contemporary practice of publishing anonymously, making secure identification of authors difficult, and partly the absence of any indexing for many of these early publications. The bibliography in Sarah Elizabeth Williams's thesis, "William Dunlap and the Professionalization of the Arts in the Early Republic," Ph.D. diss., Brown University, 1974, and that in Carrie Rebora's thesis were immensely helpful in assembling the contents of appendix A. Although they often based their attributions of articles to Dunlap on entries in his diaries—also accessible to me—their citations saved me much valuable time.

writings, partisan essays intended to champion certain artists and art institutions, and general reports on the local artistic scene. Dunlap had a particularly close relationship with one of the weekly literary magazines that emerged during the period: the *New-York Mirror*. These weeklies, unlike the majority of eighteenth-century serials, targeted their sketches of cultural life to the middle class and began to provide news from the art world as a regular feature. Not only were they influential in their own right, they would have a discernible effect on the style and content of less ephemeral art literature in the United States, including Dunlap's *History*.

New York Serial Publications of the Early Nineteenth Century and the Visual Arts

Newspapers and magazines published in New York, as in other U.S. locations, experienced sustained growth during the period of William Dunlap's professional lifetime, roughly from the 1780s to the 1830s.[8] These publications' regular, ongoing coverage shaped public perceptions of the visual arts, and art no longer appeared as the province of connoisseurs. Politics dominated the typical New York newspaper during the antebellum period, but the art world also appeared regularly in its pages. Most dailies had a column in their advertisement section labeled "Amusements," and among promotions for theatrical and musical performances it was possible to find valuable information about the art scene. Both the American Academy of the Fine Arts and National Academy of Design, for example, advertised their annual exhibitions in local papers, and the latter institution promoted its school. Newspapers also carried paid notices of the independent exhibitions of the era that ranged from displays of so-called Old Master paintings to single-painting exhibitions by contemporary European and American artists, and from exotic panoramas to oddities such as the life-size wax reproduction of Leonardo da Vinci's *Last Supper* that

8. The observations in this section are based on the research that resulted in appendix A and on my systematic review of several New York periodicals, including a reading of every article on the visual arts that appeared in the *New-York Mirror* from 1830 to 1840 and a survey of both the *New-York American* and *Evening Post* for the year 1834, the date of the *History*'s publication. Frank Luther Mott wrote the two classic studies on American serials: his *History of American Magazines*, cited above, and *American Journalism: A History of Newspapers in the United States through 250 Years: 1690–1940* (New York: Macmillan, 1941). For a more recent survey of American magazines that focuses on their literary contributions, see Edward E. Chielens, ed., *American Literary Magazines: The Eighteenth and Nineteenth Centuries* (New York: Greenwood Press, 1986).

traveled to New York in 1834. Print shops and stores carrying artists' supplies also advertised new stock regularly.

Newspaper articles on the visual arts tended to be brief and to focus on specific local artists or exhibitions. For example, the *New-York American* published two notices during the spring of 1834 about a painting by Thomas Cole being exhibited at the American Academy. Referring to the lengthy debate raging about the rechartering of the Bank of the United States, a letter to the editor observed of the exhibition, "Every American should be proud to pay the tribute of his homage to this surpassing production of the genius of his countryman. We can imagine no surer mode of suspending (for a while at least) the . . . cares of this world—of raising the mind above *deposits* and *discounts* and all mere temporary interests—than by a contemplation of the picture of the Angels appearing to the Shepherds."[9] This passage presented Cole's exhibition as a foil to the bank crisis, but readers found reports of both items in the same newspaper, suggesting the show's topicality. The dailies also provided a popular forum for airing disputes within the art world. Letters to the editor publicized various contemporary controversies, including the war waged between the two New York art academies.[10] Articles and advertisements conveyed a sense of the wide variety of art activities taking place in the city and encouraged readers to view the art world as newsworthy.

Magazines directed more concentrated attention to the U.S. and international art worlds than did newspapers, adapting their coverage to suit their respective audiences. Regular articles on the art world began to join fiction, fashion notes, poetry, travel journalism, and criticism in the pages of weekly magazines beginning in the 1830s. As these publications were meant to entertain above all else, their offerings remained relatively brief and were locally focused. As a recent survey of nineteenth-

9. *New-York American*, March 19, 1834, n.p. The painting in question is Cole's *The Angel Appearing to the Shepherds*, 1833–34 (Chrysler Museum, Norfolk, Virginia). The second notice in the *American* appeared on March 31, 1834.

10. Thomas S. Cummings reprints some of this literature in his *Historic Annals of the National Academy of Design* (New York: Da Capo Press, 1969 [orig. pub., Philadelphia, 1865]), pp. 37–110. As the dispute flared up during 1828, the publications favored by the rebel artists included the *Journal of Commerce*, which published a two-part justification of the National Academy by Samuel Morse (in reply to an attack on him published by the *North American Review*); the *Morning Courier*, which published an 1828 series signed "Boydell," probably written by Dunlap (see below); the *Evening Post*, which ran several anonymous articles by "Denon" also sympathetic to the National Academy; and the *New-York American*, which published a number of letters to the editor from both sides of the conflict. As Rebora points out, a series of writings critical of the American Academy that the New York artist John Rubens Smith published under the name "Neutral Tint" in the *National Advocate* during 1817–18 provided a model for subsequent attack articles (Rebora, "American Academy," pp. 254–61).

century periodicals reveals, the literary form of the sketch—characterized by its brevity and informality—suited both the needs of magazine editors and the changing tastes of readers.[11] Notice of the visual arts appeared in the editorial columns, book reviews, and feature articles published by the weeklies. These publications made knowledge of the fine arts fashionable among a middle-class readership and promoted the American artist as a distinct public type.[12]

Though newspapers and weekly magazines provided comprehensive coverage of local events such as exhibitions and offered some news of art in other regions—including the commissions awarded for the decoration of the U.S. Capitol Building—they did not have the space or inclination to publish extended essays on the fine arts; such focus was generally the province of the monthly magazines whose articles strove for a more scholarly tone. In lengthy book reviews and articles—such as "The Fine Arts in America, and its Peculiar Incentives to Their Cultivation" by the Philadelphia artist J. Houston Mifflin, which appeared in the *Knickerbocker* in 1833—the monthlies considered the theoretical and nationalist implications of the fine arts.[13] Less driven by topicality, these magazines could take the longer view. Observing that "there can be no surer evidence of the propitious state of its Literature and Science, than the success of the Arts in a country," Mifflin argued that the United States presented its artists not only with a rich choice of subjects—including the landscape and native inhabitants—but also with the freedom necessary for their healthy development.[14] Such essays as Mifflin's were often adapted from addresses delivered before audiences—a reminder that the spoken word remained a vital means of disseminating ideas during the period. The monthly magazines broke new ground by treating American art as a worthy subject for published analysis, but their writers employed a traditional oratorical and literary format—the academic discourse.[15]

11. Kristie Hamilton, *America's Sketchbook: The Cultural Life of a Nineteenth-Century Literary Genre* (Athens: University of Ohio Press, 1998).

12. For example, in its prospectus the *New-York Mirror* promised to satisfy a "national character . . . so strongly marked with the love of novelty, variety, and mystery" that "we are perpetually in search of something *new*," August 2, 1823, p. 1. For the growing public prominence of American artists, including their appearance in contemporary fiction, see Neil Harris, *The Artist in American Society: The Formative Years, 1790–1860* (New York: George Braziller, 1966), chap. 9.

13. J. Houston Mifflin, "The Fine Arts in America, and its Peculiar Incentives to Their Cultivation," *Knickerbocker* 2 (July 1833): 30–35. For more information on Mifflin and further analysis of the address from which the article derived, see Storr, pp. 291–305.

14. Mifflin, p. 30.

15. According to William H. Gerdts, Mifflin delivered his address to the Platonian Literary Association in Philadelphia on February 19, 1833; see Gerdts, "The American 'Discourses': A Survey of Lectures and

Dunlap's Writings on the Visual Arts in Serial Publications

William Dunlap was a prolific published writer throughout his life, and the bulk of his writings on the visual arts, apart from the *History*, were submissions to local newspapers and magazines (see appendix A).[16] These articles, which do not fall neatly into the recognizable categories of modern art criticism or art history, offer insight into the nature of an extensive body of earlier art writing. A thorough survey of the serial publications with which Dunlap was affiliated during the 1830s also makes it possible to reconstruct the major events of the New York art world on a week-by-week basis. More than a chronicle, however, articles on the visual arts demonstrate the influence of the print culture in constructing both the artistic profession and a viewing public in the United States. Reviews of annual exhibitions at art academies, for example, like published reports of the patriotic festivities discussed by David Waldstreicher, cued readers as to the proper way to encounter the artworks on display while also validating their decision to incorporate the exhibitions into their social calendars.

Dunlap's earliest recorded writings on the visual arts can be found in a short-lived magazine that he published himself. The *Monthly Recorder* resembled many of its eighteenth-century predecessors in the miscellaneous nature of its contents. The magazine featured theater and book reviews, travel essays, short biographies, poetry, and a log of significant foreign and domestic events. The *Recorder* survived for only five issues in 1813, but it printed several articles on the art world, including a review of the third annual exhibition of Philadelphia's Columbian Society and a profile of the American Academy of the Fine Arts.[17]

During the 1820s Dunlap's contributions to serial publications related primarily to the American Academy; he first reviewed exhibitions there (including his own), and then championed the artists who became disgruntled with the Academy and went on to found the National Academy of Design in 1826. Most significant among the latter contributions is the series of letters to the editor signed "Boydell" that appeared in the *Morning Courier* newspaper during 1828. These seven articles were in

Writings on American Art, 1770–1858," *American Art Journal* 15 (Summer 1983): 79. Annie Storr's thesis, cited above, is the most complete source regarding oratory on the visual arts.

16. Other formats employed by Dunlap included the anonymous pamphlet, the biographical sketch contributed to a multivolume series, and the academic discourse.

17. Dunlap later published the five issues in one volume as *A Record, Literary and Political, of Five Months in the Year 1813* (n.d.). The American Antiquarian Society, Worcester, Mass., owns the entire run of the magazine.

all probability the work of Dunlap.[18] They display a sympathy to the National Academy and set out, in the words of the first letter, to make "known the truth in relation to the circumstances under which the National Academy was established, the reasons why that measure was resorted to by the associated artists, and the advantages which already have resulted, and will result from it, to the cultivation and improvement of the Fine Arts in America."[19] In addition to Samuel F. B. Morse's published defenses of the National Academy, this series presented the most comprehensive account, from the dissenting artists' point of view, of the defection from the American Academy. The articles, like other published accounts of New York's art wars, drew the reading public into the dispute; as the last of Boydell's letters asked, regarding the National Academy, "Is not an institution like this, struggling with such difficulties, deserving of some notice and assistance from the public? Is not the existence of a school like theirs an object worthy of the first city in the United States?"[20]

Retaining his partisan edge in his published articles of the 1830s, Dunlap also broadened his range of topics, turning out comprehensive exhibition reviews, profiles of individual artists, and overviews of the state of American art. Most of his contributions during this decade were to the *New-York Mirror*, but important articles by him also appeared in the *Knickerbocker* and the *American Monthly Magazine*. Dunlap's surviving diaries end in December 1834, making it more difficult to track his submissions during the last five years of his life; the list assembled in appendix A, however, suggests that his contributions to serials remained steady up until his death.

During the 1790s Dunlap wrote regularly for the *Monthly Magazine and American Review* edited by his friend Charles Brockden Brown. Moreover, his acquaintance with William Cullen Bryant, the editor of both the *New-York Review and Athenaeum Magazine* and New York's *Evening Post*, George Pope Morris, the longtime editor of

18. Both Williams (pp. 179–80) and Rebora ("American Academy," pp. 297–98) propose Dunlap as the author of this series. As they observe, Dunlap relied heavily on these articles for his section in the *History* on the founding of the National Academy. Rebora argues convincingly that although Dunlap usually was scrupulous about attributing his sources, he used some of the passages from the *Morning Courier* letters verbatim in the *History* without placing them in quotation marks, suggesting that he felt no need to quote himself. Dunlap was certainly in a position to have the inside information that "Boydell" displayed, and the letters are in keeping with his writing style. In addition, Dunlap is known to have published many of his more inflammatory writings anonymously; for example, his diary reveals him as the author of a pamphlet attacking John Trumbull, published in 1833 and titled *Conflicting Opinions, or Doctors Differ* (*Diary*, p. 659).

19. "Boydell," "Letter I. To the Editors of the *Morning Courier*," *Morning Courier*, January 10, 1828, reproduced in Cummings, p. 67.

20. "Boydell," "Letter VII. To the Editors of the *Morning Courier*," *Morning Courier*, February 11, 1828, reproduced in Cummings, p. 75.

the *New-York Mirror*, and Charles King, the editor of the *New-York American*, gained him access to the most prominent publications of the 1820s and 1830s.[21] The art historian Anna Chave has recently detailed the symbiotic network of personal and professional relationships linking Minimalist artists and the critics who wrote about their work during the 1960s and 1970s;[22] the impact of personal relationships was no less influential for those writing during the early nineteenth century. As the index of Dunlap's published articles reveals, discussions of the visual arts in the popular press were authored by intimates of the art world. For this reason, historians making use of nineteenth-century periodical sources must acknowledge that these writings were as much promotional as reportorial.

Dunlap and the *New-York Mirror*

The weekly *New-York Mirror* was the contemporary serial with which Dunlap had his longest and most productive association; not only did it report on Dunlap's activities as a painter and review his numerous publications, it also offered him a forum for his writings on the arts of design and other topics. Founded in 1823 by the poets George Pope Morris and Samuel Woodworth, the *Mirror* announced in its prospectus its intention to reflect "back to many, the intellectual treasures of the few, who may voluntarily throw them into one common stock for the general good."[23] Like other periodicals of the era, the magazine offered an eclectic range of subjects and featured original contributions as well as articles reprinted from other published sources. Although its attention to the visual arts was limited at the outset,

21. These men had memberships in many of the same clubs and organizations. For example, Bryant, King, and Dunlap all belonged to the Bread and Cheese Club, and Bryant and Dunlap were instructors at the National Academy of Design and members of the Sketch Club. The participation of these three journalists in the two benefits organized for Dunlap during the 1830s suggests they shared a relatively close personal relationship with him. Both King and Morris contributed to the theatrical benefit held in 1833, which the *Post*, *Mirror*, and *American* all promoted. King served as secretary of this benefit and Morris penned a tribute to Dunlap read at the performance; see Dunlap, *Diary*, pp. 634 and 656–60, and the unidentified clipping (perhaps from the *New-York Mirror*) publishing Morris's address in full in the William Dunlap—Personal Misc. file at the Rare Books and Manuscripts Division of the New York Public Library. Five years later Bryant and Morris served as committee members for the benefit art exhibition honoring Dunlap. According to his diaries, other influential editors of the period known to Dunlap were M. M. Noah (*Evening Star*) and Charles Fenno Hoffman (*Knickerbocker*, *American Monthly Magazine*, and *New-York Mirror*).

22. Anna Chave, "Minimalism and Biography," *Art Bulletin* 82 (March 2000): 149–63.

23. "Prospectus," *New-York Mirror*, August 2, 1823, p. 1. The principal sources on the *Mirror* are Mott, *History of American Magazines*, pp. 320–30; Cortland P. Auser, "The Contribution of George Pope Morris to American Journalism," Ph.D. diss., New York University, 1960; and Callow, pp. 94–102.

news of the art world eventually became a regular staple of the *Mirror*'s weekly offerings. Unlike most of its competitors, the magazine had a long and successful life as much because of its regular inclusion of high-quality engravings as because of its lively tone. The *Mirror*'s engravings included original compositions as well as prints after works by Alexander Jackson Davis, Robert W. Weir, Henry Inman, Charles Leslie, and William Sidney Mount, among others; written descriptions often accompanied those engravings reproduced as a full page.

By the 1830s, subscribers to the *Mirror* could expect fairly comprehensive, albeit local, coverage of the visual arts. The magazine published lengthy reviews of the annual exhibitions at the American Academy and National Academy as well as a number of independent exhibitions. Readers also learned more detailed information about individual artists through articles on their travels, new works, and studios; Thomas Cole and Robert W. Weir seem to have been particular favorites of the editors. Brief editorials also regularly addressed the fine arts. For example, an August 30, 1834, editorial entitled "Original paintings" described the popularity of Old Master paintings among collectors and mocked the gullibility of New Yorkers who frequented auction houses where, "if the catalogues may be believed, Murillos, Correggios, Vandykes, Titians, Morlands, and Raphaels are knocked down at about the rate of a dollar the square yard, including the frames."[24] A common theme sounded throughout these varied offerings was the lack of patronage—both local and national—available to American artists.

Another of the magazine's interests during this decade was the American landscape. Through articles on individual artists and commissioned engravings, and comments in exhibition and book reviews, the *Mirror* helped to create and popularize an American landscape tradition. By 1840 the magazine considered the American landscape an identifiable enough genre to warrant a two-part article entitled "Our Landscape Painters" that surveyed the leading practitioners.[25]

Dunlap's first signed contribution to the *Mirror* was a letter to the editor in 1834 announcing the imminent publication of the *History*, though he had been submitting material to the magazine since at least 1832. He likely penned many of the magazine's unattributed articles during this period in addition to those listed in appendix A. John Durand contended in an 1894 biography of his father, the painter

24. *New-York Mirror*, August 30, 1834, p. 71.
25. *New-York Mirror*, July 18, 1840, pp. 29–30, and July 25, 1840, p. 38. As Janice Simon documents in her thesis, the American landscape would subsequently preoccupy both the editors and the readers of the *Crayon*.

Asher B. Durand, that Dunlap was the regular art critic for the *Mirror*.[26] In addition, in a posthumous tribute of 1840, the *Mirror* noted of Dunlap: "Like nearly all of his literary contemporaries, he was a constant contributor to the New-York Mirror, and the pages of this journal contain all his briefer and better compositions."[27] Although it is unclear whether Dunlap ever entered into a formal arrangement to write for the *Mirror*, his diaries for the period from March 1832 to December 1834 contain frequent references to meetings with the editor George Morris and visits to the *Mirror*'s office. It is likely that the magazine compensated him in some way for his contributions, but no record of payment survives.[28]

Dunlap contributed fictional tales, poetry, and book reviews to the *Mirror*, but the majority of his offerings related to the visual arts. Most prominent were the extracts of the *History* that appeared in the *Mirror* during the fall and winter of 1834–35.[29] The format and tone of these selections suited the general interests of the magazine in several ways. First and foremost, the material fit the *Mirror*'s campaign to encourage American—and more specifically Knickerbocker—art and literature. In addition, because Dunlap arranged the *History* as a series of individual sketches, it was easy for the editors to pick out self-contained passages while capitalizing on the national "biographical mania" that the magazine had described in an 1830 editorial.[30] The book also satisfied the magazine's penchant for the antiquarian; Dunlap's notices of colonial artists, for example, complemented the *Mirror*'s series "American Antiquities," which highlighted colonial architecture extant in New York City.[31]

26. John Durand, *The Life and Times of A. B. Durand* (New York: Da Capo Press, 1970 [orig. pub., New York, 1894]), p. 63. Durand does not specify the years that Dunlap served in this capacity.

27. *New-York Mirror*, April 4, 1840, p. 323.

28. Mott reported that serial publications had only skeletal staffs during the early national period and depended heavily on reprinted material as well as on outside correspondents. Although most contributors were unpaid, at least during the early nineteenth century, some magazines did offer stipends for submissions. It was not until the second quarter of the nineteenth century that the professional "magazinist" emerged (Mott, *History of American Magazines*, p. 340). Morris helped to solicit subscriptions for the *History* and played a role in its printing.

29. The first extract appeared in the *Mirror* in February—February 1, 1834, p. 248—and the bulk appeared later that year; see *New-York Mirror*, September 20, 1834, p. 95; September 27, 1834, pp. 102–3; October 18, 1834, p. 126; November 8, 1834, pp. 149–50; December 13, 1834, pp. 185–87; December 20, 1834, pp. 193–94; January 3, 1835, pp. 213–14, 216; and February 21, 1835, pp. 265–66. Two extracts published later include December 19, 1835, p. 195, and January 25, 1840, p. 246 [to mark the death of the painter John Wesley Jarvis].

30. *New-York Mirror*, May 15, 1830, p. 359.

31. This feature, accompanied by engraved illustrations after original drawings by Alexander Jackson Davis, was part of the *Mirror*'s larger series on New York architecture that appeared during the late 1820s and early 1830s; see Callow, pp. 95 and 194–204.

William Dunlap was himself a subject for the *Mirror* as well. The magazine's first mention of him appeared in a full-length article from 1825 signed "J. G." that announced the near completion of Dunlap's new exhibition painting *Death on the Pale Horse*, to which was appended a lengthy critical assessment, republished from a British journal, of Benjamin West's earlier painting of the same title.[32] Articles devoted to Dunlap appeared regularly in the *Mirror* throughout the 1830s, including the biography of Dunlap written by William Cullen Bryant and published under the heading "American Authors and Artists."[33] The *Mirror* also reviewed and published extracts from a number of Dunlap's books. In addition to the *History*, these included his *History of the American Theatre* (1832); *Thirty Years Ago; or the Memoirs of a Water Drinker* (1836), his temperance novel; *A History of New York, for Schools* (1837); and *History of the New Netherlands, Province of New York, and State of New York, to the Adoption of the Federal Constitution* (1839–40).[34] The magazine also promoted both the theatrical and painting benefits dedicated to Dunlap, held in 1833 and 1838 respectively, reviewed his 1837 lecture on the early history of New York, and published several notices of his death in 1839.[35]

32. "Death on the Pale Horse," *New-York Mirror*, October 29, 1825, p. 110. This format is typical of arts notices in serial publications—an American work is favorably linked to a European one while the *Mirror's* hard-pressed editors fill most of the column with reprinted material. This notice was followed up by lengthy reviews of additional independent exhibitions of Dunlap's paintings: see May 17, 1828, p. 359; March 19, 1831, pp. 294–95; February 11, 1832, p. 254; March 24, 1832, p. 299; and April 14, 1832, pp. 322–23. The extensive coverage that his exhibitions and publications received in the *Mirror* and other serials suggests Dunlap's skill at self-promotion. His diary records the advertisements he placed in local journals announcing the publication of the *History* (p. 844), and it is likely that he initiated similar campaigns to publicize his other activities. Some magazines and newspapers probably printed the notices he submitted verbatim.

33. Dunlap's biography was also noticed in a book review of Ignatius Loyola Robertson, *Sketches of Public Characters. Drawn from the Living and the Dead* (1830); see *New-York Mirror*, July 3, 1830, p. 413.

34. On the *History of the American Theatre*, see *New-York Mirror*, May 26, 1832, pp. 373–74; November 3, 1832, p. 143; and November 2, 1833, pp. 142–43 [extract]. On *Thirty Years Ago*, see ibid., March 28, 1835, p. 310 [extract]; May 14, 1836, p. 365 [extract]; and August 13, 1836, pp. 54–55 [extract]. The coverage for *A History of New York, for Schools* was particularly extensive, pairing the following extracts with engraved illustrations from the book: see ibid., May 27, 1837, p. 377; June 10, 1837, p. 393; June 17, 1837, p. 401; July 22, 1837, p. 25; September 16, 1837, p. 89; and December 23, 1837, p. 201. The *Mirror* even recommended this history as a holiday gift for children; see December 9, 1837, p. 191. On the *History of the New Netherlands*, see ibid., January 13, 1838, p. 231, and June 23, 1838, p. 414.

35. For the theatrical benefit, see *New-York Mirror*, January 12, 1833, p. 222. For the benefit exhibition, see ibid., October 20, 1838, p. 134; November 24, 1838, p. 175; December 1, 1838, p. 182; December 8, 1838, p. 192; December 29, 1838, p. 215; and January 12, 1839, p. 321, as well as the epilogue to this book. For coverage of Dunlap's lecture, see *New-York Mirror*, February 18, 1837, p. 271. For the death notices, see ibid., October 5, 1839, p. 119; October 26, 1839, p. 143 [reprinting an obituary from the *Commercial Advertiser*]; and April 4, 1840, p. 323.

Dunlap's diaries reveal that he was the author of a series of anonymous articles reviewing the eighth annual exhibition at the National Academy of Design and the fifteenth annual exhibition at the American Academy of the Fine Arts, both held in 1833.[36] Dunlap's allegiances were such that he offered a friendly review of the National Academy's annual while scorning its rival's presentation.[37] In his preliminary article on the National Academy's exhibition, Dunlap revealed his partisan allegiances by providing a detailed justification for that institution's existence; he would revisit a number of these themes in the *History*. For example, he noted that the National Academy, in pointed contrast to the American Academy, exhibited only original compositions by living artists in order to "present a view of the present state of the art of painting," and continued that the National Academy did not exhibit copies "because they mislead the judgment of the public who do not generally know that a good copyist may be a bad painter of any thing original." In another dig at the American Academy, Dunlap observed that the National Academy was entirely artist-run, and therefore "wealth, said to be power, has not the power to gain for its possessor the honors of this academy." Dunlap also argued that support of the National Academy's exhibitions benefited the public in two ways. He appealed first to the American passion for personal self-improvement (and class identification), contending that by examining the art works on display, "the public acquire that knowledge which enables them to enjoy the beauties of art, and to appreciate the difficulties of acquirement, as well as the different kinds and degrees of merit in the artists." He next called upon his audience's nationalistic spirit by reminding them that the receipts from the exhibition subsidized the Academy's schools, which in turn "diffuse the knowledge which is not only so precious to civilization and taste, but so essential to a fair competition with other countries in every species of manufacture."[38] The eight parts of the review that followed surveyed the entire exhibition, numbered entry by entry.

Dunlap's review of the American Academy exhibition could hardly contrast more

36. John Durand's comment that Dunlap "reviewed the annual displays of the National Academy of Design in a dry, perfunctory manner" suggests that Dunlap was responsible for more reviews in the *Mirror* than the series he published in 1833 (Durand, p. 63).

37. It should be noted that the two academies entered into the second of three fruitless attempts to negotiate union during this year.

38. "National Academy of Design. The Eighth Annual Exhibition," *New-York Mirror*, May 11, 1833, p. 355. Dunlap conveniently did not mention that despite the Academy's rules prohibiting the exhibition of any artwork more than once, he had allowed its sixth annual show of 1831 to be a review exhibition (when heading the institution in Morse's absence).

with the optimistic and laudatory tone of his articles on the National Academy. Though he conceded that the older institution's exhibition was a decided improvement over those of previous years, he still managed to damn the institution with faint praise. With tongue in cheek, he commented: "Heretofore her annual displays have borne a marvellous resemblance to each other, and her walls have unblushingly offered the same pictures, and almost in the same situations, thus affording the critical public an excellent opportunity to discover the various effects of time and exposure upon paint, varnish, and canvas." Turning to the current exhibition, Dunlap summed up his opinion of the display by remarking that the American Academy "has done wonders in obtaining so many pictures; it will be time enough for her to get good ones several years hence."[39] Not surprisingly, Dunlap had little good to say about individual works in the entries that follow.

Despite their partisan nature, Dunlap's reviews are distinctive for the way that they presented the artworks from an artist's point of view. Dunlap had sympathy for his younger colleagues and was generally encouraging, even to some of the artists exhibiting at the American Academy. He noted the paintings available for sale, offered advice, defended specific artistic practices, and praised evidence of careful study. For example, he made a plea for a long period of artistic training, observing, "Too great haste is the besetting sin of our young artists; they undertake difficult original compositions, when they should think of nothing but years of silent study."[40] He preempted criticism, by Americans suspicious of foreign training, of those artists who had studied abroad: "We sometimes feel, when looking at the productions of native, untravelled artists, as if a visit to Italy was not necessary to their perfection; but viewing the paintings of Cole, Morse, and Weir in the present exhibition, the doubt vanishes."[41] Dunlap also defended American artists' reliance on portraiture as a staple of their output and the dominance of portraits in public exhibitions: "Surely, as it respects the progress of the arts, we ought to rejoice, for the principal dependence of the professors of painting, for food and raiment, is on the desire, the praiseworthy desire, of friends and relatives to secure the likenesses of those they love, and of public bodies to honour those who have served them; and, but for this provision made for the painter, he could not wander among the beauties

39. "American Academy of the Fine Arts. Fifteenth Exhibition," ibid., June 15, 1833, p. 398.
40. Ibid.
41. "National Academy of Design," ibid., May 18, 1833, p. 366.

of nature in landscape, or soar to the heights of historical and poetical composition."[42] It was this awareness of the practical difficulties facing the American artist that made Dunlap such an effective advocate for the profession and that would influence his book-length treatment of its history.

Like other reviewers of his day, Dunlap used a descriptive critical approach; he spent most of each brief entry in his exhibition reviews explaining the subjects of works taken from literary sources or leading his readers through compositions. Regarding a painting by Thomas Birch, he wrote, "Though we are not so much interested in portraits of ships, as we doubt not we ought to be—a portrait of nature combined with art like this, the agitated elements, and agitated fabric of the ship-wright, where we see the very movement of the mighty deep, the spray, the mist, and imagine that we hear the wind, a portrait of a tempest portrayed with masterly skill, excites our interest and admiration."[43] This entry offers a representative example of ekphrasis rather than visual analysis in the modern sense. Dunlap did not have unconventional tastes when it came to art; he liked paintings to be carefully finished, accurate in their representation of natural forms, and, where relevant, moral in tone.[44] On occasion he made technical suggestions, writing of a large family portrait by R. W. Hamilton, "The landscape portion of this picture is well conceived and executed. If mamma will permit the painter to vary the frocks of the little girls, or if the painter will keep down some of the white, so as to leave one predominant light, the picture would be better."[45] Such criticisms are rare, however.

The alliance between William Dunlap and the *Mirror* during the 1830s was mutually beneficial. Dunlap provided the magazine with regular and varied material while the *Mirror* promoted his publications and probably remunerated him in some form. Although Dunlap became the most recognizable writer on American art

42. "National Academy of Design. Second Notice," ibid., May 25, 1833, p. 371.

43. "National Academy of Design. Eighth and Last Notice," ibid., July 6, 1833, p. 6.

44. Ethan Robey has recently noted, following the lead of Annie Storr's dissertation, that the attention to finish found in numerous discussions of art in the early nineteenth-century, whether displayed in art academies or trade fairs, relates to the language of utility employed to evaluate commercial products. Robey made this observation in a paper entitled " 'Of Superior Merit': American Artisan Societies and the Aesthetic of Utility," presented at the 2003 meeting of the College Art Association. In his series of reviews of the 1833 annual exhibition at the National Academy, Dunlap referred to finish on numerous occasions, remarking in one instance that "clearness, neatness, and truth characterizes this picture," and in another that "the whole scene is finished with great care and skill" ("National Academy of Design. Eighth and Last Notice," *New-York Mirror*, July 6, 1833, p. 6, and "National Academy of Design," ibid., May 18, 1833, p. 366).

45. "National Academy of Design. Sixth Notice," *New-York Mirror*, June 22, 1833, p. 406.

during the 1830s with the publication of his *History*, it was serial publications such as the *New-York Mirror* that introduced the contents of the *History* and his vision of American art to a far wider audience. The sketch format popularized by the weekly magazines would provide a successful stylistic model for such market-conscious authors as Dunlap.

THREE

The Mechanics of History:
The Genesis and Writing of the *History*

To trace the progress of Painting, Sculpture, Engraving, and Architecture, in our country, and bring before the Public a connected series of facts, respecting the lives and fortunes of those individuals, whether native or foreign, who have exercised any of these arts in the United States, appears to be an undertaking, which, if executed with moderate abilities, and a strict regard to truth, will form a portion of American History both entertaining and instructive.

Subscription proposal for the *History* (1833)

Although the emergence of the *History of the Rise and Progress of the Arts of Design in the United States* (figure 5) may seem predictable today, given the nationalist ambitions of the period, the book was a highly speculative enterprise. The *History* modified the cultural framework through which readers would apprehend the visual arts by stitching together preexisting and new modes of thought and communication. In this chapter I document the writing of the *History* and the means of its sale and distribution. Rather than assessing the legitimacy of the book's factual claims, my analysis focuses on the assumptions that Dunlap made about his projected audience and the publishing market. Both Dunlap's background and his assessment of popular taste led him to present the artists profiled in the *History* as intimate acquaintances.

With his health steadily failing, Dunlap needed a more sedentary occupation during the 1830s than traveling the eastern seaboard in search of portrait commissions. He turned to the writing of his histories of the American theater and American art as entrepreneurial experiments. In the preface to the *History*, he explained his venture: "I publish by subscription, because I need the immediate return of the cost of publication. I am my own publisher, because I wish to have the sole control of

HISTORY

OF THE

RISE AND PROGRESS

OF THE

ARTS OF DESIGN

IN THE UNITED STATES.

———

BY WILLIAM DUNLAP,

Vice President of the National Academy of Design, Author of the History of the
American Theatre,—Biography of G. F. Cooke,—&c.

———

IN TWO VOLUMES.

VOL. I.

———

NEW-YORK:

GEORGE P. SCOTT AND CO. PRINTERS, 33 ANN STREET.

1834.

FIGURE 5. Title page, William Dunlap's *History of the Rise and Progress of the Arts of Design in the United States*, 1834. By permission of the Houghton Library, Harvard University.

the work."[1] This statement is both remarkably candid and somewhat misleading. Though Dunlap did direct all aspects of the *History*'s production and sale by subscription, he did so more because of the realities of the market than because of a fear of losing control over his book.

William Dunlap adopted various authorial personas in his double role as writer and publisher of the *History*. When promoting the book, he presented himself as a traditional chronicler or annalist who accumulates every possible scrap of information, placing it in chronological order but attempting little synthetic analysis. He explained in the introduction: "We hope, by giving as complete a view of the subject as can now be obtained, to place in the hands of the future historian, many valuable facts, which would otherwise have been lost."[2] This rhetorical position constitutes the author as a voice from the past, preserving a worthy tradition in the face of social change, and it presupposes an audience of like-minded enthusiasts. Dunlap's antiquarian stance, however, belies the ways in which the *History* constructs a partisan view of the history of American art. That Dunlap identified a coterie of sympathetic artists and their patrons and associates as his collaborators in constructing the *History* is clear from this description: "It may almost be considered as a club-book."[3] His remark suggests that the book served as a record of and for intimates. Dunlap's account can best be read, however, as not only a professional history of visual artists in the United States but one that privileges a certain segment of the art world.

The *History*'s place within the publishing market is no less complicated than the book's shifting purpose. Dunlap's hope that his audience would include interested readers who were not artists themselves suggests that a republican ideology underlay his project. In this vision of the American republic, promoted during the years of the Revolution, individuals with specialized talents or information had a duty to share their expertise with the general public. The didactic information these authorities imparted would circulate freely and create an equivalence of knowledge among independent citizens, thereby ensuring the health of the nation. Seen from this perspective, the sale of the *History* follows a similar model of intellectual diffusion— subscribers across the country would pledge to buy the book and it would then be distributed to them, spreading access to its instructive contents. As many scholars have demonstrated, however, the expanding capitalist economy (including the

1. Dunlap, *History*, vol. 1, p. iv.
2. Ibid., p. 13.
3. William Dunlap, "To the Editors of the *New-York Mirror*," *New-York Mirror*, June 14, 1834, p. 399.

publishing market) began to challenge established visions of republicanism in the United States; one result was a circumvention of traditional figures of authority as mediators between the public and bodies of knowledge.[4] In the case of the *History*, the purported model of an expert (Dunlap) providing a desired product to an eager populace does not square with the facts of the book's publishing history. In fact, to view the creation of the *History* as proceeding simply from the top down misrepresents the effect that a growing popular audience had on Dunlap's formulation of the book and its subsequent marketing. From promotional notices in publications including the *New-York Mirror*, it is clear that Dunlap discarded the notion that readers would purchase the *History* solely because of his expertise on the subject or out of their desire for edification. As the epigraph to this chapter reveals, the prospectus for the *History* promised its readers entertainment as well as instruction by altering the traditional relationship between author and reader. Dunlap's role now vacillated between that of a tutor and that of a friend or confidant.[5]

Overview of the Text

William Dunlap's *History* represented a qualitative shift in writings on American art. In place of reviews of ephemeral exhibitions or brief reports from artists' studios, the book traced the development of an American tradition that stretched from colonial to contemporary artists. After providing a brief introduction defining the parameters of his study, Dunlap organized the *History* as a series of biographical sketches, arranged chronologically according to the estimated date of each artist's professional emergence. The book begins with John Watson (1685–1768), a colonial painter active in Perth Amboy, New Jersey (Dunlap's birthplace), and ends with artists coming of age during the 1830s. The profiles vary in length from a paragraph to several chapters and encompass nearly three hundred painters, sculptors,

4. For the impact of the expanding market economy on notions of republicanism in the United States, see Joyce Oldham Appleby's *Capitalism and a New Social Order: The Republican Vision of the 1790s* (New York: New York University Press, 1984). For a summary of the challenges to the informational supremacy of elites during the nineteenth century, see Richard D. Brown, *Knowledge Is Power: The Diffusion of Information in Early America, 1700–1865* (New York: Oxford University Press, 1989), particularly the conclusion.

5. Both guises—the historian as instructor and as confidant—imply an intimacy with the reader that would later be replaced by the model of the impartial analyst of events; for a study of this transformation in the United States, see Peter Novick, *That Noble Dream: The 'Objectivity Question' and the American Historical Profession* (Cambridge: Cambridge University Press, 1988).

architects, and printmakers.[6] While following a general chronological format, Dunlap often grouped artists by genre—assembling the relevant architects or miniaturists of a period, for example, into one chapter.

Despite differences in length, the profiles in the *History* follow a discernible pattern. Most trace the known facts of an artist's life by beginning with his or her birthplace and date. Dunlap generally noted the factors contributing to his subject's artistic education, whether these were books, instruction by an itinerant artist, or European study. He also recorded significant patrons and documented important works by the artist, indicating whether he had seen these works in person and giving their present location when known. If an artist was still active, Dunlap indicated his or her current projects. He sometimes ventured his opinion on a given artist's merits, and he frequently supplemented his own assessment with that of other prominent artists;[7] for artists unfamiliar to him he sometimes also relied on the evaluations of trusted correspondents who were not themselves artists. He usually concluded his profiles with a physical description and a general character assessment of the artist in question.[8]

Interspersed throughout the succession of biographies are several sections touching on related topics. For example, Dunlap provided short histories of some of the artistic media covered in his account, focusing particularly on their use in Great Britain.[9] He also included information about the art academies that had been founded in the United States, as well as a brief survey of some major contemporary collections of American art; the *History* reproduces catalogues of the private collections of Robert Gilmor and Philip Hone in addition to Dunlap's annotated catalogue of the Trumbull Gallery at Yale College.[10] The text also includes three passages contributed by artist-colleagues of Dunlap: a history of wood engraving by Abraham

6. Dunlap supplied an annotated list of 161 additional artists—about whom he had insufficient information to include in the main text—in an appendix to the *History* (vol. 2, pp. 467–72).

7. For example, beyond his own analysis of John Singleton Copley's career in the *History*, he also cited the opinions of the artists Henry Sargent, Thomas Sully, and Charles Robert Leslie; see Dunlap, *History*, vol. 1, pp. 103–30.

8. One of the published models for the *History*—Allan Cunningham's *The Lives of the Most Eminent British Painters, Sculptors, and Architects* (1829–33)—also included physical descriptions of its subjects; this account is discussed at greater length below.

9. These include histories of engraving, miniature painting, and architecture (Dunlap, *History*, vol. 1, pp. 145–47, 224–26, and 330–35). Presumably Dunlap did not think his readers required similar introductions to painting and sculpture.

10. Dunlap, *History*, vol. 1, pp. 418–24, and vol. 2, pp. 276–85 and 333–46 (on the academies); and vol. 1, pp. 392–93 and vol. 2, pp. 457–65 (on the collections).

John Mason, a technical handbook on miniature painting by Thomas Cummings, and "Notes on Pictures and Painting" by Thomas Sully.[11]

As the first chapter suggested, Dunlap's personal experience was his principal frame of reference as an author. He acknowledged in the book's introduction, for example, that his account focused primarily on painters.[12] Similarly, the book presents the most detailed information about artists active during the period of his professional career—from the 1790s to the 1830s. The *History* does not include any real discussion of the art of indigenous peoples,[13] and, with the exception of sections on Benjamin West and John Singleton Copley, casts a very cursory eye over the colonial period. It provides no analysis of artwork executed in the French or Spanish colonies, and the book's account of English colonial art begins after Great Britain had consolidated its control over the eastern seaboard.

Dunlap's background also influenced the emphases of the artist profiles. His experience as a playwright made him adept at sketching individual personalities, ensuring that many of the biographies in the *History* would be driven primarily by character development.[14] In consequence, Dunlap seems to have gravitated toward artists who shared his love of humor and a good story. Though he demonstrated great respect for the virtues of such leaders as Benjamin West and Samuel Morse, his writing is at its most vivid describing acknowledged reprobates such as Gilbert Stuart and John Jarvis. Perhaps because of his own professional disappointments, Dunlap was drawn to artists who had struggled to carve out their careers. He lavished praise on Thomas Cole, Robert Weir, and John Frazee, who were able to survive early poverty and discouragement.

In addition to his personal preferences, literary precedents helped shape Dunlap's account of American art. One of the features of the *History* that most strikes modern readers is the multiplicity of writing genres in the book. This stylistic variation is partially owing to the conventions of contemporary writing. Eclecticism had

11. Ibid., vol. 2, pp. 1–8, 10–14, and 137–41. Mason was a British wood engraver who lived in the United States between 1829 and 1839 and was elected an associate member and Professor of Wood Engraving at the National Academy of Design; see George Groce and David Wallace, *The New-York Historical Society's Dictionary of Artists in America, 1564–1860* (New Haven: Yale University Press, 1957), p. 427. The varied contributions of Thomas Cummings and Thomas Sully to the *History* are discussed below.

12. Dunlap, *History*, vol. 1, p. 9.

13. See ibid., p. 11.

14. James Flexner observed in his introduction to the 1969 edition of the *History* that Dunlap's frequent use of dialogue separates his account from previous histories of art and allies it more with the format used by James Boswell in his 1791 biography of Samuel Johnson (James Thomas Flexner, "Introduction to the Dover Edition," *History*, vol. 1, p. xi).

become a literary genre in its own right during the eighteenth century, affecting not only serial publications but also historical accounts.[15] Sketches published in the weekly magazines of the early nineteenth century provided Dunlap with a more recent, market-driven example of literary eclecticism. In these publications, editors offered a mixture of genres in the hope of keeping readers entertained. Though there is no doubt that these models influenced Dunlap's decisions about the format of his book, the varied forms in the *History* also underline the speculative uncertainties of the American publishing market. What did it mean to write about American art in 1834, and what was the proper format in which to construct this art's history? In the absence of an established tradition of art historical writing in the United States, Dunlap relied on European examples of art literature as well as literary genres popular among U.S. readers. An analysis of his efforts to research, publish, and promote the *History* discloses the textual, commercial, professional, and cultural waters Dunlap navigated in order to realize his account.

Research

William Dunlap offered readers of his book an informed view of the history of art in the United States. In promotional literature for the *History*, he reminded potential subscribers: "The writer of this work has had personal knowledge of most of the Artists who will be the subjects of its pages, from West and Copley to the men of the present day. Information and assistance have been liberally furnished from the best sources. Those most conspicuous in our literature and arts, have most freely aided the author. This enables him confidently to promise such a collection of facts on the subjects of which he treats, as could not be submitted to the public from any other pen."[16] Planning an encyclopedic account, Dunlap approached the task of researching the *History* with the mindset of an archivist. Facing an extremely compressed timetable for the book's production (see appendix B), he managed to

15. The use of the term "eclectic" to describe eighteenth-century periodicals typically referred to their appropriation of previously published (usually European) material; see Frank Luther Mott, *A History of American Magazines*, vol. 1: *1741–1850* (Cambridge, Mass.: Belknap Press, 1957), pp. 39–41. For the predominance of the "scissors and paste" approach to history writing, see Richard C. Vitzthum, *The American Compromise: Theme and Method in the Histories of Bancroft, Parkman, and Adams* (Norman: University of Oklahoma Press, 1974), p. 8.

16. [William Dunlap], "Proposals for Publishing . . ." with "William Dunlap to James Fenimore Cooper," December 26, 1833, on reverse, Za Cooper 230x, Beinecke Rare Book and Manuscript Library, Yale University. An identical copy of this proposal can be found at the New-York Historical Society, and a slightly different version of the prospectus is also in the collection of the Beinecke Library.

assemble an enormous amount of information about American artists from both manuscript and published sources over the span of two years.

Dunlap began his research by focusing on living artists. As the *History* reveals, he composed most of the profiles of his contemporaries from material solicited directly from the artists. A little over two weeks after he first noted undertaking the *History* in his diary, he wrote to the painters Washington Allston, Charles Bird King, and Charles Fraser requesting biographical information. A letter written to the painter John Vanderlyn the following spring suggests the tenor of these inquiries. Dunlap began by flattering Vanderlyn and offering the artist reassurance about his projected history, explaining: "Having undertaken to publish a history of the rise and progress of the Arts of Design in the United States, my duty requires that I should call upon the leading artists of the country for information. I therefore respectfully request of you answers to the following queries, and such other information bearing on the subject generally as you please to communicate, assuring you that the facts or opinions entrusted to me shall only be used as directed by yourself."[17]

Dunlap then laid out the relevant queries, revealing his general interests as a biographer and also his specific knowledge of Vanderlyn's career:

> I would ask of you—Where born? When? What led to the study of drawing or painting? At what time? What & who aided? Your first picture or pictures? Time of leaving home for Europe? How, or by whom suggested?—Where you studied in Europe & by whom instructed? Any thing connected therewith? Your return home & employment? Second visit of Europe? Time of? Anything connected therewith? Time of your return and any thing you please to communicate since? The circumstances attending the painting of Marius and the Ariadne would be particularly desirable, as well as those connected with your full length portraits.[18]

Dunlap published many of the responses he received from artists verbatim.[19] It is not entirely clear whether this practice resulted more from his haste to complete the book or from his desire to preserve the personality of individual artists by presenting

17. "William Dunlap to John Vanderlyn," April 25, 1833, John Vanderlyn Miscellaneous folder, New-York Historical Society. See chapter 5 of the present volume for Vanderlyn's embittered response to his portrait in the *History*.

18. Ibid. Dunlap addressed the letter to "John Vanderlyn, Esq./Historical & portrait painter/New York."

19. The surviving autobiographical manuscript that the architect Alexander Jackson Davis prepared for Dunlap demonstrates the author's working method (A. J. Davis Collection I [F-2], Drawings and Archives, Avery Architectural and Fine Arts Library, Columbia University). A comparison with the *History* reveals that Dunlap used thirteen of the seventeen handwritten pages with very few editorial changes. Davis apparently did not want it to be known that he was Dunlap's source; according to the Avery catalogue for the Davis collection, the manuscript is in Davis's hand, yet the architect referred to himself in the sketch as an anonymous "informant."

them in their own words. In either case, it was certainly fortunate for Dunlap that he found such engaging correspondents.[20] Much of the interest and, it must be acknowledged, readability of the *History* is owing to these autobiographical passages that reveal, for example, Washington Allston's literary skill, Thomas Cole's fervency, or David Claypoole Johnston's humor.[21] These first-person narratives also gave the impression of eliminating the author entirely, thus collapsing the distance between artist and reader and author and reader.

Dunlap met with varied responses to his requests. Some of the artists, including the painter Henry Sargent, needed coaxing. Sargent answered Dunlap's first request by pleading,

> I hardly know how to answer the several queries contain'd in your letter—for altho' I should feel myself highly flatter'd by any notice of yours, in your intended publication— Yet—I confess that I feel greatly embarrassed in attempting to furnish you with any facts for such a purpose myself. Indeed I have had so little practice in the Art, that I can hardly claim to be more than an Amateur Artist—and unless I should have good reason to change my mind upon this Subject—I beg leave most respectfully to be excused from complying with your request in this instance.[22]

Dunlap also had to entice Thomas Cole to bring his sketch up to the present date after receiving one installment. He began one letter to Cole by assuring the painter, "Your memoir is one of the most interesting and instructive that I know," but continued, "you must not leave me so abruptly—something must be said of the Aqueduct picture—and others—your impressions of Italy & Italian art."[23]

20. In his diaries, Dunlap faithfully recorded the dates he sent letters to and received responses from his correspondents. Most of the artists he contacted seem to have been flattered by Dunlap's interest and quick to comply with his requests. He did report a lack of cooperation, however, on the part of several artists in the *History*, scolding Benjamin Trott as follows: "Mr. Trott is one of the few artists who have shrunk from rendering me that assistance which even a few dates would give in raising, what I hope and believe will be, a monument to the arts of America" (Dunlap, *History*, vol. 1, p. 414). He dealt with Elkanah Tisdale even more summarily: "He has declined, by letter, giving me any dates or facts relative to himself; if, therefore, I err, he must excuse me—the world will care nothing about it" (*History*, vol. 2, p. 45).

21. Dunlap, *History*, vol. 2, pp. 152–88, 350–67, and 327–32.

22. "Henry Sargent to William Dunlap," May 5, 1833, Gratz Collection, Historical Society of Pennsylvania, available through the Archives of American Art, Smithsonian Institution, roll P22, frame 434. Apparently Dunlap convinced Sargent to comply through subsequent correspondence.

23. "William Dunlap to Thomas Cole," August 28, 1834, Thomas Cole Papers, Courtesy of the New York State Library (Albany), Manuscripts and Special Collections, accessible through the Archives of American Art, Smithsonian Institution, roll ALC-1 (Letters to Cole, 1833–1834). Cole expressed his misgivings about collaborating with Dunlap in a note appended to this letter; he wrote, "If I had known that [Mr.] Dunlap had the intention of publishing what I wrote I should not have acceded to his request." It is noteworthy that Dunlap was still soliciting information as late as August of 1834; the *History* would be published a little over two months later (see appendix B).

In addition to providing information about themselves, a number of artists supplied Dunlap with information about mutual colleagues. The most useful of these sources was Thomas Sully. During the summer of 1833 Dunlap made a weeklong research trip to Philadelphia, meeting with the painter several times.[24] Sully recounted anecdotes about his own life, and he also gave Dunlap access to a manuscript now known as "Hints for Pictures."[25] This notebook, which Sully began in 1809 and continued throughout his life, contained technical information, passages copied from various published sources, and Sully's comments on American and European artists. Dunlap observed in a diary entry made during the journey, "Many passages of Sully's book will be valuable if distributed under different h[ea]ds for the Hist'y of ye Rise & progress."[26] Dunlap followed his own advice, and devoted a section at the end of his biography of Sully to further excerpts from the manuscript—the "Notes on Pictures and Paintings" mentioned previously.

Washington Allston and Charles Robert Leslie supplied reminiscences about a wide range of American artists, and Alexander Jackson Davis of the New York architectural firm Town & Davis furnished Dunlap with general information about American architecture.[27] Assistance in tracking down information on artists from other regions of the country came from correspondents in key locations including the painters Charles Fraser (Charleston, South Carolina), John Neagle (Philadelphia), and James Reid Lambdin (Pittsburgh and Louisville).[28] Without traveling

24. Dunlap first met Thomas Sully when the latter came to New York in 1806. Thomas A. Cooper, the theater manager for whom Dunlap was working at the time, sponsored Sully during his visit (see Dunlap, *History*, vol. 2, pp. 110–11).

25. The original "Hints for Pictures, 1809–1871" manuscript is in the collection of the Yale University Library; a typescript is available through the Archives of American Art, Smithsonian Institution; see New York Public Library, roll N18, frames 75–254. Sully's posthumously published *Hints to Young Painters, and the Process of Portrait-Painting* (1873) drew upon this manuscript.

26. Dunlap, *Diary*, p. 696.

27. Dunlap identified the firm of Town & Davis as a source for the historical survey of architecture in the *History* (vol. 1, p. 330), though A. J. Davis was probably his primary contact. Dunlap's diaries record several meetings with the architect; for one of Dunlap's letters of inquiry, see "William Dunlap to A. J. Davis," September 11, 1834, written on the reverse of [William Dunlap], "Proposals for Publishing, By Subscription, A History of the Rise and Progress of the Arts of Design, in the United States," William Dunlap Miscellaneous Manuscripts folder, New-York Historical Society.

28. Many of these regional correspondents also helped Dunlap find subscribers for the *History*. John Neagle was particularly active on Dunlap's behalf, sending information about himself and other Philadelphia-area artists as well as gathering subscribers and arranging for the distribution of the book once it was available; see the *Diary* index for Dunlap's numerous communications from Neagle as well as "John Neagle to William Dunlap," January 9, 1833, Gratz Collection, Historical Society of Pennsylvania, accessible through the Archives of American Art, Smithsonian Institution, roll P22, frame 342.

himself, Dunlap had knowledgeable sources on artists active in the southern, mid-Atlantic, and western states.

Dunlap's correspondence and the list of contributors included in the *History*'s prospectus indicate that he also solicited information from nonartists.[29] Predictably, he tapped prominent members of his New York acquaintance including Gulian Verplanck, Dr. John Francis, and Dr. David Hosack. He also requested information from a wide array of other people including the Baltimore collector Robert Gilmor and the author and art collector James Fenimore Cooper.[30]

In addition to his correspondents, Dunlap relied on a variety of published sources for his biographies of American artists. Benjamin West was the most documented American-born artist to date, and his profile in the *History* provides a cross section of these printed sources.[31] Dunlap depended heavily on two British publications for the details of West's life: John Galt's authorized biography of the painter, *The Life, Studies, and Works of Benjamin West*, which had appeared in two installments in 1816 and 1820, and the more recent sketch of West's life that had appeared in Allan Cunningham's *The Lives of the Most Eminent British Painters, Sculptors, and Architects*.[32] Dunlap also made ample use of magazines and newspapers; in the West profile he referenced such diverse periodicals as the *Friend*, a Quaker publication originating in Philadelphia, and the London magazine *Bell's Weekly*

29. [William Dunlap], "Proposals for Publishing by Subscription, A History of the Rise and Progress of the Arts of Design in the United States," with "William Dunlap to James Fenimore Cooper," September 24, 1834, on the reverse, Za Cooper 230x, Beinecke Rare Book and Manuscript Library, Yale University. Unlike the earlier prospectus, this version includes the names of contributors to the *History* and a selective list of artists profiled in the work (the descriptive text is the same in both versions).

30. See "William Dunlap to Robert Gilmor," December 17, 1832, Dreer Collection, Historical Society of Pennsylvania, available through the Archives of American Art, Smithsonian Institution, roll P20, frame 413, and "William Dunlap to Robert Gilmor," July 15, 1833, Etting Papers, Historical Society of Pennsylvania, Archives of American Art, Smithsonian Institution, roll P21, frame 52. This and other correspondence between the two reveal that in addition to soliciting Gilmor's help for the *History*, Dunlap was helping Gilmor build his autograph collection. See also, "William Dunlap to James Fenimore Cooper," December 26, 1833, and September 24, 1834, Za Cooper 230x, Beinecke Rare Book and Manuscript Library, Yale University.

31. Dunlap, *History*, vol. 1, pp. 33–97.

32. The first volume of Galt's biography, tracing West's life until his arrival in London in 1763, had appeared as *The Life and Studies of Benjamin West, Esq.* (London: 1816). After West's death in March 1820, Galt added a second volume detailing West's career in Great Britain and renamed his work *The Life, Studies, and Works of Benjamin West, Esq.* (London: T. Cadell and W. Davies, 1820). Galt's biography was the basis for the profile of West in Allan Cunningham, *The Lives of the Most Eminent British Painters, Sculptors, and Architects*, 6 vols. (London: John Murray, 1829–33). Both of these publications appeared in American editions. Dunlap did not use these two sources uncritically; he pointed out factual inaccuracies in both Galt's and Cunningham's accounts.

Messenger.[33] Dunlap also cited some of West's published correspondence as well as encyclopedias, biographies, academic discourses, and general surveys of western art.

An examination of the West biography provides essential insight into the way Dunlap synthesized manuscript and published sources. Dunlap followed the chronology first established in Galt's biography closely and quoted both Galt and Cunningham at considerable length. He also embellished these accounts—somewhat remote for an American audience—with personal memories of his time in West's studio during the 1780s, as well as with the reminiscences of fellow students including Washington Allston, Samuel Morse, and Charles Robert Leslie. Dunlap would follow this pattern throughout the *History*; hoping to engage his readers, he would supplement the facts of an artist's life, which were generally provided by an outside source, with personal observations, moral judgments, or anecdotes. His own diaries often provided the raw material for these editorial overlays.

In some cases Dunlap's editorial asides directly contradicted the expert testimony provided by one of his correspondents. For example, in a letter to Dunlap reproduced in the *History*, Washington Allston offered a radical interpretation of the power of color. Referring to the experience of viewing sixteenth-century Venetian paintings during a trip to Paris, Allston recalled:

> Titian, Tintoret, and Paul Veronese, absolutely enchanted me, for they took away all sense of subject. When I stood before the Peter Martyr, the Miracle of the Slave, and the marriage of Cana, I thought of nothing but of the *gorgeous concert of colours*, or rather of the indefinite forms (I cannot call them sensations) of pleasure with which they filled the imagination. It was the poetry of colour which I felt; procreative in its nature, giving birth to a thousand things which the eye cannot see, and distinct from their cause. I did not, however, stop to analyze my feelings—perhaps at that time I could not have done it. I was content with my pleasure without seeking the cause. But I now understand it, and *think* I understand *why* so many great colourists . . . gave so little heed to the ostensible *stories* of their compositions . . . they addressed themselves not to the senses merely, as some have supposed, but rather through them to that region (if I may so speak) of the imagination which is supposed to be under the exclusive dominion of music.[34]

Allston concluded with an endorsement of one of the key tenets of romanticism, asserting that the Venetian painters "leave the subject to be made by the spectator, provided he possesses the imaginative faculty—otherwise they will have little more

33. The *Friend* could be either of two magazines of that name published in Philadelphia during this period; one ran from 1827 to 1955 and the other from 1828 to 1831. *Bell's Weekly Messenger* ran from 1796 to 1896 (*Union List of Serials*).

34. Dunlap, *History*, vol. 2, pp. 162–63.

meaning to him than a calico counterpane."[35] Dunlap immediately distanced himself from these observations and hastened to reclaim Allston as a narrative painter: "It is certainly not fair to leave the spectator to make out the story of a picture, and to be puzzled by finding Pope Gregory alongside of Saint Peter, and both dressed in costume as far from truth as they were from similarity of opinion. All the charm of color may be attained without sacrificing truth," he wrote, adding that Allston's "own pictures are replete with this magic of colour, at the same time that he is strictly attentive to the story in all its parts, character, actions, and costume."[36]

Although Dunlap identified his personal involvement with his subject matter and the sheer volume of facts he collected as the *History*'s greatest strengths, these factors produced a number of notable omissions in the text. His account is strongest discussing painters active in New York during the early nineteenth century; artists practicing in different media, in other regions of the country, or during an earlier period often received less attention. For example, Dunlap was dismissive of the Philadelphia-based painter Charles Willson Peale and his artistic dynasty despite their prominent collective role in early American art.[37] Dunlap's correspondents, belonging to the same network as the author, reinforced rather than challenged his views. In some rare cases, Dunlap's treatment of an artist went beyond neglect to outright attack; as John Trumbull would discover, much to the painter's chagrin, Dunlap's biases proved costly for his enemies within the art world.

The Challenges of Publishing the *History*

As Dunlap was actively engaged in promoting the *History* at the same time that he was researching and writing his account, it is unsurprising that the publishing market affected the book's scope and direction. Surveying the publishing landscape when embarking on his project in 1832, Dunlap could not have failed to notice that relatively few books on the visual arts had appeared in the United States, despite modest increases in the scale of domestic publishing. He must have hoped that the novelty of his account would attract a wider readership than previous art publications. Without the benefit of predecessors, however, he would need all of his

35. Ibid., p. 163.
36. Ibid.
37. Dunlap's biography of Charles Willson Peale can be found in the *History*, vol. 1, pp. 136–42. The reasons for Dunlap's prejudice are not immediately apparent. Peale fit the artist type that Dunlap generally praised: he had studied with Benjamin West, was an ardent patriot during the War for Independence, and took a leading role in the Philadelphia art community.

entrepreneurial ingenuity in order to publish and create an audience for the *History*. The remark of the eminent literary historian William Charvat, that the history of publishing was only relevant to his field if it could be shown to have had a "shaping influence" on the resulting works, serves as a useful reminder when analyzing the terms under which the *History* entered the market.[38]

When it appeared in 1834, Dunlap's *History* entered an extremely limited segment of the publishing market. The bibliography of all art books and pamphlets published in the United States from 1770 to 1865, as compiled by Janice Schimmelman, provides a means to characterize this market.[39] Although the number of entries steadily increased throughout the first third of the nineteenth century, many of the publications dating from this period were as ephemeral as the coverage of the visual arts in American newspapers and magazines. Slender pamphlets, individual engravings, prospectuses, and broadsides make up a large proportion of the list. The limited number of art imprints that did find an audience might have given pause to an author attempting a synthetic history of art. According to Schimmelman, instruction manuals for drawing dominated the publication list throughout the entire antebellum period.[40] Though handbooks of this kind were increasingly marketed to a middle-class audience as the nineteenth century progressed, they were first directed to a smaller population of self-taught American artists and artisans in search of

38. William Charvat, *Literary Publishing in America, 1790–1850* (Amherst: University of Massachusetts Press, 1993 [orig. pub., Philadelphia, 1959]), p. 7.

39. Janice G. Schimmelman, *American Imprints on Art through 1865: Books and Pamphlets on Drawing, Painting, Sculpture, Aesthetics, Art Criticism, and Instruction: An Annotated Bibliography* (Boston: G. K. Hall, 1990). Schimmelman's bibliography includes "addresses and essays, biographies of artists, histories of art, descriptions of paintings and sculpture, art journals, trade catalogs of artists' materials, practical handbooks on the preparation and use of materials, and instructional books on the techniques of drawing, painting, and perspective" (p. vii). Although her bibliography does not include exhibition catalogues, Schimmelman does record some published broadsides and pamphlets relating to contemporary exhibitions. She includes both American reprints of European works as well as original American compositions. It should be noted that this source lists only European books that had been republished in America and not works that could have been imported directly by American readers or booksellers. For an introduction to the latter, see Schimmelman, "A Checklist of European Treatises on Art and Essays on Aesthetics Available in America through 1815," *Proceedings of the American Antiquarian Society* 93 (April 1983): 95–195; Schimmelman, "Books on Drawing and Painting Techniques Available in Eighteenth-Century American Libraries and Bookstores," *Winterthur Portfolio* 19 (Summer/Autumn 1984): 193–205; and Schimmelman, "Architectural Treatises and Building Handbooks Available in American Libraries and Bookstores through 1800," *Proceedings of the American Antiquarian Society* 95 (1986): 317–500.

40. Schimmelman, *American Imprints*, p. vii. In the years before 1834, the most popular of these manuals included Henry Williams's *Elements of Drawing Exemplified in a Variety of Figures and Sketches of Parts of the Human Form* (first edition, Boston: 1814); Louis Benjamin Francoeur's *An Introduction to Linear Drawing* (first American edition, Boston: 1825); and Charles Davies's *A Treatise on Shades and Shadows, and Linear Perspective* (first edition, New York: 1832); see Schimmelman, *American Imprints*, entries 626, 207, and 147.

practical technical information.[41] If reprints are any indication of demand, British aesthetic treatises republished in the United States were also among the most popular of the early art publications.[42] Presumably American publishers hoped to find customers among the same types of wealthy gentlemen who had imported these essays to enhance their personal libraries during the colonial period. Dunlap would need to attract as many of these diverse reading constituencies as possible in order to make a success of the *History*.

The *History* fell most naturally into the publishing categories of history and biography, and though both genres were popular during the period, there were few art books in these categories. By 1834 American publishers had introduced only a few biographies of individual artists, most of which were reprints of European works. These included the *Life of Benvenuto Cellini* (first U.S. edition, 1812); John Galt's *Life and Studies of Benjamin West* (simultaneously published in Philadelphia and London, 1816); James Northcote's *Memoirs of Sir Joshua Reynolds* (1817); and *The Works of William Hogarth* (1833).[43]

American imprints surveying the history of art were also uncommon. The principal examples before the publication of the *History* tended to minimize American art in their general chronicles of western art, if not bypass it completely.[44] The few

41. The titles of many of these early instructional manuals—which promote themselves as "recipe books," or as artists' "assistants," "companions," or "guides"—suggest an audience of practicing artists. See for example, Schimmelman, *American Imprints*, entries 27, 59, 144, 169, 203, 330, 368, 399, 509, 516, and 558, all published before 1834. Such titles as the *Young Ladies' & Gentlemen's Complete Drawing Book* (Philadelphia: 1798) imply that a few of these early manuals were designed to further the drawing-room accomplishments of the American gentry (entry 553).

42. Lord Kames's *Elements of Criticism*, originally published in Edinburgh in 1762, was reprinted by a Boston publisher in 1796 and remained in print almost continuously through the 1860s. Similarly, *A Philosophical Enquiry into the Origin of Our Ideas of the Sublime and Beautiful* (1756) by Edmund Burke and *Essays on the Nature and Principles of Taste* (1790) by Archibald Alison, appearing in the United States in 1806 and 1812 respectively, went through numerous American editions (Schimmelman, *American Imprints*, entries 299, 82, and 8). One notable exception to the popularity of treatise reprints is Joshua Reynolds's *Discourses*, which appeared in a single American edition before 1850 (Schimmelman, *American Imprints*, entry 447).

43. Schimmelman, *American Imprints*, entries 93, 214, 381, and 260.

44. These include "An Essay on the Causes that have Promoted or Retarded the Growth of the Fine Arts" (Edinburgh and Philadelphia, 1785), which traced the fine arts from ancient Greece to seventeenth-century France; Samuel Miller's *A Brief Retrospect of the Eighteenth Century* (New York, 1803), which devoted only one paragraph to American art in its survey of advances made during the eighteenth century in various fields of knowledge including the fine arts, science, medicine, and agriculture; John Smythe Memes's *History of Sculpture, Painting, and Architecture* (Edinburgh, 1829; Boston, 1831 and 1834), which ranged from ancient to contemporary art but did not include American art; and Josiah Holbrook's *A Familiar Treatise on the Fine Arts, Painting, Sculpture, and Music* (Boston, 1833 and 1834), a general history of art for children. With the exception of Samuel Miller's survey, I am relying on Schimmelman's descriptions of these publications in *American Imprints*; see entries 191, 264, 342, and 349.

historical reviews of American art that did exist appeared in published academic discourses or lectures to private associations.[45] Despite the dearth of historical accounts of American art, Dunlap may have taken specific encouragement from the fact that in 1831 the rising New York publishing firm J. & J. Harper republished the first three volumes of Allan Cunningham's *The Lives of the Most Eminent British Painters, Sculptors, and Architects* as part of its Family Library series.[46] This series, printed in an inexpensive, pocket-sized format, targeted a general audience. Perhaps the publication of Cunningham represented Harper's gamble that a broader readership would develop for national surveys of visual arts. Dunlap apparently reached a similar conclusion, hoping that his audience would be even more responsive to an account of American artists.[47]

Dunlap ignored the rigid divisions within the existing American art publishing market and combined a number of genres within one book. The *History* is part autobiography, biography, history, instruction manual, and collection catalogue. It presented more biographical information on a greater number of American artists— including Dunlap—than had been published to date. By organizing these profiles chronologically and introducing the term "progress" into the book's title, Dunlap implied that his account provided a historical narrative. He also acknowledged the well-established American taste for practical art manuals by including technical information on a variety of subjects ranging from color theory to architectural terms. Through the inclusion of catalogues of the private art collections of Philip Hone and Robert Gilmor, the book offered one of the first public records of art patronage in the United States. Dunlap surely intended this eclecticism to broaden

45. For a thorough investigation of this genre, see Annie V. F. Storr, "Ut Pictura Rhetorica: The Oratory of the Visual Arts in the Early Republic and the Formation of American Cultural Values, 1790–1840," Ph.D. diss., University of Delaware, 1992, and William H. Gerdts, "The American 'Discourses': A Survey of Lectures and Writings on American Art, 1770–1858," *American Art Journal* 15 (Summer 1983): 61–79. As the appendix to Gerdts's article reveals, many of these addresses were published in periodicals. Since Schimmelman does not include periodicals in her bibliography, only those speeches published in pamphlet form or in both pamphlets and magazines overlap with Gerdts's list.

46. Allan Cunningham, *The Lives of the Most Eminent British Painters and Sculptors*, 3 vols. (New York: J. & J. Harper, 1831–33). Reprints of British publications composed the bulk of the Family Library series according to Cass Canfield's entry in Madeleine B. Stern, ed., *Publishers for Mass Entertainment in Nineteenth-Century America* (Boston: G. K. Hall, 1980), p. 147 (see pp. 147–56 for an overview of the Harper firm).

47. Dunlap's *History* did not face any real competition from other art imprints when it appeared in 1834. The six other listings in Schimmelman's bibliography for that year include several published descriptions of European and American art works currently touring the United States—such as the four paintings of Rome by Giovanni Paolo Panini; the first volume of *The National Portrait Gallery of Distinguished Americans*, a series of biographies of prominent citizens accompanied by engraved portraits that will be discussed further below; and the translation of a French treatise on perspective (Schimmelman, *American Imprints*, pp. 356–57).

the *History*'s appeal, yet it may have had the unintended effect of making the book harder to publish.

Dunlap's diaries reveal that the state of contemporary American publishing circumscribed his ambitions for the *History*. He must have been aware from the beginning of the many obstacles that could prevent his cultural histories from ever reaching print. The most daunting of these hurdles was finding a publisher. As numerous historians of early nineteenth-century American publishing have documented, bringing out a book written by an American writer was a perilous undertaking even for the more established publishers of the period. These firms typically suffered from undercapitalization, high costs, and uncertain distribution networks. For these reasons, many early publishers, such as Carey & Lea in Philadelphia, depended on reprints of European works in order to remain financially solvent.[48] As there were no international copyright laws, American publishers were not required to pay foreign authors for the rights to a work and therefore could produce their own editions of European works at a much higher profit margin than American ones.[49] Because of this international competition, very few early American writers were actually paid by publishers. Instead, most authors assumed the financial risks of publishing themselves, paying out of pocket for a book's printing, binding, and advertising, while the typical publisher "simply acted as a wholesale distributor."[50] Successful authors of the period, including Washington Irving and James Fenimore Cooper, were able to survive during their early careers because they had sufficient financial resources to self-publish and could thus retain control of their books (including rights to future editions), while negotiating lucrative profit margins with retailers.[51]

Many publishing firms would agree to publish the books of American writers only if they were offered by subscription.[52] In this arrangement, an author or pub-

48. For information on early publishing in the United States, see Charvat, particularly chap. 2, and James N. Green, "From Printer to Publisher: Mathew Carey and the Origins of Nineteenth-Century Book Publishing," in *Getting the Books Out: Papers of the Chicago Conference on the Book in 19th-Century America*, ed. Michael Hackenberg (Washington, D.C.: Center for the Book, Library of Congress, 1987), pp. 28–29.

49. Charvat, p. 42. Charvat explains that publishers would pass on part of the savings gained from these duplicate editions to booksellers in the form of a substantial discount.

50. Ibid., p. 41.

51. Ibid., chap. 2, esp. pp. 38–44.

52. Lawrence C. Wroth noted the parallels between the subscription system and earlier literary patronage. The modern author, he wrote, relinquished "the single patron for the many, the single patron, with his indefinite assurance of aid, for the many, with their pledges to purchase upon publication, at a fixed price, one or more copies of a proposed book. Instead of the dedication to the single patron, the book contains under the subscription system a list of the many patrons who have made its publication possible"; see

lisher would begin by generating a prospectus that announced the work's subject and the terms of its sale (figure 6). Printing would not proceed until a certain number of the subscriptions had been sold, guaranteeing that the publisher would recoup a percentage of the production costs. During the early nineteenth century, American publishers were just beginning to develop a national network of booksellers and independent agents who could gather subscription orders. Although these networks were not always dependable or extensive, they were designed to stimulate demand and to serve as distributors.

If publishers were initially unwilling to assume the risks of subsidizing the writing of such popular authors as Cooper and Irving, they would certainly have been leery of taking on unfamiliar types of works such as Dunlap's cultural histories. In addition, since Dunlap was often destitute, he could exercise very little leverage in negotiations with publishers.[53] Despite these disadvantages, Dunlap had succeeded in convincing the Harper firm to publish his *History of the American Theatre* in 1832.[54] The Harper brothers planned an edition of 1,500 and guaranteed Dunlap at least $500 of the total subscription proceeds; he would receive more if the book sold well.[55] Dunlap apparently considered these terms stringent and complained at one point in his diary, "The Harpers have done nothing & it appears only mean to publish when the list of subscribers is full without any intention of exertion to help me, as professed."[56] Although Dunlap

Wroth's essay in Hellmut Lehmann-Haupt et al., *The Book in America: A History of the Making, the Selling, and the Collecting of Books in the United States* (New York: R. R. Bowker, 1939 [orig. pub. in German, Leipzig, 1937]), pp. 48–49. For more recent scholarship on the topic, see Michael Hackenberg, "The Subscription Publishing Network in Nineteenth-Century America," in Michael Hackenberg, ed., *Getting the Books Out: Papers of the Chicago Conference on the Book in 19th-Century America* (Washington, D.C.: Center for the Book, Library of Congress, 1987), pp. 45–75.

53. Dunlap was probably able to pursue the *History* project only because of a theatrical benefit held in his honor in February 1833, which netted him over $2,000; see Dunlap, *Diary*, pp. 633–65, and "Correspondence of the Dunlap Benefit," *Knickerbocker* 1 (May 1833): 323–29. As I discuss in the epilogue, proceeds from a later benefit exhibition were intended to subsidize Dunlap while writing the *History of the New Netherlands*.

54. According to a letter preserved in the Harvard Theatre Collection, Harvard College Library, Dunlap had earlier attempted to interest the Philadelphia publishing firm Carey & Lea in this manuscript (see "William Dunlap to James Kirke Paulding," June 30, 1828). The *History of the American Theatre* appeared in print just as Dunlap was embarking on the art history.

55. Dunlap, *Diary*, p. 597. According to Sarah Elizabeth Williams, Dunlap did not make more than the $500 guarantee; "William Dunlap and the Professionalization of the Arts in the Early Republic," Ph.D. diss., Brown University, 1974, p. 237.

56. Dunlap, *Diary*, p. 593. The author James Kirke Paulding, answering Dunlap's request for advice on his contract with the Harpers, recommended that Dunlap agree to their terms. Noting that national book sales were depressed, Paulding wrote, "As you had already so far advanced in your work it would have been a pity to lose the reward of your labours entirely. By this arrangement the publishers in fact take the risk of

PROPOSALS FOR PUBLISHING BY SUBSCRIPTION,

A HISTORY OF THE

RISE AND PROGRESS OF THE ARTS OF DESIGN
IN THE UNITED STATES.

BY WILLIAM DUNLAP,

Vice President of the National Academy of Design, Author of the History of the American Theatre,—Biography of G. F. Cooke—&c.

To trace the progress of Painting, Sculpture, Engraving, and Architecture, in our country, and bring before the Public a connected series of facts, respecting the lives and fortunes of those individuals, whether native or foreign, who have exercised any of these arts in the United States, appears to be an undertaking, which, if executed with moderate abilities, and a strict regard to truth, will form a portion of American History both entertaining and instructive.

The materials collected by the author of this work, will be chronologically arranged, from the early days of our existence as colonies to the present time. To rescue from oblivion or misrepresentation the names of our earlier Artists, and to record the effects produced by the visits of foreign Professors to our shores, appear to be subjects of sufficient interest to command the attention of our citizens generally: to the great body of Artists now exerting their talents in the Republic, it is a species of knowledge that seems indispensable.

The writer of this work has had personal knowledge of most of the Artists who will be the subjects of its pages, from West and Copley, to the men of the present day. Information and assistance have been liberally furnished from the best sources. Those most conspicuous in our literature and arts, have most freely aided the author. This enables him confidently to promise such a collection of facts on the subjects of which he treats, as could not be submitted to the Public from any other pen.

The worth of the work will principally consist in its authenticity. Opinions advanced may be valuable; historical accounts of pictures curious; personal narratives interesting; but facts shall be undeniable—and of such importance to the history of the country, that it would be incomplete without them; for it is presumed, that the history of those arts which civilized mankind, and embellish society, form an essential portion of the history of all nations.

Terms.

The work will be printed on good paper, and with fair type, in two volumes, octavo, each containing not less than 430 pages. Price, in boards, $5 the set, payable on delivery. To be published in November 1834.

NAMES OF A PART OF THE CONTRIBUTORS TO THIS WORK.

Hon. Joseph Hopkinson, President of the Pennsylvania Academy of Fine Arts.	Charles R. Leslie, R. A. Hon. Judge Cranch,	David Hosack, M.D. F. R.S. Robert Gilmor,
Washington Allston,	Washington Irving,	A. J. Davis,
John Neagle,	Chester Harding,	R. W. Weir,
Charles Fraser,	Benjamin Waterhouse, M. D.	John Frazee,
Hon. Gulian C. Verplanck,	John Stephano Cogdell, Secretary to the S. C. Academy of Fine Arts.	John W. Francis, M. D.
Samuel F. B. Morse, President of the National Academy of Design.	A. J. Mason,	Mrs. H. Whitehorne,
James Herring, Secretary of the American Academy of Fine Arts.	Alexander Anderson,	Henry Greenough,
	Charles Rhind,	N. Joscelyn,
Thomas Sully,	Professor Goodrich, of Yale College.	J. R. Lambdin,
Thomas Pratt,	Robert Mills,	George Cooke,
James Fennimore Cooper,	Robert M. Sully,	D. C. Johnson,
Thomas S. Cummings,	James Mc Murtrie,	T. Cole,
Henry Clay, Jun.	H. B. Latrobe,	Francis Alexander, Henry Sargent.

Names of a small part of the Artists whose biographies may be found in this work.

J. Smybert,	M. Houdon,	Robert Fulton,	Samuel L. Waldo,	John Neagle,
Benjamin West,	W. J. Bennett,	Miss A. Hall,	Jacob Eickholz,	Henry Inman,
John Singleton Copley,	John Vanderlyn,	Alvan Fisher,	N. Jocelyn,	Charles C. Ingham,
Matthew Pratt,	William Dunlap,	Gilbert Stewart Newton,	James Herring,	M. J. Danforth,
Henry Bainbridge,	Edward G. Malbone,	Samuel F. B. Morse,	James Sharpless,	G. Farman,
Charles W. Peale,	A. B. Durand,	Thomas Cole,	H. C. Shumway,	James B. Longacre,
Gilbert C. Stuart,	Charles Fraser,	J. W. Dodge,	A. J. Mason,	T. Doughty,
John Trumbull,	A. W. Wertmuller,	James Frothingham,	A. Anderson,	M. Jonett,
Thomas Sully,	Horatio Greenough,	Chester Harding,	Francis Alexander,	William Jewett,
Washington Allston,	Henry Sargent,	George Cooke,	R. W. Weir,	Benjamin Trott,
John W. Jarvis,	Rembrandt Peale,	William E. West,	F. S. Agate,	Charles R. Leslie,
Robert Edge Pine,	Alexander Lawson,	N. Rogers,	William S. Mount,	George W. Twibill,
Joseph Wright,	Alexander Wilson,	B. H. Latrobe,	J. J. Audubon,	Thomas S. Cummings,
Signor Ceracchi,	Ithiel Town,	C. B. King,	D. Edwin,	Archibald Robertson,
J. S. Cogdell,	A. J. Davis,	J. L. Krimmel,	James Freeman,	Joseph A. Adams.

SUBSCRIBERS NAMES.	RESIDENCE.	NO. OF COPIES.

FIGURE 6. *Proposals for Publishing by Subscription,* A History of the Rise and Progress of the Arts of Design in the United States, *1834. Yale Collection of American Literature, Beinecke Rare Book and Manuscript Library.*

did not receive the full support of his publisher, he also did not assume the entire financial risk for the book.[57]

Perhaps because of the slow sales of the *History of the American Theatre*, Dunlap encountered even more difficulties when he tried to publish his account of American art.[58] Although Dunlap stated in the preface to the *History* that he acted as his own publisher by choice, it is likely that he had first attempted to interest a firm such as J. & J. Harper in the book. An entry in his diary from the summer of 1834, recording a visit with James Fenimore Cooper, supports this idea. Dunlap noted, "J. F. Cooper with me & advises me to publish my work myself (if I do not sell the edition) giving credit & mak'g discount according to the numbers taken by the individual Booksellers."[59] As this note was recorded after Dunlap had arranged independently for a printer, it suggests that he was still hoping to attract a publisher for the *History* at a late date in its production.

In the end, as his diaries record, Dunlap assumed all of the responsibilities and costs of producing the *History* himself.[60] He did, however, receive some assistance from his friend, George Pope Morris, the editor of the *New-York Mirror*. Dunlap's

publication allowing you the entire proceeds of the subscription should they not exceed 500 dollars. And though I fully believe this risk is not great; Yet it is impossible to [see] the fate of the work on a subject of this kind." Dunlap copied this letter—"James Kirke Paulding to William Dunlap," May 10, 1832—into his *Diary* (pp. 598–99, where the letter is incorrectly dated May 15, 1832); the original is at Houghton Library, Harvard University.

57. Through the assistance of James Fenimore Cooper, then in Paris, Dunlap found a publisher in London, Richard Bentley, who bought the rights to a British edition of the *History of the American Theatre* for £50 (Williams, pp. 238–39). Charles Robert Leslie's subsequent attempt to interest Bentley in the *History* manuscript was unsuccessful (Dunlap, *Diary*, p. 830). Cooper had warned Dunlap about the European market, remarking, "I fear too you have adopted a little of the prevailing error concerning the interest which is felt in England about America and her literature. Certain individuals have been willing to turn us to account if possible and their puffs and notices have, quite evidently, thrown dust into the eyes of our credulous people, always too much disposed to receive impressions from abroad, when in truth the English reading public would greatly prefer reading abuse of us than anything else. Mrs. Trollope has made three times as much (I happen to know her receipts) by her travels than I can get for a Novel. I tell you this that you may understand one reason England is not quite a mine for us Americans" ("James Fenimore Cooper to William Dunlap," November 14, 1832, copied into Dunlap's *Diary*, p. 644).

58. It is impossible to know how many copies of the *History of the American Theatre* Dunlap did sell. The fact that the Harpers never published a second edition, although Dunlap was preparing one, suggests disappointing sales.

59. Dunlap, *Diary*, p. 792.

60. From the meticulous records that Dunlap kept about the *History*'s expenses in his diaries, it is possible to assess the profits he hoped to achieve. According to the subscription prospectus, Dunlap offered the two-volume *History* at the price of $5 per set. He estimated the cost of each two-volume set at $2, which would have left him with a $3 profit per sale (ibid., pp. 837–38). Following the advice of James Fenimore Cooper, cited above, and contemporary practice, Dunlap offered booksellers a discount of $1 per set (p. 847). His notes about meetings with one New York bookseller, Long & Wiley, offer a glimpse into these negotiations (pp. 849–50).

first notice of an arrangement with Morris is cryptic; he recorded that "I have determined that Morris shall print my book & he undertakes to arrange with the publishers."[61] Given the interchangeability of terms such as "publisher" and "printer" during this period, it is difficult to say definitively what this entry means. It is true, however, that the printing firm for the *Mirror*, George P. Scott, also printed the *History*. Though there is no record that Morris assumed any of the book's expenses, he did assist Dunlap in acquiring subscribers for the *History*.[62]

Without the sales support of a publisher, Dunlap needed to establish a subscription network for the *History* on his own. Like the publishing firms of Philadelphia and New York, he relied on regional representatives in the key locations of Boston, Philadelphia, New Haven, and Charleston, South Carolina, to promote the book. He had employed at least one commercial agent for selling the *History of the American Theatre*.[63] But it appears that Dunlap depended primarily on friends and volunteers to stimulate interest in his history of American art and to take orders. He was also able to use the contacts he had made while researching the *History* to solicit additional subscribers.

Not only did Dunlap direct the subscription campaign, he also supervised the distribution of the *History*. According to his diaries and advertisements for the book, George Morris helped Dunlap to distribute the *History* in New York. Copies could be picked up locally at the *Mirror* office, at Lewis Clover's store, a frequent haunt of artists, and at Dunlap's home.[64] Dunlap shipped books intended for subscribers in other areas; his diaries record that in the first shipment, copies reached as far south as Key West, as far west as New Orleans, and as far north as Plattsburgh, New York.[65] Some of these books were directed to friends for distribution, while others were routed through independent agents and bookstores. Dunlap's system of

61. Ibid., p. 759.

62. Dunlap's diaries record his payment of various expenses; see ibid., pp. 801, 822–23, and 837–38. On Morris's assistance, see ibid., pp. 831 and 842, and Thomas S. Cummings, *Historic Annals of the National Academy of Design* (New York: Da Capo Press, 1969 [orig. pub., Philadelphia, 1865]), p. 131.

63. Dunlap, *Diary*, p. 624.

64. Ibid., p. 844. Dunlap tried to avoid distribution costs whenever possible. For example, an advertisement in New York's *Evening Post* announced, "Subscribers who wish the work sooner than it can be distributed by the persons employed for that purpose, or who wish to spare expense to the author" could obtain their promised copies at the three locations noted above (December 8, 1834).

65. Dunlap, *Diary*, p. 850. Charvat's analysis of the early American publishing market suggests that a book could not generate substantial sales unless it reached beyond the eastern seaboard to penetrate the South and the West (see Charvat, chap. 1). Although Dunlap did assemble some subscribers from these regions, he was not able to match the far-flung distribution networks established by a publisher such as Mathew Carey.

subscription and distribution parallels the itinerancy practiced by contemporary artists. Unable to rely on patronage generated in one centralized urban location— whether a shop or display space—those selling books, their services as portrait painters, or tickets to independent exhibitions of their work would travel widely in order to generate business. Their success depended on knowledge of local conditions and a network of personal references. In turn, this commercial diffusion became an agent in the transformation of local patterns of production and consumption by creating new standards of reference and helping to construct the impression of a shared national culture.[66]

Without the support of a publisher's advance, Dunlap was rushed to get the *History* to print in order to collect payments from subscribers and recoup his expenses. During the fall of 1834, he was engaged simultaneously in correcting proofs, making final requests for information from correspondents, selling book subscriptions, and submitting notices of the *History* to local serials. His divided responsibilities as the book's publisher explain many of the text's anomalies. For example, he often made additions or corrections to the text by attaching footnotes, as it was quicker and easier than revising the text as a whole.[67] In addition, as the *History* was sent to the printer in batches rather than in one run, Dunlap continued to write after printing began. The repetitiveness of the text and other evidence of disorganization reflect this piecemeal approach. More important, focusing on individual installments impeded Dunlap's ability to develop overarching themes within the book.

The Influence of the *History*'s Projected Readers on Its Contents

Unable to predict the audience for a history of American art, Dunlap made every attempt to stimulate demand for his book through a vigorous campaign of promotion. Though the subscription records for the *History* do not survive, making an exact profile of its readers impossible, the available evidence—Dunlap's diaries and the proposals and advertisements he wrote on behalf of the book—does allow for the ob-

66. See David Jaffee, "The Age of Democratic Portraiture: Artisan-Entrepreneurs and the Rise of Consumer Goods," in *Meet Your Neighbors: New England Portraits, Painters, and Society, 1790–1850*, ed. Caroline F. Sloat (Sturbridge, Mass.: Old Sturbridge Village, 1992), pp. 35–46.

67. William P. Campbell, "Introduction" to William Dunlap, *History of the Rise and Progress of the Arts of Design in the United States*, ed. Alexander Wyckoff (New York: Benjamin Blom, 1965), p. xxiv. For an example, see *History*, vol. 1, p. 131.

servations that follow.[68] Publications on the fine arts had traditionally been targeted to an educated elite, and Dunlap certainly hoped to number New York's leading citizens among his subscribers.[69] He seems, however, to have made particular efforts to reach two emerging constituencies: the art profession and the middle-class pub- lic. A consideration of the *History*'s contents with reference to these two targeted groups reveals their substantial influence on the book as well as the ways in which the modes of discourse used to address each group sometimes came into conflict.

As the author of the first history of American art, William Dunlap needed to convince practicing artists, as well as the general public, of the legitimacy of their professional enterprise. This campaign took place during a period in American history in which numerous other groups, including lawyers and doctors, were also attempting to codify the boundaries of their respective professions.[70] In November 1832, before he began his research, Dunlap noted in his diary that "the Artists are subscribing for a History of the Arts of Design," suggesting that one motivation for his undertaking was the encouragement of his colleagues.[71] The *History* responded to the concerns Dunlap perceived among contemporary artists in two ways: by placing American art firmly within the context of the western art tradition and by documenting the means by which artists had begun to professionalize their ranks. Neither of these strategies, however, was free of difficulty. At the moment that Dunlap sought to link American art to the history of western art, that tradition was in the process of being radically redefined by the conditions of the modern world, including the rise of nationalism. Dunlap's account—like American artists them- selves—was caught between the pull of cultural nationalism and a desire to join a larger art community transcending national borders. In addition, the professionali- zation of American artists being a contested process, numerous factions had emerged within the art world. Rather than offering an objective overview of these conflicts, the *History* provided Dunlap with the opportunity to advance the partisan concerns of one wing of the early nineteenth-century art community.

The discernible influence of an international body of art literature on the format

68. Fragmentary records of subscribers to the *History* exist in the records of purchases noted in Dunlap's diaries, a few extant receipts and prospectus forms, and inscriptions on the flyleaves of surviving copies of the book. A partial subscription list for the *History of the American Theatre* can be found at Houghton Library, Harvard University, with "James Kirke Paulding to William Dunlap," May 10, 1832, Autograph file.

69. Dunlap recorded signing up the mayor of New York City as a subscriber (*Diary*, p. 827).

70. See Samuel Haber, *The Quest for Authority and Honor in the American Professions* (Chicago: University of Chicago Press, 1991), esp. pt. 1.

71. Dunlap, *Diary*, p. 627.

and contents of the *History* reflects Dunlap's desire to suture his account to a larger tradition.[72] By organizing the *History* as a series of biographies, Dunlap followed a long-established practice tracing back to Giorgio Vasari's *Lives* published during the sixteenth century.[73] This is the same format of the two histories of British art that Dunlap used as models: Horace Walpole's *Anecdotes of Painting in England* (1762–80) and Allan Cunningham's *The Lives of the Most Eminent British Painters, Sculptors, and Architects* (1829–33). Although Vasari's biographical formula was still popular when Dunlap undertook the *History*, the German scholar Johann Joachim Winckelmann had published influential writings during the second half of the eighteenth century on the art of antiquity—particularly that of ancient Greece—that dispensed with the biographical format in favor of a focus on stylistic development within discrete historical periods. Winckelmann's theory of the rise and decline of artistic traditions would have a long-lived effect on subsequent art scholarship.[74] Though Dunlap neither attempted Winckelmann's culturally synthetic approach nor followed his model of stylistic development, the *History* does reveal the indirect influence of the German writer's historical specificity. Building upon the example of Renaissance writers including Vasari, Winckelmann promoted the practice of isolating individual artistic traditions for study. Enlightenment projects of classification and the emergence of the modern nation-state accelerated this trend toward specialization. It is not surprising that citizens of the United States, relatively new to the community of nations, would want to shed the country's image as a cultural outpost and that an author would emerge to create an American visual arts tradition.

Beginning in the colonial period, observers linked American art to the concept of

72. In the introduction to the *History*, Dunlap referred specifically to previous writings on the visual arts: "Of the many elements of art and science, which must combine to produce these almost miraculous effects, it is not our immediate province to speak; neither to give the history of the progress of painting and her sister arts in Europe. The writers before the public are many and good. We will mention a few, as the names are suggested to memory—Visari [sic], De Piles, Leonardo da Vinci, Albert Durer, Du Fresnoy, (with notes by Reynolds,) Winkleman [sic], Mengs, Reynolds, Opie, Fuseli, Pilkington's Dictionary . . . Shee and Burnet" (*History*, vol. 1, p. 12). In 2000 I took part in a session at the College Art Association annual meeting that analyzed, through the lens of writing genres, art literature produced during the nineteenth century. The diverse formats of art publications discussed—including artist manuals, national and international surveys of art, and catalogues raisonnés—as well as the emphasis of many papers on German imprints convinced me that existing studies of American art historiography have not accounted sufficiently for art writing in other areas of the world.

73. See Patricia Lee Rubin, *Giorgio Vasari: Art and History* (New Haven: Yale University Press, 1995). Rubin's account suggests that several parallels exist between Vasari's and Dunlap's histories—for example, their emphasis on master-student relationships and the fact that both books brought their surveys up to the present day.

74. Alex Potts, *Flesh and the Ideal: Winckelmann and the Origins of Art History* (New Haven: Yale University Press, 1994), esp. pp. 7–8.

translatio studii—the theory that the genius of art was continually moving west-ward—and predicted a leading future role for the "New World." Although Dunlap never described American art as the pinnacle of the history of art, he did present it as the heir to a long European tradition. Noting a general movement from "sav-agery" to "civilization" in the development of the visual arts, Dunlap explicitly placed American art within an unbroken chain reaching back to ancient Greece and distinguished it from the "rude efforts" of indigenous American peoples, Africans, or Polynesians.[75] According to Dunlap this legacy offered limitless possibilities for the contemporary artist. He summarized excitedly for the painter: "The Greeks taught us beauty and expression; modern art has added colour, chiara scuro, per-spective, composition—all by which distance, space, air, light, colour, transparency, solidity—may be brought before the eye on a flat surface. The painter knows no limits but time and place, and even the last has been burst by Raphael and by Tintoret."[76] Artists of all "civilized" regions were therefore not only working from a common standard of artistic greatness but also from a shared aim to continue build-ing upon the advances of their predecessors.

Dunlap laid claim not only to the visual legacy of western art but also to its accumulated theory. Throughout the text, he accepted many of the tenets that had been developed in European academies including the hierarchy of genres, the didac-tic function of art, and the secure place of painting, architecture, sculpture, and engraving within the liberal arts. Yet as the *History* and other contemporary Euro-pean writings reveal, a growing interest in individual national traditions began to challenge the neoclassical ideal of a timeless standard of art.[77] Although authors continued to produce universal art surveys, some historians and critics began to discern a connection between the decisions made in the creation of an artwork—

75. Dunlap, *History*, vol. 1, pp. 10–12. Dunlap explained the development as follows: "The progress of the arts of design is from those that are necessary to those that delight, ennoble, refine. Man first seeks shelter from the elements, and defense from savages of his own, or the brute kind. In his progress to that perfection destined for him, by his bountiful Creator, he feels the necessity of refinement and beauty" (p. 10).

76. Ibid., p. 12.

77. William Vaughan has demonstrated how the development of a British "school" of artists (including history painters—at the top of the academic hierarchy) was inextricably linked to the nation's identity ("The Englishness of British Art," *Oxford Art Journal* 13 [1990]: 11–23). Vaughan's study is of particular relevance to Dunlap's *History*, for Vaughan used published histories of British art, including Allan Cunning-ham's *Lives*, as the means to trace changing national conceptions of art production. It is worth noting that American efforts to define an art tradition followed quickly upon the heels of Great Britain's similar attempts during the second half of the eighteenth century. See also Alex D. Potts, "Political Attitudes and the Rise of Historicism in Art Theory," *Art History* 1 (June 1978): 191–213.

the design of visual elements or choices of subject matter, for example—and the distinctive character of the nation to which the artist belonged.[78] These criteria were put to use not only in the definition of the art of one's own nation, but also in making value judgments about the cultural productions of other nations.

Dunlap saw no anomaly in adopting the aesthetic values of the European art tradition while also suggesting that American art was unique. He believed, for example, that the visual arts had appeared in the United States with amazing rapidity, observing in the *History*, "However discursive I have been in this work, I have had but one object in view: to show the steps by which the arts that place the civilized man so far above the savage, not only in power, but enjoyment, have arisen in America, to a level with those of any community now in existence." Dunlap also predicted future glory for American art by adding that "to an attentive reader I have shown that they are not at a stand, but are on the way to a much higher state of excellence."[79]

Dunlap made it clear in the *History* that, because of the political conditions under which it would be created, American art could only improve. In the book's introduction, he compared the debased status of the artist in aristocratic England with the independent American artist. In a burst of republican sentiment he exulted:

> Happy! thrice happy country! where the lord, the prince, or the king, on touching your shores, becomes a man, if he possesses the requisites for one: or, if not, falls below the level of the men who surround him;—where the man of virtue and talents is the only acknowledged superior, and where the man possessing those requisites of an artist, needs no protector and acknowledges no patron. . . . The agriculturist, the mechanic, the sailor, the cartman, the sawyer, the chimney-sweeper, need no protectors. When they are wanted they are sought for—so should it be with the artist; at least let him be as independent as the last.[80]

Taken as a whole, the *History* suggested that it was not only desirable but possible to transplant selected values and practices of the European art tradition to the different political and social setting of the United States. Dunlap never resolved the tension between the implicit value of American exceptionalism on the one hand and a traditional academic allegiance to the past on the other, and the incompatibil-

78. See Vaughan, pp. 15–17, on the correlation between the English and the "naturalism" of their art.

79. Dunlap, *History*, vol. 2, pp. 465–66.

80. Ibid., vol. 1, pp. 16–17. According to Potts, "Central to the reputation Winckelmann enjoyed among the more politically radical artists and theorists was his eloquent formulation of the widely held view that 'freedom' was the 'principal cause of the pre-eminence of Greek art' " (*Flesh and the Ideal*, p. 225).

ity of these ideas would confront American artists throughout the nineteenth century.

The *History* discussed the specific conditions under which American artists worked as well as their relationship to the history of art. Since the lack of art education was one of the most pressing problems of the early American art community, the *History* took up the topic of the proper function and direction of American art academies. Given his role as one of the founders of New York's National Academy of Design and given that institution's continuing competition with the American Academy of the Fine Arts, it is not surprising that Dunlap would promote the National Academy's message and argue for its legitimacy. Thomas Cummings, the National Academy's first historian, recalled that the *History* "emanated in the Academy." He explained that such an account

> had often been suggested to Dunlap, but by him declined for want of means. In one of the conversations, the writer [Cummings] proposed a subscription for that purpose, drafted a heading, and at once set to work; and alone, caused the subscription to nearly double what Dunlap had named as the amount requisite to enable him to complete the work. The material for the work was found to be more than anticipated. John L. Morton [an Academy officer] took the subscription list, and nearly equaled the writer's efforts. The contemplated work grew in size, and it was proposed to extend it to two volumes.[81]

The National Academy was well rewarded for its early encouragement of Dunlap's project. For example, it was surely no accident that "arts of design" in the title of the *History* related directly to the most recent New York art institution. In addition, the roster of artists affiliated with the National Academy played a prominent role in the book. Although Dunlap provided extensive treatment of respected artists such as Washington Allston regardless of their affiliation with the National Academy (Allston never was a full academician), he gave disproportionate attention to contemporary artists of the second rank who were members or students of the Academy. In other words, an artist had a better chance of, first, being included in the *History*, and second, receiving more than a few sentences of biography, if he or she were connected to the Academy. Institutional affiliation was therefore one determining factor in the canon of American artists established by the *History*.

In order to cultivate an audience for the *History* among his artist-colleagues Dun-

81. Cummings, p. 131. Cummings's role as an early champion of the *History* is verified in "William Dunlap to Henry Inman," December 20, 1832, Gratz Collection, Historical Society of Pennsylvania, accessible through the Archives of American Art, Smithsonian Institution, roll P22, frame 145.

lap needed to convince them that they had a stake in the fate of their profession.[82] As Henry Sargent's reluctance to be included in Dunlap's account indicates, this was not always an easy task. The lines between artists and craftsmen and between gentlemen-amateurs and professional artists were not always clearly defined in the early nineteenth century, even in the minds of the practitioners. Once the *History* reached print, however, American artists' frame of reference changed irrevocably. They could dispute points of information within the book, but after 1834 they could not escape thinking of themselves as members of an American art tradition.

Dunlap constituted his fellow artists as one audience for the *History*, but the extracts and advertisements he submitted to New York serials clearly targeted a larger readership. Just as these newspapers and magazines had stimulated public interest in U.S. art, so too were they the means of the *History*'s promotion. Submitting paid advertisements to the leading New York serials to announce the *History*'s publication—he noted canvassing the offices of six such publications on one day— Dunlap also benefited from extensive free publicity in these serials.[83] For example, two months before its appearance, a brief notice in the New York *Evening Post* reported, "We are pleased to learn that Mr. Dunlap's work . . . is in a great state of forwardness, and will probably be published early in the next month," and promised that "the biographical notices of individuals who are or have been connected with the arts of design in this country, in any of their departments, will be numerous and replete with interesting particulars."[84] A brief editorial in the *New-York American* recommended the *History* to its readers and reminded them of the entertaining value found earlier in Dunlap's history of the American theater, with its "intermingling of narrative and fact, the biographical sketches, criticism, literary and dramatic anecdote, and amusing *gossip* of all kinds."[85] Dunlap employed two principal strategies to satisfy a nonprofessional audience: the text's appeal to nationalist sentiments and

82. This was also the principal aim of the National Academy of Design. Dell Upton has argued that the founding of such organizations as the National Academy and the American Institution of Architects (est. 1836) stemmed more from the members' desire to distinguish themselves within the marketplace than to enforce the standards of "high" art; see Upton, "Inventing the Metropolis: Civilization and Urbanity in Antebellum New York," in *Art and the Empire City: New York, 1825–1861*, ed. Catherine Hoover Voorsanger and John K. Howat (New York: Metropolitan Museum of Art/ New Haven: Yale University Press, 2000), p. 38.

83. Dunlap, *Diary*, p. 844. As noted in the previous chapter, the *New-York Mirror* printed the most extensive series of extracts from the *History*, but a number of the daily newspapers also excerpted the book in the weeks leading to its publication. For a sample, see New York *Evening Post*, November 14, 1834, n.p.; *Evening Star*, November 21, 1834, n.p.; and *American*, November 22 and November 27, 1834, n.p.

84. New York *Evening Post*, October 6, 1834, n.p.

85. *New-York American*, December 6, 1834, n.p.

its effort to balance the didactic and the diverting. To understand the book's poten-
tial interest for general readers, it is important to analyze the form in which Dunlap
framed his popular appeal. Just as references in the text to established conventions
of art writing connoted a particular meaning for those involved in the art world, the
echoes in the *History* of the literary genres of biography and fiction held a culturally
specific significance for American readers during the early nineteenth century.[86]

Invoking cultural nationalism was one long-standing technique for attracting an
American audience to the fine arts. Critics had praised many early American plays,
poems, or paintings solely because their creators were native-born. This strategy
was particularly effective during the heady years following the Revolution and the
War of 1812.[87] Pride in the United States acquired a retrospective cast in the 1830s;
and 1834 was also the year that the first volume of George Bancroft's pioneering
History of the United States of America appeared (the final installment would not be
published until 1874).[88] Though Dunlap did not express rabid patriotism in the
pages of the *History*, he did interject a number of nationalistic themes into the text
that would have resonated with readers.

The most obvious way Dunlap catered to American patriotism was by drawing
pointed contrasts between British and American society. Although he confirmed the
close links between the artistic traditions of the two nations and noted British

86. Novels and biographies were both expanding genres in the nineteenth-century publishing market,
and each was the subject of substantial contemporary critical debate. For the multiple roles played by
American biography during the period, see Scott E. Casper, *Constructing American Lives: Biography and
Culture in Nineteenth-Century America* (Chapel Hill: University of North Carolina Press, 1999). The Ameri-
can novel has been the focus of much scholarship; this research ranges from the novel's role in the so-called
reading revolution of the late eighteenth century, to its insights into the lives of contemporary women
readers, to its relationship to republican culture. Cathy N. Davidson provides an introduction to this
scholarship in *Revolution and the Word: The Rise of the Novel in America* (New York: Oxford University
Press, 1986). See also Michael Warner, *The Letters of the Republic: Publication and the Public Sphere in
Eighteenth-Century America* (Cambridge: Harvard University Press, 1990), esp. chap. 6, and Jane Tompkins,
Sensational Designs: The Cultural Work of American Fiction, 1790–1860 (New York: Oxford University Press,
1985).

87. Neil Harris, *The Artist in American Society: The Formative Years, 1790–1860* (New York: George
Braziller, 1966), pp. 15–25; Lillian B. Miller, *Patrons and Patriotism: The Encouragement of the Fine Arts in
the United States, 1790–1860* (Chicago: University of Chicago Press, 1966), pp. 8–11; and Kenneth Silver-
man, *A Cultural History of the American Revolution: Painting, Music, Literature, and the Theatre in the Colonies
and the United States from the Treaty of Paris to the Inauguration of George Washington, 1763–1789* (New
York: Thomas Y. Crowell, 1976), pp. 454–69. Silverman notes that in the years following the Revolution
many of the American artists being praised were living abroad.

88. Dunlap sent two letters to George Bancroft during the spring of 1835, expressing his admiration of
Bancroft's first volume and promising to send him a complimentary copy of his own *History*; see "William
Dunlap to George Bancroft," March 5, 1835, and April 27, 1835, George Bancroft papers (folder 1835/
January–April), Massachusetts Historical Society.

influences on American art practice and education, he also scattered asides through-
out the book enumerating the limitations of Great Britain as a cultural model.[89]
Most frequent were his criticisms of British patronage. Dunlap repeatedly deplored
the fact that although England was "the freest and best governed country in Eu-
rope," an artist there was still "considered as an appendage to my lord's tailor."[90]

Dunlap's definition of who would qualify as an American artist represented an-
other of his methods for identifying a national art tradition. One potential difficulty
was the number of foreign-born artists active in the United States. In the introduc-
tion Dunlap acknowledged that "in the commencement of our history as colonies,
every painter was from beyond [the] sea," and he promised his readers would find
a full account of the contributions of foreign artists.[91] He also quickly established,
however, a standard for labeling an artist "American." He remarked that "while
England claims our artists as her own, because thrown on her shores, or invited by
her liberality, we are content to call those only American, exclusively, who were
born or educated as artists within our boundaries."[92]

Dunlap did not really explain his criteria for authentic "American artist" status
further; rather, he presented his decisions to the reader as self-evident. For example,
he saw no need to elaborate on his statement that the painter John Wesley Jarvis
"was, like many of our artists who are strictly American, born in England."[93] Dunlap
did offer a glimpse of his reasoning in the profile of another English-born artist—
the miniaturist Thomas Cummings—when he wrote:

> It is a most happy circumstance for a country so liable to be flooded by emigrants, who
> are strangers to its constitution, laws, manners, and customs, that the children of these
> strangers, whose fathers are so apt to misunderstand us, all become Americans, even
> though they first drew breath in Europe. There may be some who imbibe prejudices
> from their parents . . . but generally every man bred in America is a democrat; learns to
> estimate worth by talent and virtue alone, and not by fortune or descent; and to see that
> the democratic system is not that which European sophists represent, a leveling by
> bringing down the few, but an equalizing, by lifting up the many.[94]

89. For Dunlap's condemnation of British mercantile policy, see *History*, vol. 1, p. 398.
90. Ibid., p. 14.
91. Ibid., p. 13. Though recognizing the role of foreign-born artists, Dunlap claimed that "no sooner did
native artists appear than their works exceeded in value immeasurably, the visiters [sic] who had preceded
them." He qualified this statement, however, by saying that it only applied to American painters, not to the
practitioners of other media (p. 13).
92. Ibid., pp. 13–14.
93. Ibid., vol. 2, p. 72.
94. Ibid., p. 400.

In this formulation, foreign-born artists, like other emigrants, could absorb those values that would later define their work as unequivocally American simply through their physical presence in the United States at an impressionable age. The most successful transplant in Dunlap's account was Thomas Cole. In a dramatic passage, Dunlap contended that "so strong is his desire to have a right to call that country his, which he feels *to be his*, that I have heard it said he has exclaimed, 'I would give my left hand to identify myself with this country, by being able to say I was born here.' This is strong language, yet it agrees with that enthusiasm, which marks his character."[95] With this disclaimer, Dunlap silenced any possible criticism of an English-born painter becoming the preeminent delineator of the American landscape.

American-born artists allowed Dunlap to indulge in unchecked paeans to the national environment. Throughout the *History*, he promoted his view of artists in the United States as independent producers equal to any other citizen. He highlighted the legitimacy of artists' republican credentials when he remarked that the painter Nathaniel Rogers "has the honour of springing from the same class of citizens that gave birth to Benjamin West, Joseph Wright, John Vanderlyn, Asher B. Durand, Alvan Fisher, Joseph Wood, Francis Alexander, William S. Mount, and a long list of artists; the yeomanry of the country, commonly called farmers, because they till the fields that support them; but in America, those fields are the property of the man who plows them, and their harvest *his alone*."[96] The *History* thus identifies a number of prominent artists as the literal descendants of the yeoman farmer of Jeffersonian theory. Through this association with the productive labor of the soil and all its attendant values, Dunlap could counter the deep-rooted American fear that artists existed solely to promote corruption and decadent luxury. Dunlap did not, however, pursue the implications of the fact that a number of these same

95. Ibid., p. 351.
96. Ibid., p. 251. This appeal, however, contradicted Dunlap's claim that artists' profession made them public figures of note: "Artists know their stand in society, and are now in consequence of that conduct which flows from their knowledge of the dignity and importance of art, looked up to by the best in the land, instead of being looked down upon by those whose merits will only be recorded in their bank books" (ibid., vol. 1, p. 429). Francis Alexander certainly recognized that some distinction was necessary (or inevitable) in the autobiographical account he gave to Dunlap. Alexander had worked as both a farmer and an artist, and he dryly observed, "When I was a farmer, I used to go three miles before sunrise to reap for a bushel of rye per day, and return at night. Oh! had you seen me then, winding my way to my labours, shoeless, and clad in trowsers and shirt of *tow*, with my sickle on my shoulder! as you are a painter, you might have given me a few cents to sit for my picture, but you would not have taken any notes for biography" (ibid., vol. 2, p. 433).

farm-raised American artists sought training and recognition in Europe. Through-
out the *History* Dunlap sidestepped similar ambiguities as he defined an American
art tradition. He probably did not grapple openly with the question of European
influence because he was more interested in allying his subjects with the larger
western art tradition than in discovering intrinsically American characteristics in
their work.

During the 1830s two publications forged a link between the biographical and
the patriotic in the popular imagination: James Herring and James B. Longacre's *The
National Portrait Gallery of Distinguished Americans* (4 vols., 1834–39) and Jared
Sparks's *The Library of American Biography* (25 vols., 1834–48). These works ap-
peared to transcend local attachments by creating a pantheon of national heroes,
many of whom had been distinguished officers during the War for Independence or
the War of 1812.[97] Though the *History*'s biographical format can be seen as the
legacy of Vasari's *Lives*, it also provides a parallel to these multi-volume collections.
Dunlap could claim a heroic public role for American artists simply by virtue of the
association in readers' minds between the biographical sketch and the eminent
citizen. The historicizing mood indicated by the constellation of publications ap-
pearing during the 1830s—including both of Dunlap's cultural histories—suggests
a widespread need for national self-definition. In an era marked by political faction-
alism, economic uncertainty, and sharpened class distinctions, they can be seen as
responses to a collective longing for American unity.[98]

The moral judgments in the *History* are as important a key to the book's potential
attraction for a popular audience as its nationalism. That Dunlap encouraged public
interest in artists' private conduct is clear from a letter to the editor of the *New-York
Mirror* promoting the *History*. He explained, "Biography admits of anecdote and
gossip, and I believe the public love anecdote and gossip—*that I do*, I am quite
certain."[99] Following apologists for the revelatory mode of biography, however,

97. Scott Casper has argued that republican sentiments underlay such biographical collections: "Collec-
tive biographies (and their visual analogues, portrait pantheons) implied that founding a republic required
a group of men devoted to a common good larger than themselves, not just an individual" (Casper, p. 40).
For his extensive analysis of Jared Sparks, including a discussion of the pronounced regional bias of the
first installment of *The Library of American Biography* and the subsequent broadening of the series' focus,
see chap. 3, esp. pp. 135–53.

98. For a summary of scholarship on the Jacksonian era, seen through the lens of its leading landscape
painter, see Christine Stansell and Sean Wilentz, "Cole's America: An Introduction," in *Thomas Cole: Land-
scape into History*, ed. William H. Truettner and Alan Wallach (New Haven: Yale University Press/ Wash-
ington, D.C.: National Museum of American Art, Smithsonian Institution, 1994), pp. 2–21.

99. William Dunlap, "To the Editors of the *New-York Mirror*," *New-York Mirror*, February 1, 1834,
p. 248. The American biography that best exemplifies the trend toward a greater emphasis on personal

Dunlap presented his exposés of his subjects' personal lives in the *History* as a legitimate method of public education. He believed that a moral example could be made not only by recounting the praiseworthy deeds of individuals, but by exposing their weaknesses as conduct to be avoided. This moralizing current also connects Dunlap's approach to the familiar plot trajectories of early American plays and novels. His experience writing and producing for the New York stage in the years around 1800 and his knowledge of European melodrama helped form Dunlap's narrative sensibility.[100] Like dramatic and literary audiences, readers of the *History* could be titillated by unseemly conduct while being secure in its ultimate condemnation.

While Dunlap held up the lives of such artists as Thomas Sully and Thomas Cole as models for emulation, he enumerated the frailties of other artists, including himself, in some detail. He chronicled vices ranging from professional dishonesty and drunkenness to licentiousness and greed, yet he rarely presented his erring subjects as irrevocably evil or beyond reform. For example, after commenting sadly on John Wesley Jarvis's tendency to waste his talents through drink and high living, Dunlap observed: "Mr. Jarvis has often and habitually shown his care for, and love of his fellow creatures; he now knows that it is man's duty to care for his own prosperity—to love himself, that the love to his neighbour may be efficient. To preserve the gifts bestowed upon us is a duty, which if not performed, brings repentance."[101] Dunlap's tone is more one of a sorrowing father than an inflexible judge.

Ironically, Dunlap's willingness to humanize his subjects undercut his simultaneous efforts to build a professional identity for them. How could artists be just like every other citizen of the United States *and* have talents that made them distinguishable from their compatriots? This contradiction underscores the impact that market considerations had on the *History*. In his attempt to broaden the book's audience, Dunlap needed to satisfy the interests of a diverse readership. The fact that he attempted to promote professional goals through popular channels also reveals a realignment of the methods of cultural construction during the early republic.

details is Mason Locke (Parson) Weems's *History of the Life, Death, Virtues and Exploits of George Washington* (1800).

 100. See David Grimsted, *Melodrama Unveiled: American Theater and Culture, 1800–1850* (Chicago: University of Chicago Press, 1968), chap. 1.

 101. Dunlap, *History*, vol. 2, p. 82.

FOUR

The Creation of History: The Profiles
of Benjamin West and John Trumbull

It was not until after Mr. Trumbull's final return to the United States in 1816, that I had the most distant notion that he could feel enmity to his former teacher. . . . Whether it was expected that West should ascend to heaven before his time to accommodate his grateful protegée [*sic*], I know not; but I do know . . . other pupils had arisen, much more able to sustain the 'mantle,' when he should be called from the cold world where his old age needed it.

William Dunlap, "John Trumbull," *History* (1834)

One of the most striking aspects of William Dunlap's *History of the Rise and Progress of the Arts of Design in the United States* is the disparate treatment accorded the two painters who dominate the book: Benjamin West (1738–1820) and John Trumbull (1756–1843). West may be considered the hero of the *History*, and Trumbull is undoubtedly the villain. Dunlap's assignment of these polarized roles is puzzling on reflection, for although West shepherded the careers of American artists who sought his advice in London for more than fifty years, he never returned to his native country after his departure for study in Europe in 1760. In fact, he became a permanent fixture of the British art establishment, serving as court painter to that archenemy of America, George III, and rising to the presidency of the Royal Academy. Moreover, it was Trumbull who brought the grand tradition of history painting back to the United States after studying with West. His legacy to American art would seem to be beyond reproach: he recorded the heroes of the American Revolution for posterity, thereby winning the most important art commission of the first quarter of the nineteenth century—the decoration of four panels of the Rotunda at the U.S. Capitol Building (figures 7–10). Why would Dunlap disparage the most prominent artist of the period in a book that purported to celebrate the successes of an Ameri-

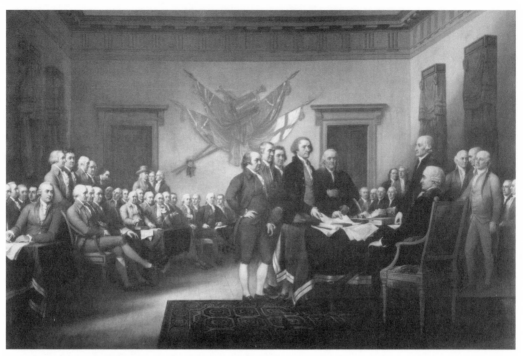

FIGURE 7. John Trumbull, *The Declaration of Independence, 4 July 1776*, completed 1818. Oil on canvas, 144 × 216 in. U.S. Capitol Rotunda. Architect of the Capitol.

FIGURE 8. John Trumbull, *The Surrender of Lord Cornwallis at Yorktown, 19 October 1781*, completed 1820. Oil on canvas, 144 × 216 in. U.S. Capitol Rotunda. Architect of the Capitol.

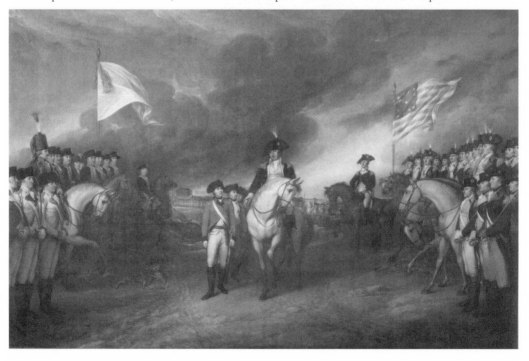

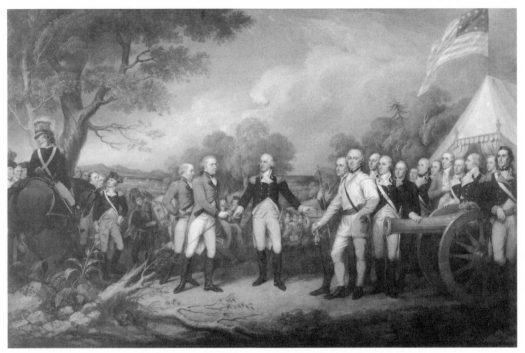

FIGURE 9. John Trumbull, *The Surrender of General Burgoyne at Saratoga, 16 October 1777*, completed 1821. Oil on canvas, 144 × 216 in. U.S. Capitol Rotunda. Architect of the Capitol.

FIGURE 10. John Trumbull, *The Resignation of General Washington, 23 December 1783*, completed 1824. Oil on canvas, 144 × 216 in. U.S. Capitol Rotunda. Architect of the Capitol.

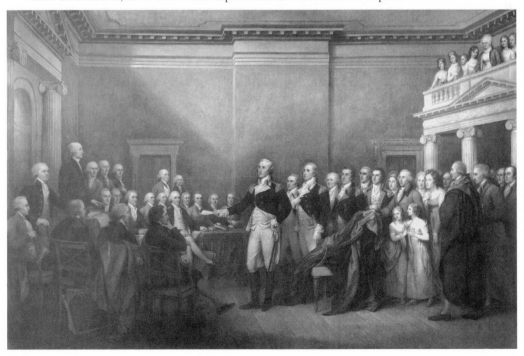

can art tradition while deeming West, who had been dead for more than a decade, worthy of continued emulation? The enhancement of West's virtues and exaggerations of Trumbull's faults only begin to make sense when considered in the light of contemporary disputes over the nature and exercise of cultural authority. In these two profiles Dunlap was supporting a radical redefinition of authority within the visual arts—carving out a place for American art within the canonical western tradition, rejecting the elevated status of the traditional art patron, and advocating the establishment of professional authority through artist-run institutions. Many of these issues surfaced in the war between the National Academy of Design and the American Academy of the Fine Arts, which provided an immediate impetus for Dunlap's criticisms of Trumbull and his enshrinement of West. As the long-time president of the American Academy, Trumbull provided an inviting target for a partisan account like Dunlap's. West, in turn, offered a suitably distant foil for Trumbull.

In establishing a narrative tension between the biographies of West and Trumbull, the *History* also rehearsed larger debates about the exercise of social and political authority in early America. Jay Fliegelman has suggested that the shift in familial relations found in eighteenth-century Anglo-American literature provides a telling metaphor for the wide-ranging social transformations occasioned by the American Revolution; in his account, individuals during this period learned to reject patriarchal authority in all its guises in favor of relationships built on voluntary affection and shared responsibilities.[1] The West and Trumbull biographies can be read against this earlier shift; unlike the tyrannical Trumbull, who lords himself over aspiring artists in the pages of the *History*, West appears as the epitome of the new, enlightened leader. This portrait of West anticipates Fliegelman's description of the revised model of authority: "The new understanding of greatness as goodness reflected an essential theme of the antipatriarchal revolution that would replace patriarch with benefactor, precept with example, the authority of position with the authority of character, deference and dependence with moral self-sufficiency, and static dichotomies with principles of growth."[2] Given Dunlap's propensity to see history in personal and dramatic terms it is unsurprising that from the outset of their biographies he constructed the figures of West and Trumbull according to

1. Jay Fliegelman, *Prodigals and Pilgrims: The American Revolution against Patriarchal Authority, 1750–1800* (Cambridge: Cambridge University Press, 1982). As part of his literary evidence, Fliegelman analyzed two of Dunlap's plays (see pp. 216–21).

2. Ibid., p. 210.

these competing models of leadership. Dunlap proclaimed proudly of West: "His virtues and his talents have shed a lustre around his name, and we view him by a light radiating from himself. His influence on the art he professed will never cease."[3] Trumbull received the following curt introduction: "This painter was emphatically well-born; and we shall see that he reaped, as is generally the case, through life, the advantages resulting from the accident."[4] These brief statements are a fair sample of the portraits that emerge from the profiles—West earns the devoted respect of his contemporaries through his superior virtue while Trumbull inherits his elevated social position. Dunlap fleshed out this contrast for his readers by demonstrating how each man's artistic practice and professional behavior reflected his personal code of conduct.

West as Hero

Although Dunlap vowed in his profile of Benjamin West that he would not take the same liberties with his subject's life as had West's principal biographer John Galt, he proceeded to create his own hagiography.[5] West emerges in the *History* as an artist who quickly attracted both patronage and the esteem of his profession. Dunlap was in awe of West's rise to fame, acknowledging at one point, "It is not always that talents, when backed by good conduct, produce such effects upon mankind." He continued:

> Talents ever command admiration, and good conduct solicits good will. But both or either may be obscured by circumstances. They may exist separately, and not be deserving of friendship. They may be united, and their effect destroyed by personal defect in the possessor, timidity, false shame, false pride or excessive sensitiveness—and as far as these defects have influence, the effects of good conduct are weakened, obscured or

3. Dunlap, *History*, vol. 1, p. 33.

4. Ibid., p. 340. Compare this with: "Benjamin West, although born in humble life, was essentially *well-born*; though not of parents who by riches or station could insure, or even promote his views of ambition" (ibid., p. 36).

5. For Dunlap's summary of these inaccuracies, see *History*, vol. 1, pp. 34–35. Dunlap shared his distrust of Galt's *The Life, Studies, and Works of Benjamin West, Esq.* (1820) with Allan Cunningham, another source for the *History*. Cunningham ridiculed the many portents Galt found in West's life, writing, "West cannot be born, nor choose his profession, nor enjoy himself in a coffee-house, nor travel through France without the influence or the accompaniment of prediction" (Cunningham, *The Lives of the Most Eminent British Painters and Sculptors*, vol. 2 [New York: Harper & Brothers, 1835], p. 27). Despite their disclaimers, however, both Cunningham and Dunlap relied heavily on Galt's account. For two modern assessments of Galt as a biographer, see Robert C. Alberts, *Benjamin West: A Biography* (Boston: Houghton Mifflin, 1978), app. 1, pp. 409–12, and Ann Uhry Abrams, *The Valiant Hero: Benjamin West and Grand-Style History Painting* (Washington, D.C.: Smithsonian Institution Press, 1985), chap. 2.

destroyed. West had talents, virtue, youth, beauty, and prudence. He appears to have possessed no quality to counteract their influence, and circumstances independent of his own good qualities seemed uniformly to favour his progress.[6]

In Dunlap's account, this marriage of an admirable character, artistic genius, and good fortune resulted in West's many successes—his conquest of the Roman art world, his ability to secure the patronage of the British monarch, and the public acclaim he garnered for his large-scale religious paintings.

The analysis in the *History* of one of West's most famous paintings—*The Death of General Wolfe*, 1770 (figure 11)—demonstrates Dunlap's implicit equation of West's moral soundness with his artistic choices. Dunlap anticipated many subsequent historians when he credited West with introducing, to the art world, with this painting, "a new species of historical composition—an heroic action or subject in modern costume."[7] After depicting a number of subjects from ancient history during the 1760s, West shifted his focus to commemorate a decisive battle from the French and Indian War that had occurred outside the city walls of Quebec in 1759. In his painting, West depicted the leader of the British forces, Major-General James Wolfe, expiring at the very moment that a messenger brings news of his army's victory over the French. Although the *Death of Wolfe* eventually received both critical and popular praise, early objections to it have become the stuff of art historical legend. According to West's biographers, both King George III and the president of the Royal Academy, Joshua Reynolds, expressed doubts about the propriety of showing Wolfe and his entourage in contemporary costume. During the planning stages of the painting Reynolds in fact suggested that the figures be clothed in classical dress. In the *History* Dunlap recorded West's famous response: " 'I answered, that the

6. Dunlap, *History*, vol. 1, pp. 52–53. The wistful note that Dunlap strikes here may have been caused by thoughts of his own career. Dunlap did acknowledge that West had some weaknesses; for example he believed that West's American works were not very skilled (vol. 1, p. 50) and that West was inferior to Joshua Reynolds and John Singleton Copley as a portraitist (p. 65). He also recorded Gilbert Stuart's irreverent criticisms of West's artistic abilities (pp. 178–80 and 185).

7. Ibid., p. 357. A vast amount of scholarly literature has been devoted to determining how innovative West's *Wolfe* really was. For an introduction to the debate, see Edgar Wind, "The Revolution of History Painting," *Journal of the Warburg and Courtauld Institutes* 2 (1938–39): 116–27; Charles Mitchell, "Benjamin West's 'Death of General Wolfe' and the Popular History Piece," *Journal of the Warburg and Courtauld Institutes* 7 (1944): 20–33 [with Edgar Wind's response, "Penny, West, and the 'Death of Wolfe,' " *Journal of the Warburg and Courtauld Institutes* 10 (1947): 159–62]; Abrams, *The Valiant Hero*, chap. 8; Helmut von Erffa and Allen Staley, *The Paintings of Benjamin West* (New Haven: Yale University Press, 1986), chap. 4 and entry 93; Werner Busch, "Copley, West, and the Tradition of European High Art," in *American Icons: Transatlantic Perspectives on Eighteenth-Century American Art*, ed. Thomas W. Gaehtgens and Heinz Ickstadt (Santa Monica, Calif.: Getty Center for the History of Art and the Humanities, 1992), pp. 35–59; and Alan D. McNairn, "Benjamin West and the Death of General Wolfe," *Antiques* 150 (November 1996): 678–85.

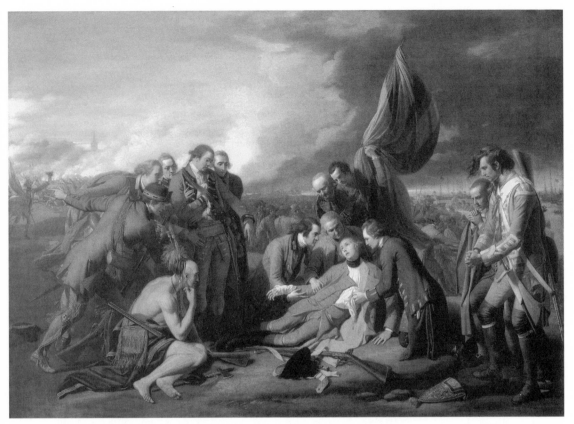

FIGURE 11. Benjamin West, *The Death of General Wolfe*, 1770. Oil on canvas, 152.6 × 214.5 cm. National Gallery of Canada, Ottawa. Transfer from the Canadian War Memorials, 1921 (Gift of the Second Duke of Westminster, Eaton Hall, Cheshire, 1918).

event to be commemorated happened in the year 1758 [*sic*], in a region of the world unknown to Greeks and Romans, and at a period of time when no warriors who wore such costume existed. The subject I have to represent is a great battle fought and won, and the same truth which gives law to the historian should rule the painter. If instead of the facts of the action I introduce fictions, how shall I be understood by posterity?' "[8] After seeing the finished painting Reynolds reportedly was forced to recant his objection and acknowledge that West's painting would "occasion a revolution in art."[9] Through this recounted tale Dunlap suggested that

8. Dunlap, *History*, vol. 1, p. 63. Both Galt and Cunningham give the wrong date for the battle in their profiles of West. Alberts provides a concise summary of the debate over contemporary dress in his appendix 2, pp. 413–16.

9. Dunlap, *History*, vol. 1, p. 63. Although Reynolds was supposed to have accepted West's use of contemporary costume, Edgar Wind noted that Reynolds continued to condemn the practice in his fourth *Discourse* of 1771; see "Penny, West, and the 'Death of Wolfe,' " pp. 159–60.

it was West's innate honesty that led him to engineer an influential redefinition of the venerable genre of history painting.[10]

According to the *History*, West's character led him not only to depict the famous battle in a historically appropriate way but also to select a subject of seminal importance for American history. Despite its relatively recent occurrence, the "victory gained by Wolfe, annihilated the power of France on this continent, and established reformed religion, English language arts and literature, and more than English liberty from Mexico to the North pole, and from the Atlantic to the Pacific."[11] Dunlap argued that West had characteristically hit upon one of "the very best subjects for the historical painter" by recording an event "which has produced incalculable good to the human race."[12] It certainly did not hurt West's cause in the *History* that the painter chose to depict a military victory that, in Dunlap's view, had helped to foster the collective identity that would make an independent American republic possible.

In addition to West's concern with historical accuracy, the *History* highlighted the seriousness with which he took his responsibilities to his fellow artists. As the first American-born artist to seek instruction in Europe and to establish an international reputation, West reached a level of professional success that other American artists could only dream about. In Dunlap's account, West used his position to benefit others by opening up his studio to a succession of his compatriots, beginning with his cousin by marriage, Matthew Pratt, who arrived in 1764.[13] When staying in London, visiting artists could reap the cosmopolitan advantages of living in a metropolis while receiving practical instruction from West. In addition, as Annette Blaugrund has pointed out, the physical circumstances of West's studio had a for-

10. Both West's and Trumbull's paintings of contemporary history had an impact beyond the confines of Great Britain and the United States. Engravings after their paintings and Trumbull's extensive European travel helped introduce these works to a Continental audience. For an introduction to American history painting, see William H. Gerdts and Mark Thistlethwaite, *Grand Illusions: History Painting in America* (Fort Worth, Tex.: Amon Carter Museum, 1988); William Ayres, ed., *Picturing History: American Painting, 1770–1930* (New York: Rizzoli in association with Fraunces Tavern Museum, New York, 1993); and Patricia M. Burnham and Lucretia Hoover Giese, eds., *Redefining American History Painting* (Cambridge: Cambridge University Press, 1995).

11. Dunlap, *History*, vol. 1, p. 43.

12. Ibid., p. 92.

13. The best source for West's impact as a teacher is Dorinda Evans, *Benjamin West and His American Students* (Washington, D.C.: Smithsonian Institution Press, 1980). Additional information can be found in the series of travel guidelines West drew up for a young German artist whom George III had taken under his wing. Franziska Forster-Hahn reproduces this document as an appendix to her article "The Sources of True Taste: Benjamin West's Instructions to a Young Painter for His Studies in Italy," *Journal of the Warburg and Courtauld Institutes* 30 (1967): 367–82. Very little is known about West's English students; see Alberts, p. 167, for some speculations.

mative influence on American artists.[14] She notes that while most colonial artists worked in their patrons' houses or in rented rooms, West set the standard of creating an independent working space.

By scattering throughout the *History* tributes to West from his students and colleagues, Dunlap constructed eloquent testimony of West's influence as an artistic mentor. The *History* documents that American artists typically sought reassurance from West once they arrived in London. After marveling that West had "condescended to walk a mile to pay me a visit," Edward Malbone proudly informed a correspondent that West had predicted that "I must not look forward to any thing short of the highest excellence."[15] West's generous manner lingered in the minds of those American artists with whom he came in contact. Years after his return to the United States, Washington Allston recalled of West: "I shall never forget his benevolent smile when he took me by the hand; it is still fresh in my memory, linked with the last of like kind which accompanied the farewell shake of the hand when I took leave of him in 1818."[16] The book records a variety of other services performed by West: he encouraged the talent of Gilbert Stuart while indulging his flamboyant behavior, arranged housing for Robert Fulton in London, and allowed Thomas Sully to copy works from his personal collection in order to honor his commitment to his American patrons. West also obtained George III's promise that John Trumbull would not be executed when he was imprisoned for suspicion of espionage, and he paid half his bail, making Trumbull's subsequent quarrel with his mentor, hinted at in the epigraph to this chapter, all the more incongruous.[17] Summarizing West's influence, Dunlap wrote, "It is curious to observe how uniformly his American pupils speak of him as a friend, a brother, or a father to them."[18] In the *History*,

14. Annette Blaugrund, "The Evolution of American Artists' Studios, 1740–1860," *Antiques* 141 (January 1992): 214–25.

15. Dunlap, *History*, vol. 2, p. 18. Dorinda Evans has written, "West developed a kind of magnetic power because of his belief in his own success. In his enthusiasm, he told his aspirants from abroad what they were starved to hear: that the profession was a noble one, fit for kings; and he 'conceived of painting as a mechanical or scientific process' which to a large degree, could be taught to nearly anyone" (p. 22).

16. Dunlap, *History*, vol. 1, p. 79.

17. West and Trumbull had some kind of falling out during the latter's stay abroad of 1808–15. According to Dunlap, Trumbull accused his former teacher of sabotaging his plans to exhibit a panorama of Niagara Falls in London (see *History*, vol. 1, pp. 372–74). West biographer Robert Alberts notes that *The Diary of Joseph Farington* confirms Dunlap's account of this incident; see Alberts, p. 354. Despite this strain on their relationship, West and Trumbull remained correspondents after Trumbull's return to the United States in 1815.

18. Dunlap, *History*, vol. 1, note, p. 99. Joseph J. Ellis discusses the significance of father figures— including Benjamin West—in Dunlap's life in *After the Revolution: Profiles of Early American Culture* (New York: W. W. Norton, 1979), pp. 119–23.

artists respond to West's gentle authority—representative of the new model of lead-
ership—with a particularly warm strain of filiopietism.

As Dunlap realized, Benjamin West served an unprecedented symbolic function
within American culture. As a native-born artist he provided an example of indige-
nous talent, and as an international figure he connected his fellow artists to a larger
art tradition. A combination of colonial pride and the artist's own efforts prevented
West from fading to a distant memory in his homeland. Americans tracked his
meteoric rise in the ranks of the artistic profession both in Rome and in his adopted
home of London. Even on the eve of the Revolution, they heralded the success
that West and his fellow emigrant John Singleton Copley were enjoying in Great
Britain. This phenomenon reveals both Americans' continued dependence on En-
gland for cultural validation and the fortuitous timing of West's departure. Unlike
John Trumbull, who made his first trip abroad during the Revolution, West bene-
fited on both sides of the Atlantic from having traveled to Europe and established
his reputation before hostilities began. Although West's position in London became
delicate after the United States declared its independence, he was able to let his
sympathy for the American cause be known while still retaining George III's
support.[19]

One measure of West's continued influence is the extent to which his authority
was invoked in the United States. Students returning from Europe readily capital-
ized on their association with the painter; Abraham Delanoy was the first American
artist to advertise himself specifically as a student of West.[20] West's former pupils
attempted to replicate his success by imitating his subjects, his practice of executing
prints after his works, and his use of independent exhibitions. West also became a
useful symbol of legitimacy for American art institutions. During the early nine-
teenth century, Philadelphia's Pennsylvania Academy of the Fine Arts and New
York's American Academy of the Fine Arts competed for the artist's imprimatur. In
1807, Robert Fulton, who had studied briefly with West in London, lent several
paintings by West from his personal collection to the Pennsylvania Academy,
thereby renewing a long association between the painter and Philadelphia.[21] After

19. See Allen Staley, *Benjamin West: American Painter at the English Court* (Baltimore, Md.: Baltimore
Museum of Art, 1989), pp. 85–87.

20. Alberts, p. 76.

21. Carrie Rebora, "Robert Fulton's Art Collection," *American Art Journal* 22 (1990): 40–63. Fulton tried
to interest the Pennsylvania Academy in purchasing works directly from West in both 1807 and 1810
(pp. 53–54 and 59–60).

Fulton's death in 1815, his widow transferred these works to the American Academy where they became staples of its annual exhibitions.[22] Two years later, the American Academy, under the leadership of John Trumbull, consolidated its connection to West by commissioning a portrait of him from the acclaimed British portraitist Thomas Lawrence (figure 12).[23] In 1835 the Pennsylvania Academy countered by purchasing West's large-scale version of *Death on the Pale Horse*, 1817 (figure 13).[24]

A close reading of the *History* reveals that Dunlap similarly required West as a legitimizing force in his account of American art. In fact, he constructed an entire national art tradition around the painter.[25] If the American artistic past had previously seemed provincial, fragmentary, and directionless, Dunlap identified a clear line of succession by emphasizing the links between West and his students. West's eminent status within the British art establishment also cemented the connection between American artists and the western visual tradition. Years before Dunlap embarked on the *History*, he considered West the founding father of American art. His diary of April 1820 contains the draft of an impassioned tribute to West, commemorating the painter's recent death, that Dunlap apparently planned to submit to a local newspaper.[26] He began his letter to an unidentified editor by writing: "In addressing a few lines to you on the subject of B[enjamin] West, I feel that it must be acceptable to the people of this great & growing Empire to peruse a tribute to the memory of their illustrious countryman, and a

22. A number of paintings by West from Fulton's collection remained at the American Academy until they were sold at auction in 1828 to pay his estate's debts (ibid., pp. 60–61).

23. For the history of this portrait, see Carrie Rebora, "Sir Thomas Lawrence's *Benjamin West* for the American Academy of the Fine Arts," *American Art Journal* 21 (1989): 18–47.

24. Allen Staley provides a summary of West's ties to Pennsylvania in his catalogue essay for *Benjamin West in Pennsylvania Collections* (Philadelphia: Philadelphia Museum of Art, 1986). When the Pennsylvania Academy purchased *Death on the Pale Horse* from Raphael West in 1835, Philadelphia was already the home of one of West's large-scale religious paintings. In 1800, the Pennsylvania Hospital had requested a painting from West for the hospital's new building; he agreed and, after much delay, *Christ Healing the Sick* (1815, Pennsylvania Hospital) arrived in Philadelphia in 1817. Dunlap, for one, expressed disappointment when he visited the painting in 1819. In the privacy of his diary he wrote, "The figure of Christ positively had no grace, no expression. The hand very fine. Composition improved as I look'd on, but the principal figure if Christ can be called the principal remained bad" (*Diary*, p. 474). For more information on *Christ Healing the Sick* and *Death on the Pale Horse*, see von Erffa and Staley, entries 338 and 401.

25. American scholars still make a point of linking West to the United States. For example, Allen Staley concluded the West catalogue raisonné (*The Paintings of Benjamin West*) by noting that three of West's major religious paintings ended up in Philadelphia, thereby "reuniting the great works that terminated West's career in the city where it had begun" (von Erffa and Staley, p. 152).

26. Dunlap, *Diary*, pp. 542–43. Immediately preceding this tribute is another passage criticizing the American Academy of the Fine Arts for not marking West's death in a fitting manner (p. 541).

FIGURE 12.
Thomas Lawrence,
Benjamin West, 1820–21.
Oil on canvas,
107 × 69 ½ in.
Wadsworth Atheneum,
Hartford, Conn.
Purchased by
Subscription.

few notices respecting him & some of his many pupils, recalled to my mind by the event of his death." After noting West's professional generosity, Dunlap described his impact on American art: "To the fame of his great success must be attributed that predilection of which so many of our American youth have shewn for the art of painting and to his benevolent liberality the astonishing efforts made by American genius in this sublime branch of the Fine Arts."[27] Dunlap

27. Ibid., p. 542.

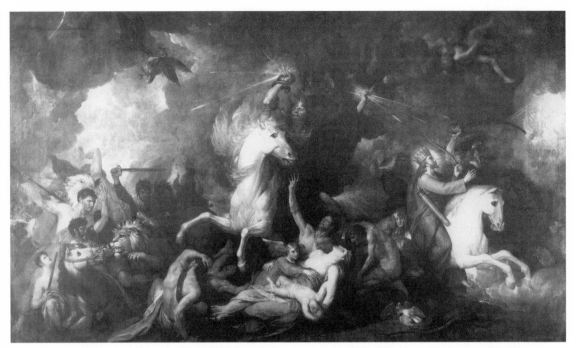

FIGURE 13. Benjamin West, *Death on the Pale Horse*, 1817. Oil on canvas, 176 × 301 in. Courtesy of the Pennsylvania Academy of the Fine Arts, Philadelphia. Pennsylvania Academy Purchase.

mentioned several of West's pupils by name in this draft, and he identified Washington Allston as West's anointed successor.[28]

Absent from the *History* is a discussion of the many ways in which West himself benefited professionally from his American background. Throughout his career West cultivated his image as a painter from the provincial outpost of Pennsylvania to great advantage, cleverly positioning himself as an innocent outsider while penetrating the inner circles of European art. For example, in Rome he first shocked and then impressed the art cognoscenti by comparing the famed ancient sculpture, the Apollo Belvedere, to a Mohawk warrior. Later, he authorized his biographer John Galt to emphasize his ties to the Quaker religion despite the fact, as Dunlap pointed out in the *History*, that he did not live as a Quaker in London.[29] West also maintained direct connections to fellow Americans after his departure. Having first

28. Ibid., p. 543. Dunlap compiled a preliminary list of West's students, noting their names on the inside cover of the 1820 diary. The names follow a rough chronology of the artists' arrival in London: "Stewart, Wright, Trumbull, Mather Brown, Peale, Earle, Dunlap, Fulton, Malbone, Sergeant, R. Peale, Waldo, King, Sully, Leslie, Alston, Morse, Newton" (ibid.).

29. Dunlap, *History*, vol. 1, pp. 71–74.

secured the assistance of several well-placed Philadelphians who helped him travel to Italy in 1760, West continued to receive the patronage of his compatriots even after he settled in England.[30] Allen Staley has documented that many of West's early portrait commissions in London came from Americans traveling abroad or from Englishmen with ties to the colonies.[31] Reinforcing his American origins and distinguishing himself from artist competitors, West set two ambitious paintings from the 1770s—the *Death of General Wolfe* and *Penn's Treaty with the Indians*, 1771–72 (figure 14)—in the New World.[32] He also contemplated undertaking a series of works commemorating the American Revolution before turning the project over to John Trumbull when he feared it might jeopardize his standing with George III.[33]

West's two sons also turned to U.S. audiences when trying to ensure their father's artistic legacy after his death. Because the British art market was currently saturated with West's works, Benjamin West Jr. arranged for his father's painting *Christ Rejected*, 1814 (figure 15), to tour the United States in 1829.[34] Following a disappointing auction of the contents of their father's studio in 1826, West's sons attempted to interest the Pennsylvania Academy in purchasing a group of West's paintings, resulting in the aforementioned purchase of *Death on the Pale Horse* in 1835. In addition to approaching the Pennsylvania Academy, West's sons wrote to the U.S. Congress suggesting that the federal government purchase their father's estate as the basis of a national art collection. After summarizing West's professional career, they argued:

> In Europe, almost every where is to be seen what is generally denominated a National Gallery, composed of pictures and statues by the old masters: the honor of having produced them belonging to Italy and Greece, no country ever yet had such an oppor-

30. West's American patrons included William Allen, the chief justice of Pennsylvania, and James Hamilton, the lieutenant governor. For correspondence between West and Allen, see E. P. Richardson, "West's Voyage to Italy, 1760, and William Allen," *Pennsylvania Magazine of History and Biography* 102 (January 1978): 3–26.

31. Von Erffa and Staley, pp. 24–27.

32. See Ann Uhry Abrams, "Benjamin West's Documentation of Colonial History: *William Penn's Treaty with the Indians*," *Art Bulletin* 64 (March 1982): 59–75; von Erffa and Staley, entry 85; and Anne Cannon Palumbo, "Averting 'Present Commotions': History as Politics in *Penn's Treaty*," *American Art* 9 (Fall 1995): 29–55.

33. See Jules David Prown, "John Trumbull as History Painter," in Helen A. Cooper et al., *John Trumbull: The Hand and Spirit of a Painter* (New Haven: Yale University Art Gallery, 1982), pp. 28–31. Prown notes that West's unfinished painting *American Commissioners of the Preliminary Peace Negotiations with Great Britain*, c. 1783 (Henry Francis du Pont Winterthur Museum), was the only work he initiated for this proposed series.

34. See Charles Coleman Sellers, "The Pale Horse on the Road," *Antiques* 65 (May 1954): 385. *Christ Rejected* did not enter the Pennsylvania Academy's collection until 1878.

tunity of commencing a truly National Gallery as now presents itself to the United States of America; for none of the nations of the old world, at such an early period of their histories, ever had an artist who stood so distinguished in the eyes of the world, or that had produced so numerous and so diversified a body of celebrated works as Benjamin West.[35]

According to West's sons, their father's bond with his native country was indissoluble; William Dunlap reached similar conclusions, but for his own purposes.

Trumbull as Villain

Dunlap's praise of Benjamin West in the *History* has an abstract, distant quality, but his criticisms of John Trumbull fairly crackle with animosity. This contrast serves as a reminder that whereas Dunlap had only a brief acquaintance with West from the three years he spent in London, he had many opportunities to observe Trumbull from close range. A comparison of Dunlap's and Trumbull's biographies reveals that their lives intersected on several occasions—as fellow art students in West's London studio during the 1780s, as competing painters in the constricted art market of the early nineteenth century, and as advocates for rival New York art institutions during the 1820s and 1830s.[36] Personal and professional envy on Dunlap's part could be partly responsible for his disparaging profile of Trumbull, but he also used the painter's biography to frame contemporary debates over the future of the artistic profession in the United States.

As with his treatment of West, Dunlap proceeded from the assumption that Trumbull's character and his artistic production were intimately connected.[37] He mounted a detailed attack of Trumbull's personal conduct, arguing that the painter

35. "Letter from Raphael L. West and Benjamin West to Hon. J. W. Taylor, Speaker of the House of Representatives of the United States of America," April 12, 1826, reproduced in John Dillenberger, *Benjamin West: The Context of His Life's Work with Particular Attention to Paintings with Religious Subject Matter* (San Antonio, Tex.: Trinity University Press, 1977), p. 199.

36. Trumbull and Dunlap initially worked amicably together as administrators of the American Academy of the Fine Arts during the period 1817–19, but their relationship seems to have deteriorated, at least on Dunlap's side, shortly after that. Carrie Rebora has suggested that Dunlap developed a grudge against Trumbull in 1825 when the American Academy closed an independent exhibition of Dunlap's painting *Death on the Pale Horse* one day early. This action resulted in a lawsuit between Dunlap and the Academy; see Rebora, "The American Academy of the Fine Arts, New York, 1802–42," Ph.D. diss., City University of New York, 1990, n. 31, p. 91, and pp. 298–300.

37. Dunlap drew upon a number of sources for his sketch of West in the *History*; for his profile of Trumbull, however, he relied primarily on a manuscript lent him by James Herring, the secretary of the American Academy of the Fine Arts (see *History*, vol. 1, pp. 340–41). Herring published a shorter version of this (unlocated) manuscript in *The National Portrait Gallery of Distinguished Americans*, ed. James Herring and James B. Longacre, vol. 1 (New York: Monson Bancroft, 1834), n.p.

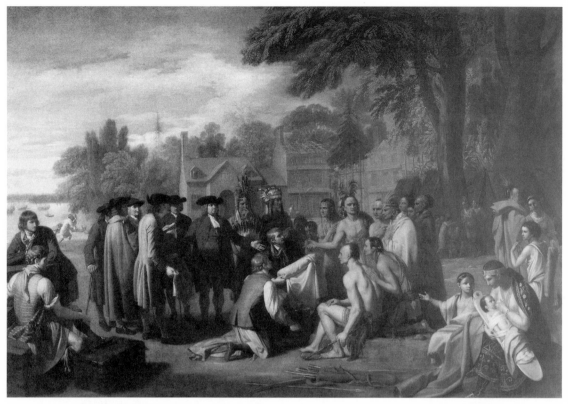

FIGURE 14. Benjamin West, *Penn's Treaty with the Indians*, 1771–72. Oil on canvas, 75 ½ × 107 ¾ in. Courtesy of the Pennsylvania Academy of the Fine Arts, Philadelphia. Gift of Mrs. Sarah Harrison (The Joseph Harrison Jr. Collection).

had built his public image as a patriot-artist—manifest in his self-portrait in which he holds both sword and palette (figure 16)—on very shaky ground.[38] Dunlap questioned Trumbull's devotion to his country by dwelling on his abrupt resignation from the army in 1777 at the beginning of the American Revolution, and also by highlighting Trumbull's residence in the enemy territory of London during both the Revolution and the War of 1812.[39] With spirited revisionism Dunlap declared:

38. Benjamin Silliman, Trumbull's nephew by marriage, was the first to apply the title "patriot-artist" to Trumbull; see John Trumbull, *The Autobiography of Colonel John Trumbull; Patriot-Artist, 1756–1843,* ed. Theodore Sizer (New Haven: Yale University Press, 1953 [orig. pub., New York, 1841]), n. 3, p. 366.

39. Dunlap scolded: "Although to this abandonment of military life, we are indebted for one of our most distinguished artists, I cannot but think that the young gentleman made a great mistake even upon the narrow calculation of self-interest . . . he abandoned the cause of his country, at the time that 'tried men's souls,' and gave up prospects, as fair as any young man of the period could have, of being an honourable agent in the great events which followed" (*History,* vol. 1, pp. 350–51). Dunlap did not condemn other American-born artists, including Gilbert Stuart and John Singleton Copley, who worked in London during the Revolution.

"The people of the United States have been habituated to surround with a halo every head presented to their view as that of a soldier of the Revolution. The feeling is natural, and has its origin in our *better* nature. But it appears to me high time to pass the grain through the sieve and separate it from the chaff which has heretofore claimed equal weight."[40] Continuing this line of attack, Dunlap deliberately contrasted West's choice of subject matter in the *Death of Wolfe* with that selected by

40. Ibid., p. 348. On the search for false patriots during the early republic, see David Waldstreicher, *In the Midst of Perpetual Fetes: The Making of American Nationalism, 1776–1820* (Chapel Hill: University of North Carolina Press for the Omohundro Institute of Early American History and Culture, Williamsburg, Va., 1997), pp. 61 and 64. Dunlap's emphasis on Trumbull's patriotism is another example of the way that his *History* reprises debates from the late eighteenth century.

FIGURE 15. Benjamin West, *Christ Rejected*, 1814. Oil on canvas, 200 × 260 in. Courtesy of the Pennsylvania Academy of the Fine Arts, Philadelphia. Gift of Mrs. Sarah Harrison (The Joseph Harrison Jr. Collection).

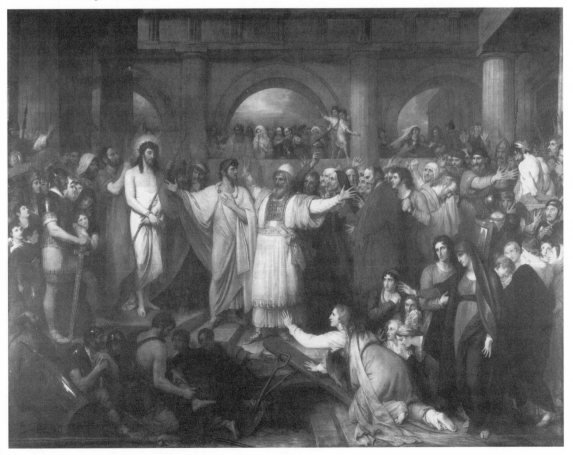

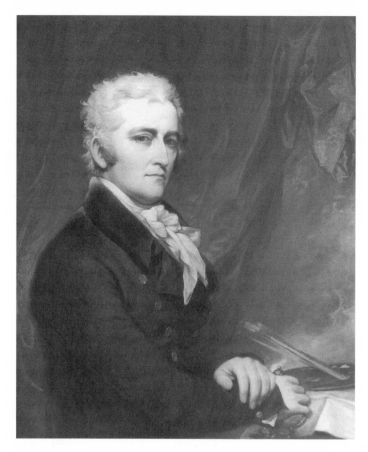

FIGURE 16.
John Trumbull, *Self-Portrait*, c. 1802. Oil on canvas, 29 ¾ × 24 ⁹/₁₆ in. Yale University Art Gallery. Gift of Marshall H. Clyde Jr.

Trumbull for the first in his projected suite of paintings commemorating the American Revolution: *The Death of General Warren at the Battle of Bunker's Hill, 17 June 1775*, 1786 (figure 17).[41] Although Trumbull painted this work in West's London studio with his teacher's encouragement, Dunlap sharply distinguished what he considered the relatively minor incident at Bunker Hill from the significance of General Wolfe's victory. He elaborated: "Wolfe died triumphant, surrounded by his friends in the moment of victory, knowing that France had lost America by the successful efforts of his genius. . . . But the dying men of the

41. Patricia M. Burnham provides a clear summary of the battle in her article "John Trumbull, Historian: The Case of the Battle of Bunker's Hill," in *Redefining American History Painting*, ed. Patricia M. Burnham and Lucretia Hoover Giese (Cambridge: Cambridge University Press, 1995), pp. 38–40. Jules Prown observes that although Trumbull planned thirteen paintings of the Revolution, he executed only eight (cited in Cooper, p. 38).

other pictures [including Trumbull's *Battle of Bunker's Hill*] are nothing more than—dying men."[42]

As Dunlap eventually made clear in the *History*, the real sticking point about the *Battle of Bunker's Hill* was that Trumbull chose to depict a battle the American forces had lost.[43] Dunlap suggested that the true hero of Trumbull's painting was Major Small, a British officer visible in the central foreground, who restrains a British

42. Dunlap, *History*, vol. 1, p. 358. Dunlap is also referring in this passage to Copley's *The Death of Major Peirson*, 1782–84 (Tate Britain) and Trumbull's *The Death of General Montgomery in the Attack on Quebec, 31 December 1775*, 1786 (Yale University Art Gallery).

43. Dunlap pointed out that Trumbull's *Death of General Montgomery* also depicted a British military victory (*History*, vol. 1, p. 358). He similarly criticized Copley's *Watson and the Shark*, 1778 (National Gallery of Art, Washington, D.C.), as a topic hostile to America. He contended that the subject of the painting, Brooks Watson, was not only an opponent of American independence but also a slave trader (anathema to Dunlap, who favored abolition); see ibid., pp. 117–18.

FIGURE 17. John Trumbull, *The Death of General Warren at the Battle of Bunker's Hill, 17 June 1775*, 1786. Oil on canvas, 25 ⅝ × 37 ⅝ in. Yale University Art Gallery. Trumbull Collection.

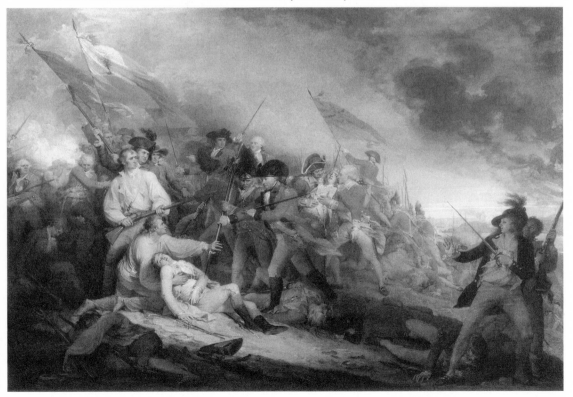

grenadier from stabbing the fallen General Warren. Dunlap observed that there were a number of heroic American actions in the battle that Trumbull could have preserved for posterity in place of his representation of British magnanimity.[44]

Dunlap did not limit his disapproval of the *Battle of Bunker's Hill* to the artist's choice of subject matter. He also enumerated several factual inaccuracies in Trumbull's depiction of the event.[45] For example, he seized on a catalogue description of the painting published by Trumbull in which the artist wrote that at the time of the battle, he had been stationed with American forces at Roxbury and could see the fighting from that post.[46] Dunlap disputed Trumbull's legitimacy as an eyewitness by pointing out that the distance between the battlefield and Roxbury made the artist's claim highly unlikely. He noted that Trumbull would only have seen the smoke emanating from the conflict.[47] Dunlap also recorded additional factual objections to the painting raised by Bostonians familiar with the details of the battle and its participants.[48] Dunlap argued forcefully that such discrepancies compromised both Trumbull's history paintings and his artistic reputation. To bolster his argument, Dunlap once again used Trumbull's own words against him. Observing that

44. Ibid., p. 357. In his *Autobiography*, Trumbull defended his conception of history painting by writing that he had intended "to show that noble and generous actions, by whomsoever performed, were the objects to whose celebration I meant to devote myself" (p. 149). For the influence of Trumbull's social class on his view of heroism and his interpretation of the American Revolution, see Irma B. Jaffe, *John Trumbull: Patriot-Artist of the American Revolution* (Boston: New York Graphic Society, 1975), pp. 88–89, and Burnham, esp. pp. 44–46, 49–50.

45. As Trumbull painted the *Battle of Bunker's Hill* in Europe eleven years after the battle occurred, the question of his sources, apart from his own memories of the day's events, is one that has engaged a number of scholars. In a sketch of Trumbull's life published at the turn of the century, John Weir described the painting as "a product of [Trumbull's] imaginative genius working upon carefully collated facts gathered from various sources, from persons actually engaged in the fight, and from sketches made on the spot at a later day" (John F. Weir, *John Trumbull: A Brief Sketch of His Life to Which Is Added a Catalogue of His Works* [New York: Scribner's, 1901], pp. 20–21). Jules Prown has suggested that Trumbull made use of American costumes that West had assembled earlier with the help of Charles Willson Peale when West was still contemplating the series (in Cooper, p. 30). Irma Jaffe proposed that Trumbull painted the portraits of several of the principal British officers from life, while he copied the likeness of General Warren from a portrait by West (*John Trumbull: Patriot-Artist*, p. 317).

46. Dunlap is probably referring here to the catalogue Trumbull compiled of his works when they were transferred to Yale College: [John Trumbull], *Catalogue of Paintings by Colonel Trumbull . . . Now Exhibiting in the Gallery of Yale College, New Haven* (New Haven: Howe & Company, 1832). Dunlap visited the Trumbull Gallery at Yale during the summer of 1834 (Dunlap, *Diary*, pp. 808–12) and reproduced his own annotated catalogue of the gallery in the *History* (vol. 1, pp. 392–93).

47. Dunlap, *History*, vol. 1, pp. 343–44. This is a point Trumbull confirmed in his *Autobiography* (p. 19).

48. Dunlap, *History*, vol. 1, p. 358. Dunlap accused Trumbull of relying on British reports of the Battle of Bunker's Hill rather than on American accounts. Burnham notes that Trumbull used the British *Annual Register* for the casualty statistics included in his catalogue entry of the painting (Burnham, p. 41) but does not comment on whether this source influenced his depiction.

Trumbull had described himself in print as a "graphic historiographer" of the events of the Revolution,[49] Dunlap countered by remarking that this chosen role entailed certain responsibilities, for "when a man becomes a 'graphic historiographer,' he has a duty to fulfil that cannot be dispensed with. If the historian or the 'graphic historiographer' cannot tell the whole truth, he must not at least violate the known truth."[50] Thus, according to Dunlap's portrait in the *History*, Trumbull not only exaggerated his patriotism but also falsified his visual account of the Revolution.

In making his case against Trumbull, Dunlap conveniently did not acknowledge that West's depiction of Wolfe's death was far from a documentary record.[51] As West's contemporaries knew from published accounts, only a few men had witnessed Wolfe's death, not the large company assembled in the painting. West grouped a symbolic representation of the key figures in the British campaign around their leader rather than his actual attendants.[52] While constructing a plausible representation of the event, West also endowed Wolfe's death with the elevated status traditionally accorded the deeds of ancient or religious heroes. Dunlap intimated that Trumbull betrayed his mentor's factual standards in his representation of the battle at Bunker's Hill, yet the only real difference between the artists' approaches is that West seems to have been shrewder in anticipating the critical and popular

49. See [Trumbull], *Catalogue of Paintings by Colonel Trumbull*, p. 3. Trumbull also used this phrase in a catalogue for the Capitol Rotunda; see [John Trumbull], *Description of the Four Pictures, From Subjects of the Revolution, Painted by Order of the Government of the United States, and now placed in the Rotunda of the Capitol, 1827* (New York: William A. Mercein, 1827), p. iii. Undoubtedly, Trumbull derived his principal ideas about painting history from West; Allen Staley has written of "West's concept of the role of the painter as equivalent to that of the historian" (*Benjamin West*, p. 52). In a different vein, Burnham's article considers Trumbull as a historian who worked in both print and paint (Burnham, p. 38).

50. Dunlap, *History*, vol. 1, p. 358.

51. Dunlap did record one contemporary criticism of West's *Death of Wolfe*. Henry Laurens informed West that the American Indian pictured in the painting would not have gone into battle barefoot (*History*, vol. 1, p. 64). In fact, as the catalogue entry for the *Death of Wolfe* in von Erffa and Staley notes, there were no Native Americans attached to the British forces at Quebec (p. 212); see the entire entry (no. 93) for a concise summary of current scholarship on the painting. West defended the lapses of factual accuracy in his paintings of contemporary history in an 1807 conversation with Joseph Farington, which Farington recorded in his diary. In a discussion about West's *Death of Lord Nelson*, 1806 (Walker Art Gallery, Liverpool), West explained "that there was no other way of representing the death of a Hero but by an *Epic* representation of it. It must exhibit the event in a way to excite awe & veneration & that which may be required to give superior interest to the representation must be introduced, all that can shew the importance of the Hero. Wolfe must not die like a common soldier under a Bush, neither should Nelson be represented dying in the gloomy hold of a ship, like a sick man in a Prison Hole." *The Diary of Joseph Farington*, ed. Kathryn Cave, vol. 8 (New Haven: Yale University Press for the Paul Mellon Centre for Studies in British Art, 1982), p. 3064, cited in von Erffa and Staley, p. 222.

52. Ann Uhry Abrams has noted that West surrounded Wolfe with loyal officers, omitting those who had criticized the general; see Abrams, *The Valiant Hero*, pp. 173–78.

response to his contemporary history paintings than Trumbull was. As numerous scholars have pointed out, James Wolfe was a venerated figure among the British public after his death and West capitalized on this popularity when he cast the general as the hero of his painting.[53] American audiences certainly had no such reverence for Major Small, the focal point of Trumbull's painting; thus Dunlap had free license in his criticisms.

How could Dunlap's rehashing of accusations made against the *Battle of Bunker's Hill*, a painting completed nearly fifty years before the *History*'s publication, damage Trumbull? Trumbull's small-scale series of paintings on Revolutionary subjects had in fact secured him the 1817 commission to fill four of the eight panels lining the Rotunda in the U.S. Capitol Building.[54] Yet Dunlap's reassessment of Trumbull's series was timely since the *History* appeared during the same period that Congress began to consider filling the four remaining Rotunda panels. Trumbull was one of the artists lobbying for the second commission, and Dunlap's profile of him joined a larger public review of the artist's earlier contributions to the Capitol. Dunlap made it clear in the *History* that although the government commission had added to Trumbull's fortune and prestige, the paintings met with less than universal approval when they were installed in 1826. He repeated criticisms of the Rotunda paintings on factual and stylistic grounds, recalling of the debut of the *Declaration of Independence* (figure 7), for example: "Public expectation was perhaps never raised so high respecting a picture, as in this case: and although the painter had only to copy his own beautiful original of former days, a disappointment was felt and loudly expressed. Faults which escaped detection in the miniature, were glaring when magnified—the touch and the colouring were not there—attitudes which appeared constrained in the original, were awkward in the copy—many of the likenesses had

53. McNairn, p. 679. Charles Mitchell observed that West's painting also benefited from a growing interest in British national history (see Mitchell, esp. pp. 23–30).

54. When the British set fire to the Capitol during the War of 1812, construction had not yet begun on the building's central section. Work on the Rotunda was authorized along with the Capitol's reconstruction under the supervision of the architect Benjamin Latrobe. For information on Trumbull's commission at the Capitol, see Jaffe, *John Trumbull: Patriot-Artist*, chap. 14; Egon Verheyen, "John Trumbull and the U.S. Capitol: Reconsidering the Evidence," in Helen A. Cooper et al., *John Trumbull: The Hand and Spirit of a Painter* (New Haven: Yale University Art Gallery, 1982), pp. 260–75; Vivien Green Fryd, *Art and Empire: The Politics of Ethnicity in the United States Capitol, 1815–1860* (New Haven: Yale University Press, 1992), chaps. 1 and 2; and Ann Uhry Abrams, "National Paintings and American Character: Historical Murals in the Capitol's Rotunda," in *Picturing History: American Painting, 1770–1930*, ed. William Ayres (New York: Rizzoli in association with Fraunces Tavern Museum, New York, 1993), pp. 65–78. As these sources reveal, Trumbull lobbied assiduously for the 1817 commission.

vanished. The arrangement of the whole appeared tame and unskilful."[55] Many of Dunlap's criticisms of the Rotunda paintings had been aired in public previous to the *History*'s publication, but his new account established an indictment of Trumbull that was both persuasive and comprehensive.

Although Dunlap could have presented Trumbull's Capitol commission as a success for the entire American art profession, he did not do so. Instead he bluntly proclaimed of the paintings in the Capitol: "Let not foreigners, or men of after days, take these pictures, because of their situation, as a standard by which to measure the arts of design in our country at the time they were painted."[56] As with the double standard he established for the factual accuracy of West's and Trumbull's history paintings, Dunlap punished Trumbull in the *History* for his professional success while celebrating West's. Rather than heralding the fact that Trumbull received $32,000 from Congress for his Rotunda paintings, Dunlap criticized the painter for monopolizing government patronage. He also implied that Trumbull, not content with the remunerative terms of his commission, extracted permission from the federal government to exhibit the four paintings for his own profit before their installation in Washington.[57] By depicting Trumbull as mercenary and self-serving, Dunlap exploited the continuing uncertainty among Americans about the proper role of art in their society. Ironically, Dunlap attempted to diminish Trumbull's achievement by contrasting his history paintings with those of Benjamin West, despite the fact, expressed by Allen Staley, that Trumbull's government commission represented "the ultimate realization, never so completely attained by West himself, of what a history painting was supposed to be: public art in a public place, serving a public purpose."[58]

55. Dunlap, *History*, vol. 1, p. 376. Dunlap traced Trumbull's artistic deterioration to the period of his third stay in Europe during 1794–1804, when "he assum[ed] a style altogether different and much less happy than that he had formerly adopted" (ibid., p. 370). In addition to his analysis of the *Declaration of Independence*, Dunlap recycled criticisms of factual inaccuracies in the *Surrender of Cornwallis* (figure 8). Trumbull originally identified the central figure in the painting as Cornwallis, but the general was not actually present at the ceremony of surrender. Although he was the ranking British officer at Yorktown, he sent a deputy in his place. Public notice of this error forced Trumbull to change the printed description accompanying the painting (ibid., p. 377; Jaffe, *John Trumbull: Patriot-Artist*, p. 262).

56. Dunlap, *History*, vol. 1, p. 378.

57. According to Robert H. Canary, Dunlap competed for the original Rotunda commission along with a number of other hopeful American artists; see Canary, *William Dunlap* (New York: Twayne Publishers, 1970), p. 32.

58. Staley, *Benjamin West*, p. 59. Though painted without a commission and exhibited publicly, the original version of West's *Death of Wolfe* as well as the copies after it were destined for private col-

Dunlap further argued that the professional self-interest evident in Trumbull's handling of his federal commission extended to his dealings with other artists. In contrast to West's encouragement of Edward Malbone, the *History* recorded Trumbull's dismissal of a number of aspiring artists. For example, Trumbull reportedly recommended that Robert Weir give up painting for shoemaking after seeing one of the young artist's paintings, counsel that made Weir "sick for a week after."[59] Dunlap made it clear that as an artist who had received instruction from West and had returned to assume a leadership position in the American art world, Trumbull was guilty of evading his professional responsibilities when he made such disparaging remarks.

Dunlap also suggested that on the rare occasions when Trumbull did assist younger artists, he did so purely out of self-interest. When Thomas Sully sought technical training in New York, Trumbull charged Sully one hundred dollars, according to the *History*, to observe him painting a portrait of Sully's wife. Though conceding that Sully "gained some knowledge for his money, and probably learned to imitate the neatness with which palette and pencils and oils and varnishes were used and preserved," Dunlap acidly observed that Sully also "gained a model, which served him as a beacon, warning him of that which it was necessary to avoid."[60] Dunlap contrasted Trumbull's reception of Sully with that offered the painter by Gilbert Stuart in Boston. Stuart agreed to critique a portrait by Sully, and Dunlap pointedly noted: "For further encouragement, Stuart showed [Sully] his palette, his arrangement of colours, and his mode of using them. He advised him in respect to his future proceedings, and recounted his own experience. There was here no necessity for purchasing a picture by way of getting a lesson; all was as it should be, and as it is with every liberal artist—gratuitous."[61]

Dunlap even found ulterior motives in Trumbull's decision to employ Asher Durand to engrave the *Declaration of Independence*. He noted: "After the completion

lections. Von Erffa and Staley note that West came closest to public art with his large-scale religious paintings (p. 143).

59. Dunlap, *History*, vol. 2, note, p. 386. Dunlap did not criticize Thomas Sully for making similarly discouraging remarks to John Neagle (ibid., p. 373). While Irma Jaffe acknowledges that Trumbull could be irascible, she notes that his advice to Weir was a warning about the uncertainty of the artistic profession. She also relates that Trumbull did offer assistance to several artists including Thomas Cole (*John Trumbull: Artist-Patriot*, pp. 270–71 and 215). For the relationship between Cole and Trumbull, see Alan Wallach, "Thomas Cole and the Aristocracy," *Arts Magazine* 56 (November 1981): 95–99, and for a discussion of Trumbull's other protégés, see Rebora, "The American Academy," pp. 77–81.

60. Dunlap, *History*, vol. 2, p. 111. In an appendix to Trumbull's *Autobiography*, Theodore Sizer suggests that Sully was more appreciative of Trumbull than Dunlap would allow (pp. 293–94).

61. Dunlap, *History*, vol. 2, p. 115.

of the large picture of the Declaration [for the Rotunda], the artist employed the first American engraver for talent, to give more extended circulation to that composition by his burin."[62] Although Dunlap acknowledged that Durand gained valuable exposure from the commission, he argued that Trumbull took advantage of the engraver by paying him far less than the work deserved. Dunlap implied that Trumbull only turned to Durand because he agreed to work for half the price demanded by his European counterparts.[63]

According to Dunlap, Trumbull's lack of concern for his fellow artists ultimately jeopardized the fate of the New York art community. He charged that Trumbull's dictatorial leadership of the American Academy led to its demise and to the founding of the rival National Academy of Design. Dunlap criticized various aspects of Trumbull's actions as the American Academy's president—accusing him of using the office to promote his own career, for example[64]—but he reserved his harshest words for Trumbull's indifference to the education of artists. Dunlap pinpointed the origin of the institutional crisis at the American Academy with one incident that he recounted in detail. Although the Academy had instituted a policy of opening its collection of antique casts to students for three hours each morning during 1824–25, the students often had difficulty gaining access to them. On one particular morning, two young artists—Thomas Cummings and Frederick Agate—were turned away by the curator at the door although they had arrived during the designated hours. A report of the confrontation reached one of the Academy's directors, who appealed to Trumbull for a response. After the curator defended his action, Trumbull "observed, in reply to the director, 'When I commenced my study of painting, there were no casts to be found in the country. I was obliged to do as well as I could. These young men should remember that *the gentlemen* [the Academy's stockholders] have gone to a great expense in importing casts, and that they (the students) have no property in them;' concluding with these memorable words for the encouragement of the curator, 'They must remember that beggars are not to be choosers.' "[65] Dunlap's framing remarks suggested that the New York artists considered Trumbull's paternalism an insupportable model of leadership. Dunlap

62. Ibid., vol. 1, p. 382.

63. Dunlap observed that Durand was paid $3,000 for three years of work (ibid., pp. 382–83). Jaffe contends that Trumbull turned to Durand after critics objected to his statement in the subscription proposal for the *Declaration* that he would be employing an "eminent" European engraver (*John Trumbull: Patriot-Artist*, pp. 238–39).

64. Dunlap, *History*, vol. 1, p. 375.

65. Ibid., vol. 2, p. 280.

concluded his account of the incident, for example, by remarking, "We may consider this as the condemnatory sentence of the American Academy of the Fine Arts" and noting the subsequent formation of the New York Drawing Association established to provide artists with a venue for mutual instruction.[66] The rest of the narrative is familiar: after several skirmishes with the American Academy, the membership of the Drawing Association went on to found the rival National Academy of Design, which pledged the establishment of a school as an immediate priority.[67]

The pages of the *History* were not the first place where Dunlap took Trumbull to task for his stewardship of the American Academy. In 1833, angered by Trumbull's rejection of a negotiated plan for the merger of the two New York art institutions, Dunlap presented himself as a public opponent of Trumbull in a four-page pamphlet entitled *Conflicting Opinions, or Doctors Differ*. This composition was published anonymously. It juxtaposed quotations from Dunlap's 1831 address to the National Academy's students, made when Dunlap assumed the president's duties in Samuel Morse's absence, with citations from a recent address John Trumbull had made to the directors of the American Academy laying out his objections to the proposed union.[68] Explaining that he was assuming a battle that Morse had fought previously on the National Academy's behalf, Dunlap began by remarking:

> Doctors Trumbull and Morse had a sparring match some years ago, but the latter having retired from the field, perhaps to heal his wounds, perhaps to seek auxiliaries, Doctor Dunlap continued the conflict of opinions by an address delivered to the students of the National Academy in 1831, and published by the Council. Nearly two years having elapsed, and Doctor Morse having returned home, Doctor Trumbull, who would not notice the substitute during the absence of the principal, delivers an address to the pupils. We wish fair play—nothing more,—and therefore place before the pupils of each learned Doctor the leading opinions of the differing sects.[69]

66. Ibid.

67. After investigating the history of art academies, Samuel Morse argued that one of the defining characteristics of a true academy was its instruction; see Morse, "Academies of Arts" (1827), reprinted in Thomas S. Cummings, *Historic Annals of the National Academy of Design* (New York: Da Capo Press, 1969 [orig. pub., Philadelphia, 1865]), p. 41.

68. A copy of *Conflicting Opinions, or Doctors Differ* (New York, 1833) is available through the Archives of American Art, Smithsonian Institution; see G. R. Lambdin Collection, Pennsylvania Academy of the Fine Arts, roll P38, frames 170–72. Dunlap's *Diary* proves that he was the author of the pamphlet (p. 659). Both Dunlap's and Trumbull's addresses were published; see William Dunlap, *Address to the Students of the National Academy of Design at the Delivery of the Premiums, Monday, the 18th of April, 1831* (New York: Clayton & Van Norden, 1831), and John Trumbull, *Address Read Before the Directors of the American Academy of the Fine Arts, January 28th, 1833* (New York: Nathaniel B. Holmes, 1833).

69. [Dunlap], *Conflicting Opinions*, p. 1. Dunlap accounted for the use of the title "Doctor" by remarking: "We remember to have seen our second title illustrated by a picture representing two professors of the healing art, pulling wigs and breaking heads. We humbly hope that the Doctors whose differences have

Although Dunlap accentuated the differences between his remarks and Trumbull's through careful editing in the pamphlet, a review of the full texts of their respective speeches reveals genuinely divergent views of the artistic profession.[70] Trumbull and Dunlap agreed that artists should hold an esteemed place in American society, but they differed in their ideas about the proper relationship between American artists and their patrons. Broadly speaking, John Trumbull subscribed to the view that artists should look to cultivated patrons as their primary source of creative encouragement and financial support. Though agreeing that artists should direct their efforts to the most educated members of society, William Dunlap envisioned American artists not as dependent on elite patrons but as self-regulating professionals entering into partnerships with their clients in a free market.[71] *Conflicting Opinions* presented these positions starkly: "Doctor D. says—'You are preparing to enter the lists of fame, as members of an honourable profession.' Doctor T. says—Artists 'are necessarily dependent upon the protection of the rich and the great.' "[72]

Trumbull's speech underscored his unwillingness to consider the American Academy's union with the National Academy unless the stockholding directors of the American Academy, most of whom were not artists, could retain their leadership positions. Echoing his reprimand to the artists over their access to the cast collection, Trumbull detailed the many ways in which the nonartist members of the Academy had sustained the profession. He argued that the support of these gentleman-directors was particularly necessary given the limited possibilities of patronage in the United States. Unlike European artists, Trumbull reminded his audience, artists in the United States could not depend on a royal patron to support their art institutions. He further observed that "the legislative assemblies of our nation, or of the separate states, cannot be looked up to by the arts, with any hope

called our attention will not proceed to such unseemly extremities. By Doctor, we mean teacher. Definition is necessary, as the sages we are about to examine have various and opposite titles; but they are all Doctors, or teachers, of the Fine Arts" (p. 1). Morse made his own public response to Trumbull's address—*Examination of Col. Trumbull's Address in Opposition to the Projected Union of the American Academy of the Fine Arts and the National Academy of Design* (New York: Clayton & Van Norden, 1833)—which was reproduced in the *History*, vol. 2, pp. 342–44.

70. Dunlap did reprint Trumbull's full address in the *History*, vol. 2, pp. 339–42.

71. For the parallels between Dunlap's vision and the emergence of an ideology of liberal republicanism, see Dell Upton, "Inventing the Metropolis: Civilization and Urbanity in Antebellum New York," in *Art and the Empire City: New York, 1825–1861*, ed. Catherine Hoover Voorsanger and John K. Howat (New York: Metropolitan Museum of Art/New Haven: Yale University Press, 2000), p. 12. For challenges facing American artists in rethinking their social position during the early republic, see Elizabeth Johns, "Science, Art, and Literature in the Republic," in *Everyday Life in the Early Republic*, ed. Catherine E. Hutchins (Winterthur, Del.: Henry Francis du Pont Winterthur Museum, 1994), pp. 347–69.

72. [Dunlap], *Conflicting Opinions*, p. 1.

of protection like this; the church offers us as little hope as the state; and the fine arts . . . are in this country, thrown for protection and support upon the bounty of individuals, and the liberality of the public."[73] He also stated that since "it is a truism, that the arts cannot flourish without patronage in some form; it is manifest that artists cannot interchangeably purchase the works of each other and prosper; they are necessarily dependent upon the protection of the rich and the great."[74] Trumbull thus argued that given their indispensability to artists, patrons should be given official standing in any art institution.

With his republican sensibilities Dunlap bristled at Trumbull's view of artistic patrons. In his address exhorting the National Academy's students, Dunlap recoiled from the very term "patron," pronouncing it inappropriate in an American context. He argued:

> Our beloved country is politically a democracy. When all our fellow citizens shall have a true notion of the character of a democrat, no man will feel pride from the mere possession of wealth, or degradation from the absence of it.—No man will be so absurd as to think he patronizes the author whose book he buys, or the painter or sculptor whose works decorate his walls and give lessons of wisdom to his children, any more than he will think that he protects the advocate who defended him in the court of justice, or the physician who rescued him from pain and death.[75]

Dunlap defended the artist-run National Academy as the only institution able to ensure that artists would enter into society as independent citizens. Contrary to Trumbull's cautious appraisal, Dunlap predicted a bright and prosperous future for the American artist: "If he truly loves his art, his pecuniary wants will be few, and the wise and the virtuous will be happy to administer to those wants, in fair exchange of their products for his, as equals, giving benefit for benefit."[76]

Despite this optimism, Dunlap, more than anyone else, must have been aware of the gap between his vision for American artists and the harsh realities of the contemporary art world. He had spent the previous decade traveling the country in search of portrait commissions and scrambling to attract audiences to independent exhibitions of his large religious paintings. He also knew that although study abroad had

73. Dunlap, *History*, vol. 2, p. 339. As part of his lobbying efforts to receive the commission to fill the four remaining panels in the Capitol Rotunda, Trumbull did propose a plan for ongoing government art patronage to President John Quincy Adams in 1826; see Dunlap, *History*, vol. 1, pp. 384–89.

74. Ibid., vol. 2, p. 339. This position is consistent with the picture that modern scholars have developed of Trumbull's social background and his increasingly conservative worldview.

75. Dunlap, *Address*, pp. 10–11.

76. Ibid., p. 8.

raised the professional expectations of American artists, the social and economic conditions in the United States during the early nineteenth century had left many of them frustrated. Though the demand for portraiture persisted, many artists had been thwarted in their attempts to interest American audiences in history painting in the "grand manner." Trumbull was the most successful of the returning artists in introducing history painting to the United States, but his attempt to market prints after his Revolutionary series failed miserably, and the artist himself viewed the four paintings decorating the Capitol Rotunda as fulfilling only a fraction of his artistic ambitions.[77] Dunlap's address and the *History* encouraged artists to view themselves as modern professionals in control of their own destiny, but Trumbull's assessment of their actual situation was more accurate.

Despite the period of their utterance, Dunlap's remarks should not be read as evidence of Jacksonian democracy at work in the visual arts. In fact, the argument between Trumbull and Dunlap is more reminiscent of the rhetorical battles of the Federalists and Jeffersonian Republicans during the 1790s.[78] Dunlap rejected Trumbull's assertion that artists should rely on the "rich and the great," but he wrote that American artists should address their work to the country's "natural aristocracy"— not necessarily those born to wealth—while warning that the "uninstructed labourer in civilized society is nearly as dead to those objects which fill us with delight, as the savage."[79] In neither his 1831 address nor the *History* did Dunlap ever suggest that American artists attempt to reach the general public directly; rather, he believed that artists should set moral examples through their conduct while encouraging an indirect elevation of taste through their artworks. He was more concerned with the proper education of American artists than with that of their audiences. Thus, though Dunlap agreed with Trumbull that the artist must form a necessary

77. After substantial delay, engravings after Trumbull's *Battle of Bunker's Hill* and *The Death of General Montgomery in the Attack on Quebec* were finally published in 1797. Much to Trumbull's consternation this venture failed both in the United States and abroad. Trumbull blamed the French Revolution for the public's neglect, noting that events in France threw Europe into chaos and deeply divided the American public. He summarized in his *Autobiography*, "In such a state of things, what hope remained for the arts? None,—my great enterprise was blighted" (p. 173). Sales of Asher B. Durand's engraving after the *Declaration of Independence*, issued in 1823, were also disappointing; see Irma B. Jaffe, *John Trumbull: The Declaration of Independence* (New York: Viking Press, 1976), p. 97.

78. See, for example, Joseph Ellis on the debate between John Adams and Thomas Jefferson about the proper definition and role of an elite in the United States in *Founding Brothers: The Revolutionary Generation* (New York: Vintage Books, 2000), chap. 6 (esp. pp. 233–37).

79. Dunlap, *Address*, pp. 6 and 15. For a similar argument, see the reprinted text of Dunlap's speech for the American Lyceum: "On the Influence of the Arts of Design; And the True Modes of Encouraging and Perfecting Them," *American Monthly Magazine* n.s. 1 (February 1836): 120–21 (article summarized in appendix A).

alliance with an elite, he simply revised the terms of their relationship while expanding the possible pool of art patrons to encompass men of professional as well as social standing.

At the time of the publication of the *History*, Benjamin West had been dead for fourteen years and William Dunlap and John Trumbull, at sixty-eight and seventy-eight years old respectively, were elder statesmen in the American art world. Dunlap's account thus arrived at a moment of generational transition similar to the one that Americans faced with the deaths of the nation's founders during the early nineteenth century. His choice of West and Trumbull as the hero and villain of his book represents not only an attempt to fill a leadership vacuum he perceived within the contemporary art community, but also a desire to preserve the values that all three men shared. Despite its acrimony, this was an argument among members of the same family. It is certainly ironic that although Dunlap played a prominent role in the founding and administration of the National Academy's schools, he presented the European-based Benjamin West as the most important instructor in the *History*, praising the willingness of experienced artists including West to establish personal relationships with their younger colleagues rather than dwelling on institutional methods of instruction.[80] It is clear from this emphasis that Dunlap continued to think of artistic education in America within the craftsman tradition. Although Dunlap condemned Trumbull and the directors of the American Academy for their failure to respond to the educational needs of American artists, Dunlap himself valued the individual transfer of knowledge taking place in West's studio more than the formal training offered by an American art academy.

By constructing an American art tradition around the person of Benjamin West, Dunlap raised the problem of artistic succession. As an artist who had enjoyed a close relationship with West and then returned to the United States, Trumbull must have initially seemed the best hope to continue West's American legacy.[81] Following his teacher's lead, Trumbull with his Revolutionary series united the ideals of traditional history painting with scenes of national importance. Trumbull also shared

80. The National Academy's schools were still struggling in 1834; for an introduction to their erratic early history, see Donald Ross Thayer, "Art Training in the National Academy of Design, 1825–35," Ph.D. diss., University of Missouri, 1978.

81. Dorinda Evans places both Dunlap and Trumbull among the second generation of West's American students. She observes: "More than any other generation, this one . . . belonged to Benjamin West" (p. 71). She continues that, unlike the first group of students, many of these artists had aspirations to become history painters and believed "completely in the ideal set by the venerated Benjamin West" (p. 120).

West's ambitions to lead an institution that would foster the growth of the arts. But his abrasive personality, uneasy relationships with other artists, and the attacks of his opponents disqualified Trumbull from a position of leadership even before Dunlap delivered the fatal blow in the *History*.

There were several other candidates who could have succeeded West as the patriarch of the American art community. As noted in Dunlap's unpublished tribute to West, Washington Allston had seemed the most likely figure in 1820 to take up West's mantle. When abroad Allston had gathered around him a group of young Americans including Samuel Morse, Charles Robert Leslie, and Charles Bird King, with West's blessing.[82] Great expectations surrounded Allston's return to the United States in 1818. After he settled in Boston, however, his distance from New York City, the emerging center of the art world, and his own reluctance to engage the public limited Allston's influence.[83] Samuel Morse was another artist who made known his ambition to guide the American art world. He successfully orchestrated the founding of the National Academy and continued as its president in 1834, yet he does not seem to have had the personal presence that drew followers to both West and Allston. In addition, his bitter disappointment at being unable to launch a career as a history painter in the United States cooled Morse's interest in leadership.[84]

These abdications forced Dunlap to present Benjamin West in the *History* not only as the founding father of the American art world but also as its permanent model. Dunlap's decision, however, ignored many contemporary realities. West's artistic reputation, which had started to come under attack during his lifetime, declined even more precipitously after his death.[85] In addition, the standards with which West had been associated—his championing of history painting as the highest art form, his brand of stylistic eclecticism, his founding of a British-American educational axis, and his vision of the artist as moral exemplar[86]—were being

82. Evans, p. 163.

83. It seems that it was Allston's location as much as his ongoing battle with his painting *Belshazzar's Feast* (see chapter 5) that circumscribed his leadership role in the American art community. Although Allston did not live and work in seclusion, he was removed from the main currents of exhibitions, patronage, and publicity.

84. After failing to win one of the remaining commissions at the Capitol Rotunda, Morse gave up painting entirely in 1837, focusing instead on his telegraph venture; see Paul Staiti, *Samuel F. B. Morse* (Cambridge: Cambridge University Press, 1989), p. 207.

85. Ann Uhry Abrams contends that West collaborated on his biography with John Galt in order to shore up his position in the British art world (Abrams, *The Valiant Hero*, p. 31). For West's posthumous reputation, see Abrams, *The Valiant Hero*, pp. 27–29, and Alberts, pp. 393–402.

86. Alberts, p. 218.

challenged not only in Europe but also by young American artists. Dunlap did not accept and probably did not understand the full implications of many of these trends. As a result, though current critical opinion including the *History* lavished praise on the charismatic young landscape painter Thomas Cole, Dunlap was unable to envision Cole as the standard-bearer of American art for succeeding generations.

FIVE

Debating History: Contemporary Reception of Dunlap's *History*

Indeed, sir, your two bulky tomes of a thousand pages, dignified by the pompous title of a "History;"—what are they but a miserable chronicle of mere gossip and scandal, about upon a par with our daily political press or police reports, with the exception perhaps, of now and then a sketch of some favored individual, who has escaped your censure.

[John Vanderlyn], *Review of the "Biographical Sketch" of John Vanderlyn, Published by William Dunlap, in his "History of the Arts of Design"* (1838)

The *History* elicited a number of positive contemporary responses; but many of its detractors—both living artists and reviewers—identified the book's greatest flaw as the way it pandered to popular taste. In his study of the dissemination of knowledge in early America, the historian Richard Brown posited a tension during the early nineteenth century between the traditional practice of accumulating information and the emerging trend to consume it.[1] According to Brown, a vast increase in the circulation of information, both through the spoken word and in print, created a competing use for information beyond the republican desire to increase the common stock of knowledge—information as entertainment. Reactions to the *History* echo this shift as a number of reviews voiced suspicions of readers' unabashed desire to be amused. The expressed condemnation of short-term gratification masks another, unarticulated anxiety alluded to by Brown: the fear that the wrong people were gaining access to information and thereby given license to pass judgment on matters that had been the province of traditional elites.[2] The debate over informa-

1. Richard D. Brown, *Knowledge Is Power: The Diffusion of Information in Early America, 1700–1865* (New York: Oxford University Press, 1989), pp. 273–76 and the Conclusion.
2. Brown is careful to note that the expansion of available information did not necessarily translate to social egalitarianism; rather, a new "market-oriented elite" emerged to shape the content of the information revolution and were its principal beneficiaries (p. 243).

tional authority has a particular inflection when transferred to the arena of the visual arts. Criticisms of the *History* often focused on the propriety of informing readers of personal information about artists. Dunlap suggested that knowledge of an artist's life prepared readers to pass judgment on that artist's work. Rather than introducing readers to the tools of visual connoisseurship, Dunlap deputized them to become diviners of artistic intention by positing a determinative connection between personal character and artistic production. The artists who felt obliged to defend themselves after reading the *History* focused on the aspersions they believed had been cast on their characters rather than on defending their professional abilities.

The Artists Respond

Many artists in the United States would have responded favorably to a book documenting the existence of a national art tradition. Annotations in copies of the *History* owned by Thomas Sully, John Neagle, and James Reid Lambdin document that some contemporary artists used the book as a means of preserving their own memories and keeping current records of their profession.[3] These three artists, all of whom had supplied Dunlap with information, read the *History* carefully. They made factual corrections or additions to Dunlap's text, inserting death dates or the current location of artworks, for example, while also juxtaposing their own opinions of various artists with those of Dunlap. The art historian Lillian Miller once wrote that Matthew Pilkington's *Dictionary of Painters* (1770), a British publication, became a "family bible" of sorts for the Charles Willson Peale family, and the annotated copies of Dunlap's *History* suggest that his account served a similar function for some U.S. artists.[4]

Perceived inaccuracies in the *History* moved several artists to contact the author or issue a public reaction to the book. Washington Allston (1779–1843), for example, drafted at least two letters to Dunlap in which he attempted to counter the negative impressions he felt had been left by his biography. Since Dunlap responded to it in print, it is certain that one of Allston's letters reached Dunlap; however, another letter existed only in draft form when it was found in Allston's copy of the

3. Anna Wells Rutledge, "Dunlap Notes," *Art in America* 39 (February 1951): 36–48. In 1951 these three annotated copies of Dunlap's *History* were all located in private collections.

4. Lillian B. Miller, *In Pursuit of Fame: Rembrandt Peale 1778–1860* (Washington, D.C.: National Portrait Gallery, Smithsonian Institution in association with University of Washington Press, Seattle, 1992), p. 18.

History by Jared Flagg and included in Flagg's 1892 biography of the artist.[5] Dunlap's diaries from this period have not survived, making it impossible to know definitively if Allston ever sent this earlier, more significant letter. Its tone and the fact that Allston mentioned it to another correspondent suggest that he did mail it.[6] In his first communication, Allston disputed the reports repeated in the *History* that social engagements led him to neglect his art. Accepting without comment the connection Dunlap drew between artists' personal habits and the quality of their artistic productions, Allston was quick to forestall charges that he approached his art in the undisciplined manner of a dilettante. He assured Dunlap, "Next to what is vicious, there is no character more offensive to me, or one that I would most strenuously avoid realizing in my own person, than a company-loving idler. So far from wasting time in company, my friends both in England and here have often complained that I did not go into it enough. I would not be an excuser of late hours. My late hours were spent not in company, but in solitary study: in reading, often in sketching, or in other studies connected with my art."[7] Allston's defense has a particular resonance; he was well aware that readers of the *History* might accept idleness as the explanation for the continuing delay in the completion of his heavily publicized and long-awaited painting *Belshazzar's Feast*, 1817–43 (figure 18).[8]

Although Allston complied with Dunlap's request to supply him with biographical information for the *History*, he expressed resistance to the idea that the public was entitled to know more information than he himself was willing to disclose. In a

5. See "Washington Allston to William Dunlap," March 20, 1835, and October 1, 1835, in *The Correspondence of Washington Allston*, ed. Nathalia Wright (Lexington: University Press of Kentucky, 1993), pp. 373–74 and 379–81. The October letter concerned an anecdote in the *History* supplied by Thomas Sully (Dunlap, *History*, vol. 1, p. 214), in which Sully recounted viewing a portrait by Gilbert Stuart with Allston and noted their agreement that it could be compared favorably with the Old Masters. The note of provincialism struck in this story embarrassed Allston and he asked Dunlap to publish a correction, a request with which Dunlap complied. For Dunlap's retraction, see "To the Editors of the New-York Mirror," *New-York Mirror*, October 24, 1835, p. 131. On the details surrounding the discovery of the March letter, see Wright, p. 374, n. 1.

6. Allston reported in a letter to John Stevens Cogdell that he would request Dunlap to amend the relevant passage in any future edition of the *History* (see "Washington Allston to John Stevens Cogdell," May 16, 1835, in Wright, p. 376).

7. "Washington Allston to William Dunlap," March 20, 1835, in Wright, pp. 373–74. For the passage in question, see Dunlap, *History*, vol. 2, p. 188.

8. Begun in London in 1817, *Belshazzar's Feast* remained unfinished at Allston's death. For the significance of this painting, see William H. Gerdts, "The Paintings of Washington Allston," in William H. Gerdts and Theodore E. Stebbins Jr., *"A Man of Genius": The Art of Washington Allston (1779–1843)* (Boston: Museum of Fine Arts, 1979), pp. 106–10, 123–31, and 158–62, and David Bjelajac, *Millennial Desire and the Apocalyptic Vision of Washington Allston* (Washington, D.C.: Smithsonian Institution Press, 1988).

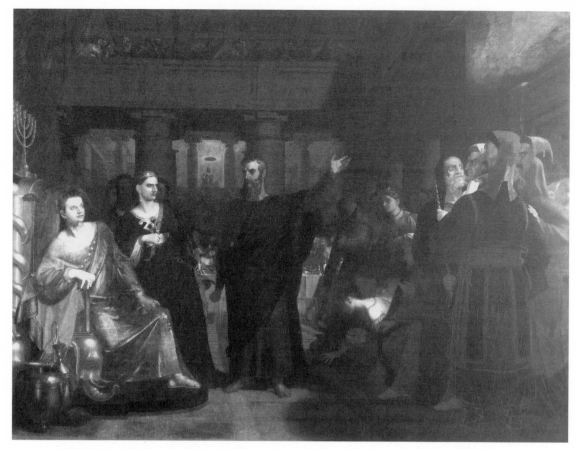

FIGURE 18. Washington Allston, *Belshazzar's Feast*, 1817–43. Oil on canvas, 144 ½ × 192 ⅛ in. Detroit Institute of Arts. Gift of the Allston Trust. ©1994 Detroit Institute of Arts.

letter to Dunlap, reprinted in the *History*, Allston wrote of *Belshazzar's Feast* and the private financial trust established to underwrite it: "Although my large picture is still unfinished, yet I ought perhaps to say something about it, as many inquiries have been made respecting my progress in it, and the probable time of its being completed. In assigning this reason for speaking of it in this place, I do not mean to admit any *right* in the public to be made acquainted with it; for so far, it is wholly a matter between the subscribers and myself. Still I am not disposed to withhold all information from a very natural curiosity."[9] Allston's assertion of artistic independence contradicted Dunlap's contention that artists should expect scrutiny because

9. Dunlap, *History*, vol. 2, p. 186.

of their role as public figures. The general reading public, whom Dunlap courted so assiduously in promotions for the *History*, had no authority in Allston's estimation.

John Trumbull's reaction to the *History* also displays a resistance to involving the general public in assessments of his artistic career. The profile of Trumbull attracted more attention than any other biography published in the *History*, provoking responses from the artist, his friends, and book reviewers. Recognizing the injury inflicted by Dunlap's account, the painter's friends quickly offered their support. One of Trumbull's allies during this crisis was Philip Hone, the New York businessman, politician, and art patron. Although Hone became affiliated with the National Academy of Design after its founding in 1826, he remained involved in the leadership of the American Academy, of which Trumbull was president.[10] A member of the aristocratic New York elite whose claim to cultural leadership Trumbull was trying to sustain, Hone attempted to console Trumbull after the *History*'s publication in an affectionate letter written during the spring of 1835.[11] Hone's letter also hinted at some tension between artists and patrons arising from the institutional battles in New York. He remarked of the *History*: "Its subject is one which always interests me, for I feel more regard for artists, and take more interest in their works than I imagine they give me credit for," and he referred pointedly to Dunlap's disdain for the term "patron."[12] Hone reserved most of his comments, however, for the personal nature of Dunlap's attacks. Although he had been "willing to make

10. Philip Hone was elected a member of the American Academy in 1818 and served as one of its directors in 1823, 1824, 1829, and 1830 (Carrie Rebora, "The American Academy of the Fine Arts, New York, 1802–1842," Ph.D. diss., City University of New York, 1990, pp. 502, 523, and 527). Hone was also an honorary member of the National Academy between 1827 and 1851 according to Mary Bartlett Cowdrey, ed., *National Academy of Design Exhibition Record, 1826–1860* (New York: New-York Historical Society, 1943), p. 236.

11. "Philip Hone to John Trumbull," March 16, 1835, miscellaneous Hone file, New-York Historical Society. All subsequent quotations in the paragraph are taken from this source. Hone had contributed to the *History*, providing Dunlap with a catalogue of his personal collection (Dunlap, *History*, vol. 2, pp. 462–64). Alan Wallach offered an important discussion of the relationship between the New York elite and art patronage during the early nineteenth century in his article "Thomas Cole and the Aristocracy," *Arts Magazine* 56 (November 1981): 94–106.

12. Dunlap also seems to have ruffled the feathers of another prominent patron of American art: Robert Gilmor Jr. In a response to a letter in which Gilmor apparently offered his criticisms of the *History*, Dunlap wrote, "I turn to the remark on the bargaining of mercantile man, and find it a passage in a quotation from Cunningham [Allan Cunningham's *The Lives of the Most Eminent British Painters, Sculptors, and Architects*]: but I shall remember your remarks in future & do all possible justice to merchants and bankers" ("William Dunlap to Robert Gilmor," February 28, 1835, Boston Public Library, Rare Books Department, Courtesy of the Trustees). For another example of Gilmor's sensitivity, see Alan Wallach, " 'This Is the Reward of Patronising the Arts': A Letter from Robert Gilmor, Jr., to Jonathan Meredith, April 2, 1844," *American Art Journal* 21 (1989): 76–77.

some allowances for the irascibility of an old man who has not always been on the sunny side of the hill," Dunlap's "ill-natured remarks . . . have excited my indignation." He continued, "I cannot refrain from addressing you on the subject not to excite your animosity against the Author, but to tell you frankly what your fellow Citizens think about it," and he reassured Trumbull that "you have risen in the opinions of your fellow Citizens by the attacks of this Gentleman." Hone does not seem to have felt inclined to defend the artist publicly, however, remarking that knowledge of support such as his "ought to be, and is no doubt, consolation enough for you."

The press did give Trumbull public support. The anonymous reviewer of the *History* for the *American Quarterly Review* observed, "We do not like the manner in which the memoir of Colonel Trumbull is written. The tone of asperity and disparagement by which it is pervaded, wears the appearance of a feeling of personal rancour altogether at variance with the spirit which should actuate the historian."[13] While conceding that some of the charges leveled at Trumbull in the *History* were valid—such as its condemnation of the artist's paintings in the Capitol Rotunda—the *American Quarterly* reviewer contended that Dunlap's patent hostility compromised his message: "Even supposing that Colonel Trumbull is really obnoxious to the imputations here cast against him, the mode in which they are thrown is calculated, we think, to weaken their force in a material degree."[14] A correspondent for the *North American Review* registered similar complaints about Dunlap's lack of objectivity: "The wearisome attacks on Colonel Trumbull are marked by a harshness of temper which a sensible man ought to keep under the control of his better nature."[15] Acknowledging the partisan undercurrents influencing Dunlap's assault, the *North American*'s critic added, "We cannot go into the battles of the artists; the space in Mr. Dunlap's book taken up by this unpleasant subject, is worse than wasted." This reviewer concluded his consideration of the Trumbull biography with the following ambivalent assessment: "We leave it with the single remark, that we do not admire Colonel Trumbull as an artist, but that his industry and zeal entitle him to respect, if not to applause."[16]

John Trumbull's own response to Dunlap's assault was strangely muted. His only public comment on the *History* profile took the form of a letter to the editor submit-

13. "*History of the Rise and Progress . . . ,*" *American Quarterly Review* 17 (March 1835): 162. See appendix C for a list of the reviews of the *History* published in leading contemporary magazines.
 14. Ibid.
 15. "Dunlap's History of the Arts," *North American Review* 41 (July 1835): 147–48.
 16. Ibid., pp. 163–64.

ted to the *New-York American* shortly after the book's publication. Trumbull allowed himself one paragraph of restrained indignation in this communication, informing the newspaper's readership:

> I have been looking over Mr. Dunlap's work on the Arts of Design in America, some pages of which I find he has devoted to a notice of me and my works—written with as much accuracy as could be expected from the mode in which the materials were collected, from the shreds and patches of detached conversations reported to him from memory, and put together with a studied spirit of ill-will. To this I have no objection, nor to the bitterness with which he criticises some of my professional works, for to Artists in particular is applicable the admirable rule given by our Saviour on another occasion, '*By their works ye shall know them.*' The works of Mr. Dunlap and myself will be judged by future, and perhaps more impartial judges than we are of each other.[17]

Trumbull devoted the remainder of the letter to addressing only one of Dunlap's many accusations. In the *History*, Dunlap expressed his disbelief that Trumbull had taken part in the American attempt to recapture Rhode Island from the British during the Revolution, as Trumbull had resigned his army commission a year before the campaign occurred.[18] In his letter to the *American*, Trumbull explained that he had participated in the operation as a volunteer, detailed the events of the siege, and noted sarcastically that although his principal commander was dead, he was sure that "with the talents which he has shown for investigation, Mr. Dunlap may perhaps hunt up some survivors of that day, and ascertain the correctness of this statement."[19] Although willing to leave the evaluation of his artistic skill to posterity, Trumbull was clearly averse to seeing his patriotic service diminished.

Despite his seeming public indifference to the *History*, Trumbull expressed his concern about its impact in private correspondence. In a letter to his nephew by marriage, Benjamin Silliman, Trumbull acknowledged being wounded by his critics, informing Silliman, "I have been so worried by Mr Dunlap + the foolish people of Washington, that I have really resolved to commence Something in the Shape of

17. John Trumbull, "To the Editor of the N.Y. American," *New-York American*, December 13, 1834, n.p. Trumbull's letter was included as part of a review of the *History*.

18. See Dunlap, *History*, vol. 2, pp. 288–89. Dunlap mentioned the incident in his biography of Asher B. Durand, who had been commissioned by Trumbull to commemorate his participation in the battle by engraving notice of it on a sword captured in the campaign.

19. Trumbull, "To the Editor of the N.Y. American." Dunlap responded with his own letter to the editor of the *American*, published on December 16, 1834, in which he accepted Trumbull's explanation, and in a shameless plug for his book assured Trumbull that "it will give me pleasure in a second edition of my work (which from the demand for it in this city and elsewhere will probably soon be called for) to insert the narrative . . . of a transaction so honourable to the gentleman . . . the passage objected to being rendered superfluous and irrelative, will be expunged" (n.p.).

Biography."[20] Trumbull published his *Autobiography* in 1841, seven years after the *History*'s appearance.[21] True to his proud nature, he did not deign to mention either his controversial tenure as president of the American Academy or William Dunlap in its pages. These omissions reflect Trumbull's earlier decision to absent himself from the turmoil of the contemporary art world. He resigned as president of the American Academy in 1836 in order to concentrate his energies on defending his personal reputation through the *Autobiography* and on guaranteeing his artistic legacy through the founding and supervision of the Trumbull Gallery at Yale College.[22] Trumbull's refusal to address the majority of Dunlap's criticisms reveals his generational outlook as well as his vision of the appropriate exercise of cultural authority. By choosing to hold himself above the partisan fray, Trumbull mirrored the public stance of political detachment taken by leading figures such as George Washington and Thomas Jefferson. Also implicit in Trumbull's response to the *History* was the belief that it was unseemly to be forced to defend his artistic practice in public, particularly since he had reassurance from such traditional elites as Phillip Hone that his reputation was secure.

John Vanderlyn (1775–1852) had neither the inclination nor the luxury of issuing a gentlemanly reply to his profile in the *History*. His embittered response, published in pamphlet form in 1838, reflects his isolated position in the early nineteenth-century American art world.[23] More than Trumbull, who held a position of cultural leadership in New York when the *History* was published, and Allston, who enjoyed great support among Boston's art patrons, Vanderlyn was vulnerable to

20. "John Trumbull to Benjamin Silliman," February 19, 1835, John Trumbull Papers, Manuscripts and Archives, Yale University Library, quoted in *The Autobiography of Colonel John Trumbull; Patriot-Artist, 1756–1843*, ed. Theodore Sizer (New Haven: Yale University Press, 1953), p. 299.

21. The book was published under the title *Autobiography, Reminiscences and Letters of John Trumbull, from 1756 to 1841* (New York: Wiley and Putnam, 1841). For information on the *Autobiography*, see the preface to Sizer's 1953 edition (pp. xi–xx).

22. Irma B. Jaffe, *John Trumbull: Patriot-Artist of the American Revolution* (Boston: New York Graphic Society, 1975), p. 276. By refusing to revisit the professional debates of the 1820s and 1830s in his *Autobiography*, Trumbull may have cultivated an air of detachment, but his silence ensured that Dunlap's version of the conflict between the two New York art institutions would prevail.

23. [John Vanderlyn], *Review of the "Biographical Sketch" of John Vanderlyn, Published by William Dunlap, in his "History of the Arts of Design;" With Some Additional Notices, Respecting Mr. Vanderlyn, As An Artist. By A Friend of the Artist* (New York, 1838), p. 62. A copy of this pamphlet is available through the Archives of American Art, Smithsonian Institution: New York Public Library, roll N44, frames 950–82. Although Vanderlyn's tone in this document was much more openly aggrieved than that of Allston or Trumbull, his decision to publish an anonymous attack on the *History* adhered to the code of partisan politics during the early republic. Gentlemen did not attack other gentlemen directly in the press but left this responsibility to their agents.

the impact of negative public opinion on his career.[24] By virtue of his training, he stood outside the Anglo-American art tradition that Dunlap sought to enshrine in his account; at the urging of his principal sponsor, Aaron Burr, Vanderlyn was the first American-born artist to undertake formal study in France.[25] Upon his return from Europe, Vanderlyn deliberately removed himself from the protective orbit of New York's art institutions by distancing himself from both the American Academy and the National Academy of Design.[26] As an art world outsider, Vanderlyn was in a unique position to expose Dunlap's prejudices. His pamphlet presents the most compelling contemporary indictment of the *History*, yet because of Vanderlyn's long history of airing his private grievances, his vigorous defense seems to have had little impact.[27]

Like Allston, Vanderlyn complied with Dunlap's request for biographical information, only to be unhappy with the final result. Although Dunlap cited a "memoir written by a friend of the artist" as his principal source for the facts of Vanderlyn's life, it is almost certain that the artist himself was the author of this sketch.[28]

24. Another factor governing artists' responses to public opinion was surely social class, but scholarly investigations of the relationship between American artists and class are rare. One noteworthy exception is Phoebe Lloyd, "Washington Allston: American Martyr?" *Art in America* 72 (March 1984): 145–55, 177, 179.

25. During 1796–98, Vanderlyn studied in the Parisian atelier of François-André Vincent and at the École des Beaux-Arts. For more information on his education in France, see William Townsend Oedel, "John Vanderlyn: French Neoclassicism and the Search for an American Art," Ph.D. diss., University of Delaware, 1981, chap. 2, and H. Barbara Weinberg, *The Lure of Paris: Nineteenth-Century American Painters and their French Teachers* (New York: Abbeville Press, 1991), pp. 26–35. Lois Fink discusses Vanderlyn's submissions to the French Salons during his first two stays in Paris in *American Art at the Nineteenth-Century Paris Salons* (Washington, D.C.: National Museum of American Art, Smithsonian Institution/ Cambridge: Cambridge University Press, 1990), pp. 10–30.

26. Vanderlyn served an unhappy stint as a purchasing agent for the American Academy during his second trip abroad and quickly came into conflict with the Academy's administration after he settled in New York in 1815. A dispute flared up the following year when the Academy attempted to close an independent exhibition Vanderlyn was holding in its rooms in order to install its first annual exhibition. The incident angered the artist and he subsequently considered the Academy as his enemy, refusing academician status and helping to circulate criticisms of the art institution in the press (Rebora, "American Academy," pp. 124–33). Vanderlyn did not have a closer relationship with the National Academy of Design after its founding. He publicly declined nomination to the Academy by publishing a scathing refusal in a local newspaper, and he submitted no works to its first four annual exhibitions; see Louise Hunt Averill, "John Vanderlyn, American Painter (1775–1852)," Ph.D. diss., Yale University, 1949, p. 150–52, and [Vanderlyn], pp. 37–42. Vanderlyn also blamed the members of both institutions for their failure to support the New York Rotunda, his unsuccessful venture to create a permanent venue for the exhibition of panoramas in New York City.

27. C. Edwards Lester did not even include John Vanderlyn in *The Artists of America: A Series of Biographical Sketches of American Artists* (New York: Baker & Scribner, 1846), the first survey of American art to appear after Dunlap's *History*.

28. Two of Dunlap's letters of inquiry to Vanderlyn survive ("William Dunlap to John Vanderlyn," April 25, 1833, and July 26, 1834, New-York Historical Society), but Vanderlyn's reply (dated August 7, 1834) has disappeared from the New-York Historical Society. Fortunately an appendix to Louise Hunt Averill's 1949 dissertation on the artist preserves a transcription of Vanderlyn's letter; see Averill, p. 278. This letter

Vanderlyn must have been alarmed to read Dunlap's assertion at the beginning of the biography that "as it is not the intention of my work merely to praise," he would not rely entirely on the manuscript biography given him but would "give my own opinions both of the painter and his works."[29] Such editorial comments were the principal subject of Vanderlyn's 64-page rebuttal published under the name of the same anonymous "friend of the artist" who had supplied Dunlap with information.[30] Writing in the third person, Vanderlyn began his pamphlet by explaining: "In consequence of sundry omissions in the published sketch, and of the general tenor and spirit of Mr. Dunlap's comments, which seemed, at least, to lack courtesy towards Mr. Vanderlyn, if not positively illiberal and invidious, the writer of the sketch deems it due to the distinguished Artist who was its subject, to publish some comments in his turn, on the remarks of Mr. D., and vindicate so far as is in his power, the character of his friend."[31]

One parenthetical remark that provoked Vanderlyn's ire regarded his copy of Correggio's *Antiope* (figure 19), executed in Paris in 1809.[32] Dunlap introduced a moralizing note when he wrote of the painting: "I first saw this admirable copy at the house of John R. Murray, Esq. from whom, I then understood, Mr. Vanderlyn

strongly suggests that Vanderlyn was the author of the sketch. Vanderlyn wrote: "The enclosed sketch will I presume suffice you, my absence from here [New York] for the last six or seven months has been the cause of delay in furnishing the documents—and I am not able even at this time to give you the concluding part of it, relating to the business with the Rotunda and Corporation of the City. I propose in a short time to publish the whole of that transaction in a small pamphlet which may furnish you with matter for the concluding part." Entries in Dunlap's diaries are also consistent with this attribution (see Dunlap, *Diary*, pp. 720, 743, 806, 813, and 824). As the manuscript autobiography of the architect A. J. Davis at the Avery Architectural and Fine Arts Library, Columbia University, indicates, Dunlap willingly maintained the anonymity of his correspondents if they desired it.

29. Dunlap, *History*, vol. 2, p. 31.

30. There is compelling evidence to suggest that Vanderlyn was also the author of this pamphlet. In fact, Averill attributed both memoir and pamphlet to Vanderlyn (see n. 85, p. 155). As documented by Vanderlyn's many publications regarding his New York Rotunda, the artist had a record of attacking his enemies in print. Also, it is unlikely that anyone but Vanderlyn would have had cause (or the patience) to produce such a detailed defense of his reputation. In a note to his chapter "Labyrinths of Meaning in Vanderlyn's *Ariadne*," David Lubin attributed the pamphlet to Vanderlyn's nineteenth-century biographer Robert Gosman, but this seems unlikely; see Lubin, *Picturing a Nation: Art and Social Change in Nineteenth-Century America* (New Haven: Yale University Press, 1994), n. 70, p. 325. Averill reproduced the text of Gosman's never-published biography, as edited by Dorothy Barck of the New-York Historical Society, in appendix B of her dissertation. Barck had noted in her introductory remarks that Gosman wrote his sketch c. 1849–52 after extended conversations with the artist during 1849—more than ten years after the pamphlet was published (Averill, p. 293).

31. [Vanderlyn], p. 3.

32. During the 1840s, Vanderlyn painted a second, smaller version of the *Antiope* (Gibbes Museum of Art, Charleston, S.C.); see Kenneth C. Lindsay, *The Works of John Vanderlyn: From Tammany to the Capitol* (Binghamton: State University of New York, 1970), catalogue no. 15, for a reproduction of the later version.

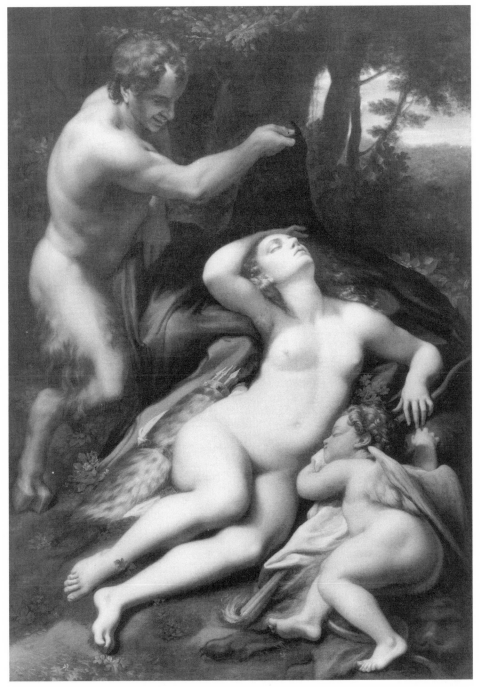

FIGURE 19. John Vanderlyn, *Antiope* (after Correggio), 1809. Oil on canvas, 70 ¼ × 51 in. Courtesy of the Century Association, New York.

had received a commission to copy a picture for him. Murray admired it, but he said 'What can I do with it? It is altogether indecent. I cannot hang it up in my house, and my family reprobate it.' The artist had consulted his own taste, and the advantage of studying such a work, more than the habits of his country, or the taste of his countrymen."[33] Vanderlyn took this passage as a personal attack and retorted disdainfully in the pamphlet: "Mr. V. is not to be charged with possessing an indelicate or indecent taste himself in regard to his profession, because his picture did not please the family of Mr. Murray, or his countrymen at large, if that be the fact. It was painted for neither the one nor the other."[34] In addition to denying his need for popular approval, Vanderlyn intimated that his critics lacked sophistication, reminding his readers that both painted and sculpted nude figures by acclaimed masters were exhibited in Europe without prejudice. Playing upon the cultural insecurities of Americans, he contended that no "person of refined and cultivated taste" would consider such works indecent, and suggested that any "impure or immoral feeling" in response to the *Antiope* originated in the mind of the viewer, not in the artwork itself.[35] Vanderlyn also argued that without recourse to the study of the human form, American artists would stifle their artistic development and reduce the number of their possible subjects, for "if artists are to be limited in studying and painting the human subject to the mere face and drapery, and to be debarred entirely from pourtraying the naked figure or any portion of it except the uncovered face and hands, not only the half naked savage, (a noble subject, certainly, for the sculptor and painter,) can never be represented on canvass or by the chisel, but the entire of heathen mythology, nay the Holy Scriptures themselves . . . would be *tabooed* to the artists of modern times."[36]

Vanderlyn's explanation demonstrates the gap between his Continental training and contemporary conditions in the United States. In the French academic system, student painters often copied works such as Correggio's as a prelude to creating an

33. Dunlap, *History*, vol. 2, p. 36.

34. [Vanderlyn], p. 13. Vanderlyn's relationship with his patron John Murray, whom he had met when both were students at the Columbian Academy in New York City during the 1790s, seems to have been permanently strained when the artist acted as the European agent for the American Academy of the Fine Arts and Murray was an Academy officer. For the beginning of Vanderlyn's acquaintance with Murray, see Oedel, "John Vanderlyn," p. 25. For full details of Vanderlyn's troubled relationship with the American Academy, see Rebora, "American Academy," chap. 3.

35. [Vanderlyn], p. 15.

36. Ibid., pp. 15–16. Vanderlyn noted that Benjamin West, John Trumbull, and even Dunlap himself had painted nude figures and that the casts imported by the American Academy were unclothed (p. 14). Vanderlyn's reference to the "half naked savage" serves as a reminder that the artist had painted the seminude figures of Native Americans in the *Death of Jane McCrea*, 1804 (Wadsworth Athenaeum).

original composition. Vanderlyn followed this procedure when he executed the *Antiope* before attempting his ambitious painting *Ariadne Asleep on the Island of Naxos*, 1809–14 (figure 20).[37] Although Vanderlyn achieved significant critical success in Paris, he faced a more skeptical audience on his return to the United States. He initially benefited from his association with the Parisian art world, valued by Aaron Burr and his Republican, pro-French allies, but his training became a liability owing to strained Franco-American relations and the precipitous decline of Burr's political fortunes.[38] In addition, the art community in the United States remained either unfamiliar with or resistant to the French academic tradition during the early nineteenth century. The assessment of contemporary French art by Thomas Cole included in the *History* is representative of American opinion: "Modern French painting pleased me even less than English. In landscape they are poor—in portrait, much inferior to the English; and in history, cold and affected. In design they are much superior to the English; but in expression, false.—Their subjects are often horrid: and in the exhibition at the Louvre I saw more murderous and bloody scenes than I had ever seen before."[39] It would not be until the middle of the nineteenth century that interest in contemporary French art would gain momentum among collectors in the United States and encourage American artists to pursue education in Paris.[40] Although Vanderlyn's career anticipated the replacement of London by Continental art centers as the primary stylistic and educational models for American artists, he remained well outside the artistic mainstream in the 1830s. It was Vanderlyn's misfortune that at the very time he offered a stylistic alternative to British models, Dunlap was celebrating and codifying the Anglo-American art tradition.[41]

37. Vanderlyn also made copies of Correggio's *Leda and the Swan* and Titian's *Danaë* (both copies unlocated) during the period 1809–14 as further investigations of the nude female form (Oedel, "John Vanderlyn," pp. 361–62). David Lubin presents a variety of cultural lenses through which to view Vanderlyn's *Ariadne*—including some of the debates about the female nude discussed here (Lubin, pp. 1–53).

38. Oedel, "John Vanderlyn," pp. 6–14. Lubin discusses Vanderlyn's *Ariadne* within the political context of the battle between pro-French (Democratic-Republican) and pro-English (Federalist) factions within the United States during the early republic (see Lubin, esp. pp. 42–48).

39. Dunlap, *History*, vol. 2, p. 363. Barbara Weinberg notes that French art was also thought to be lascivious by Americans (Weinberg, p. 25).

40. Boston was the center of the subsequent development of an American taste for French art, according to Alexandra R. Murphy's essay "French Paintings in Boston: 1800–1900," in *Corot to Braque: French Paintings from the Museum of Fine Arts, Boston* (Boston: Museum of Fine Arts, 1979). Murphy notes that several contemporary French paintings were exhibited during the 1820s and 1830s in Boston including a replica of Jacques-Louis David's *Coronation of Napoleon* (now at Versailles) and Claude-Marie Dubufe's paintings of Adam and Eve (discussed below), indicating that French art had some popular appeal during the period (p. xxiv).

41. William Oedel has argued persuasively that the influence of French neoclassicism on the paintings of John Vanderlyn and Rembrandt Peale had political implications. According to Oedel, both artists were

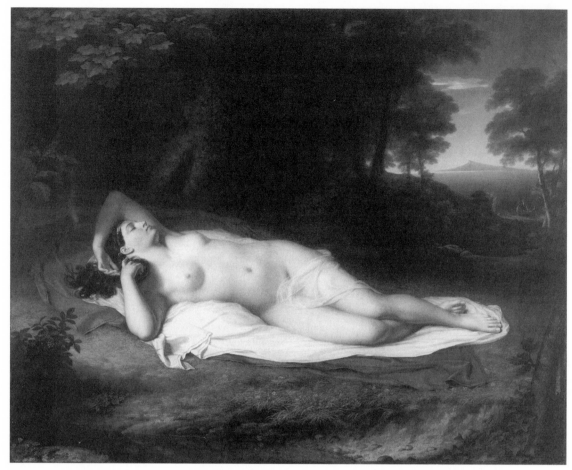

FIGURE 20. John Vanderlyn, *Ariadne Asleep on the Island of Naxos*, 1809–14. Oil on canvas, 68 ½ × 87 in. Courtesy of the Pennsylvania Academy of the Fine Arts, Philadelphia. Gift of Mrs. Sarah Harrison (The Joseph Harrison Jr. Collection).

In addition to highlighting contemporary mistrust of Vanderlyn's French training, the artist's lengthy defense of the *Antiope* copy raises the related issue of American uncertainty about the propriety of the nude as a subject of art.[42] The art histo-

searching for a style that would represent a clear break from the American colonial past and that would be consonant with the republican principles of the new nation. See William T. Oedel, "After Paris: Rembrandt Peale's Apollodorian Gallery," *Winterthur Portfolio* 27 (Spring 1992): 1–27. As noted elsewhere in the present study, Dunlap's concern for artistic continuity consistently overrode any interest in encouraging the creation of a distinctive American style.

42. See William H. Gerdts, *The Great American Nude: A History in Art* (New York: Praeger, 1974), esp. chaps. 2 and 3; E. McSherry Fowble, "Without a Blush: The Movement toward Acceptance of the Nude As

rian William Oedel has shown that Vanderlyn was aware that the *Antiope* could occasion controversy but was hoping its sensationalism might draw the public as had Adolf Wertmüller's *Danaë and the Shower of Gold*, 1787 (figure 21), when it was exhibited in Philadelphia and other American cities during the early nineteenth century.[43] In fact Vanderlyn anticipated John Murray's objections to the *Antiope* in an 1809 letter to his patron. Vanderlyn warned Murray: "The Subject may not be chaste enough for the most chaste & modest Americans, at least to be displayed in the house of any private individual, to either the company of the Parlour or drawing room, but on that account it may attract a greater crowd if exhibited publicly, & the subject may thus invite some who are inca[pa]ble of being entertained by the merits the picture may possess as a work of art."[44] In short, Vanderlyn was willing to market the *Antiope* as a spectacle.

Negative reactions to Vanderlyn's depictions of the nude not only reveal Americans' moral qualms but also suggest the fear inspired by popular interest in the controversial paintings.[45] A number of nineteenth-century American commentators were worried by the eager public response to the exhibition of titillating works. This concern is evident in the press coverage surrounding the successful U.S. tour of Claude-Marie Dubufe's pendant paintings *The Temptation of Adam and Eve* and *The Expulsion from Paradise* (1828), known today only through engravings (figures 22 and 23).[46] Although often shown in rooms rented from established art institutions such as the Boston Athenaeum or New York's American Academy of the Fine Arts, the Dubufe exhibitions were an independent venture organized by two British art

an Art Form in America, 1800–1825," *Winterthur Portfolio* 9 (1974): 103–21; Lubin, pp. 10–17; Oedel, "John Vanderlyn," chap. 7; and Oedel, "After Paris," pp. 9–10 and 14–24.

43. Oedel, "John Vanderlyn," pp. 355–58. Wertmüller was a Swedish emigrant to the United States. Oedel argues that based on the success of Wertmüller's painting of Danaë, Vanderlyn made a reasonable gamble when he undertook the *Antiope*. He writes that Vanderlyn "is too often portrayed as woefully out of step with his times; actually he was only a half-step off the tempo" (p. 352). See also [Vanderlyn], p. 13, and Gerdts, *The Great American Nude*, pp. 39–41.

44. "John Vanderlyn to John R. Murray," July 3, 1809, Charles Henry Hart Autograph Collection, 1731–1912, Archives of American Art, Smithsonian Institution (available on roll D5, frames 323–26), quoted in Oedel, "John Vanderlyn," p. 357.

45. As Dunlap predicted, Vanderlyn's paintings of the female nude met with resistance when they were exhibited in New York and elsewhere. See Dunlap, *History*, vol. 2, p. 277, and Oedel, "John Vanderlyn," pp. 396–97. David Lubin relates the story of the *Ariadne* being stopped by customs officials in Havana because of the figure's nudity (Lubin, p. 14).

46. Kendall B. Taft, "Adam and Eve in America," *Art Quarterly* 23 (Summer 1960): 171–79, and Gerdts, *The Great American Nude*, pp. 46–47. Fire destroyed Dubufe's original paintings sometime in the mid-1830s, but the artist painted replicas during the 1850s (also lost) that were engraved by Henry Thomas Ryall (Taft, p. 179).

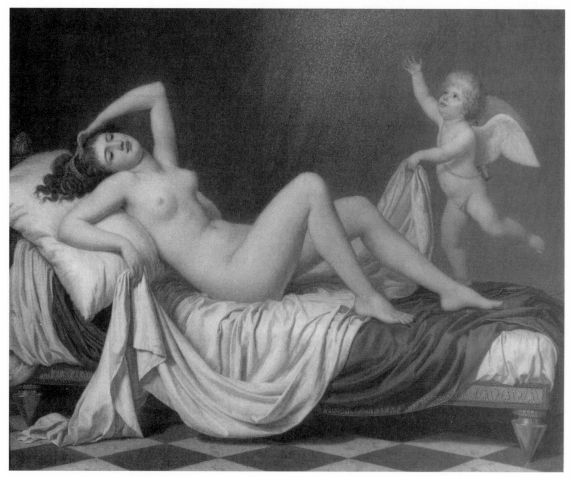

FIGURE 21. Adolf Wertmüller, *Danaë and the Shower of Gold*, 1787. Oil on canvas, 150 × 190 cm. The National Swedish Art Museums, Stockholm. Photo copyright Erik Cornelius, National Museum.

dealers.[47] While the paintings received substantial critical praise, they also occasioned anguished soul-searching among certain viewers. A correspondent for the *New-York Mirror* asked, somewhat breathlessly, "How is it that our citizens are thus enamoured of *primitive nakedness*? And in what school of glittering iniquity did they first learn to pronounce eulogium on the artist whose pencil could 'round the swelling muscles,' and cause the canvas to glow with the tints and heave with the passions

47. Taft, p. 172. According to this source, 25,000 people saw the Dubufe paintings during their four-month exhibition in New York in 1833 (p. 173). That these paintings were shown at such established art institutions as the American Academy of the Fine Arts despite their controversial nature indicates the financial dependence of early American art institutions on the rent money brought in by independent exhibitions.

of denuded flesh? Or is this propensity to admire what is abominable unlearned, innate, a deep-seated 'leprosy of the soul,' now breaking forth in its might to keep pace with the *refinement of the age*?"[48] Such protests suggest that self-appointed cultural arbiters—including the writer for the *Mirror*—would have viewed Vanderlyn's willingness to cater to popular taste and to jettison a didactic function for his artwork as a formidable social threat. Just as Vanderlyn and others criticized Dunlap's *History* for appealing to its readers' appetite for gossip and scandal rather than stimulating thoughtful reflection, critics attacked the exhibition of paintings such as Vanderlyn's *Antiope* for catering to the prurience of the viewing public.[49]

Allston, Trumbull, and Vanderlyn all displayed a discomfort in relinquishing the shaping of their public personas to a biographer such as Dunlap and in allowing the public to pass judgment on their work. In the autobiographical letters sent to Dunlap for use in the *History*, Allston, for example, developed a very careful portrait of himself as a dedicated, self-effacing artist, only to see this image threatened by Dunlap's annotations.[50] The independent publications issued by each painter—Allston's aesthetic treatise, *Lectures on Art* (1850), which appeared posthumously, Trumbull's autobiography, and Vanderlyn's pamphlet—clearly illustrate a desire not to allow Dunlap to have the final word. One may contrast the distaste the three men displayed toward the popular art market with the alacrity with which numerous artisans assumed the role of itinerant portrait painter during the early republic as a means of social advancement.[51] The success enjoyed by painters including Rufus Porter, Ammi Phillips, and Erastus Salisbury Field—none of whom is mentioned in the *History*—contrasts sharply with the professional disappointment expressed by European-educated artists such as Trumbull, Vanderlyn, Rembrandt Peale, and Samuel Morse. This difference also highlights the inconsistencies in the *History*: Dunlap placed emphasis in his account on artists with ambitions to paint

48. "Adam and Eve," *New-York Mirror*, June 1, 1833, p. 379. The vividness and directness of the language used in this passage stand out from the vague descriptions found in many contemporary exhibition reviews.

49. In addition to his accusation cited in the epigraph to this chapter, John Vanderlyn charged Dunlap: "Have you not ransacked [artists'] firesides, their 'sacred homes,' their 'domestic board,' to spy out something pitiable or ridiculous, whereby to pamper a corrupted public taste" ([Vanderlyn], p. 62).

50. David Bjelajac has suggested that Allston depicted himself in his autobiographical sketches for the *History* as a kind of New World prophet who was willing to sacrifice fame and patronage within the British art world in order to devote himself to furthering the spiritual progress of the United States; see Bjelajac, chap. 6, esp. pp. 132–33.

51. David Jaffee, "The Age of Democratic Portraiture: Artisan-Entrepreneurs and the Rise of Consumer Goods," in *Meet Your Neighbors: New England Portraits, Painters, and Society, 1790–1850*, ed. Caroline F. Sloat (Sturbridge, Mass.: Old Sturbridge Village, 1992), pp. 35–46.

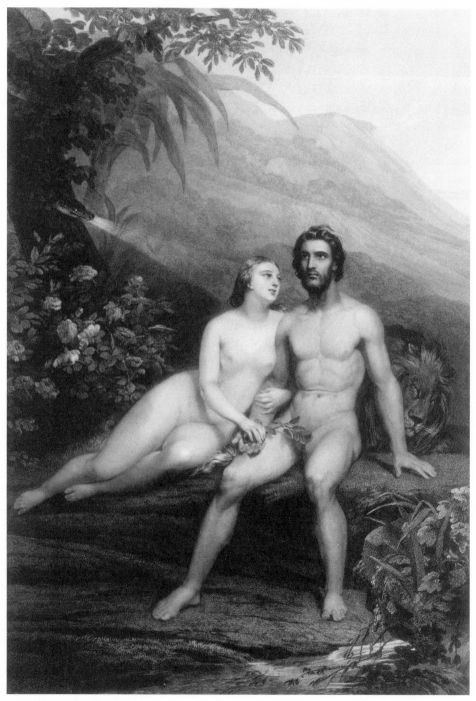

FIGURE 22. Henry Thomas Ryall, engraving after *The Temptation of Adam and Eve* (1828) by Claude-Marie Dubufe, 1860. British Museum, London. © The British Museum.

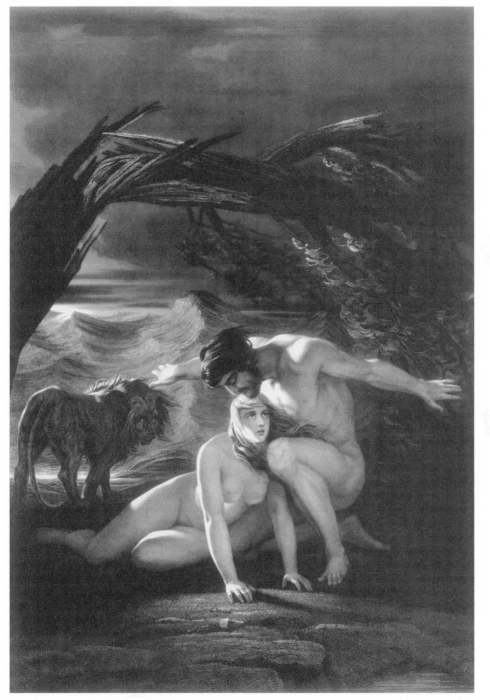

FIGURE 23. Henry Thomas Ryall, engraving after *The Expulsion from Paradise* (1828) by Claude-Marie Dubufe, 1860. British Museum, London. © The British Museum.

in the "grand manner," but did not acknowledge that the growing role of public taste within the U.S. art market—a trend the book accelerated—threatened the tradition on which these aspirations were based. The objections voiced by Allston, Trumbull, and Vanderlyn should be read as evidence of the concerns of a specific contingent of U.S. artists in the face of changing conditions.

The Press Responds

Incomplete sales records make it impossible to develop a composite portrait of the *History*'s subscribers, leaving published reviews to supply the only measure of public reaction to the book (see appendix C).[52] Differing conclusions about the book in these reviews disclose the regional allegiances of the periodicals in question. Unsurprisingly, given William Dunlap's own regional bias, New York magazines offered the most favorable reviews of the *History*. The evaluations in Philadelphia and Boston publications were more ambivalent. A correspondent of John Trumbull actually charged that Dunlap had a prejudice against artists working in Philadelphia.[53] Echoing concerns expressed by artists, criticisms of the *History* issued by some journal correspondents raised the alarm that the book's emphasis on anecdote contributed to the debased taste of the reading public. As seen in this chapter's epigraph, John Vanderlyn drew an explicit connection between the gossipy quality of the *History* and the regular diet of scandal found in the popular press. Both Vanderlyn's comment and the diverging reviews of the book reveal a contemporary struggle, mediated by the press, over the proper repository and exercise of cultural authority.[54]

52. Surviving documents reveal that four years after the *History*'s appearance, William Dunlap had sixty unsold copies on hand, from a printing of one thousand; see "William Dunlap to Joseph B. Boyd," September 12, 1837, Historical Society of Pennsylvania, available through the Archives of American Art, Smithsonian Institution, roll P22, frame 600. The National Academy of Design's order for sixty copies in 1838 was undoubtedly intended to liquidate this stock; see Thomas S. Cummings, *Historic Annals of the National Academy of Design* (New York: Da Capo Press, 1969 [orig. pub., Philadelphia, 1865]), p. 153.

53. William P. Campbell noted the regional differences among the published reviews of Dunlap's book in his introduction to the 1965 edition of the *History*; see *History of the Rise and Progress of the Arts of Design in the United States*, ed. Alexander Wyckoff (New York: Benjamin Blom, 1965), p. xxiii. For the charge of regional bias, see "James Akin to John Trumbull," February 21, 1835, John Trumbull Papers, Manuscripts and Archives, Yale University Library (HM 221, reel 2, frames 869–70).

54. Scholars are still debating the meaning of the term "popular culture" when applied to the early nineteenth century. For an introduction, see David D. Hall's book review, "A World Turned Upside Down?" *Reviews in American History* 18 (March 1990): 10–14, of Lawrence W. Levine's *Highbrow/Lowbrow: The Emergence of Cultural Hierarchy in America* (Cambridge: Harvard University Press, 1988). Levine traced the transformation in the United States from a shared public culture to an individualized, "sacralized" culture by the end of the nineteenth century, one policed by social elites. Hall took Levine to task for the generalizations implicit in his account of the emergence of a high/low cultural dichotomy. For example, he ques-

Despite the reservations expressed in some reviews, the critical response to the *History* was generally positive. Reviewers were uniform in their praise of the breadth of Dunlap's research, and they declared the *History* a valuable addition to the fund of knowledge regarding American artists. Even those critical of Dunlap's writing style conceded that his analyses displayed good sense, if not profundity. The critics also warmed to the patriotic appeal of the *History*. Though some noted specific deficiencies in the art world, they shared Dunlap's optimistic belief in the cultural progress of the United States. The correspondent for the *North American Review* spoke for many when he celebrated past glories: "That we have had many artists of exalted genius, the collections of this country and Europe fully prove." And he predicted future triumph: "The elder teachers of American artists have passed or are passing away; but a new generation is coming forward, to dispute the palm, perhaps to win the victory."[55] Although critics disapproved of Dunlap's attacks against Trumbull, and several questioned his unqualified praise of Benjamin West, they accepted most of Dunlap's assessments of his subjects.

Reviewers did identify some weaknesses in the *History*. A prominent complaint was the book's poor organization and the author's lack of discrimination. The *American Quarterly Review* grumbled: "Horace Walpole called his work on British art, 'Anecdotes of Painting,' and our author, in the same way, might have entitled his production 'Anecdotes of Painters, Sculptors, Architects, and Engravers, and of any and every body who has had the remotest connexion with the Arts of Design in the United States.' Such is unquestionably its true description."[56] Several critics suggested that Dunlap paid too much attention to minor artists, and one declared, "we should have much preferred a smaller book, containing only the lives of eminent artists, with a more detailed and philosophical analysis of their principal works."[57] The most serious fault found by Dunlap's detractors was his practice of reporting

tioned the extent to which early American culture was actually a shared one and disputed the argument that exclusion motivated all advocates of high culture. In place of Levine's portrait of stratification, Hall argued that high and low were intimately connected, borrowing constantly from each other. It was the expansion of capitalism, Hall reminded his readers, that underlay the redefinition of culture during the course of the nineteenth century. Dunlap's *History* demonstrates a similar cultural permeability; Dunlap assumed the roles of both expert (passing judgment, establishing hierarchies) and friendly guide (assuming an affinity with both his fellow artists and general readers). The *History* offered new subject matter to the expanding popular base of the publishing market.

55. "Dunlap's History of the Arts," *North American Review* 41 (July 1835): 169.

56. "*History of the Rise and Progress . . .* ," *American Quarterly Review* 17 (March 1835): 144.

57. "*History of the Rise and Progress . . .* ," *New-England Magazine* 8 (March 1835): 239.

on artists' personal lives. The *North American Review* charged that Dunlap "has been too free in showing up the private histories of artists, and blazoning abroad circumstances in their domestic or personal relations, which ought to have been held forever sacred from the public gaze. A man no more forfeits his individual rights by becoming a painter or sculptor, than he does by becoming a shoe-maker or house-carpenter,—and that great busy-body, the public, has as good a claim to pry into and violate the sanctity of domestic life, in the one case, as in the other."[58] Dunlap would certainly not have been pleased with this statement's dismissive equation of artists with craftsmen.

The *North American Review*'s condemnation of Dunlap's curiosity and that of his readers echoes contemporary debates about the biographical genre, and as with discussions about artistic representations of nude figures, exposes a fear of popular taste. Based on his study of American biography during the nineteenth century, Scott Casper has suggested that there was a division of opinion during the early republic about the suitable focus of a biographer. Although both sides of the dispute shared the republican belief that the ultimate function of any biography should be didactic, they disagreed about the best means of instruction. Some critics, citing the example of Samuel Johnson's essays, believed that readers would learn most from a subject's private life, while their opponents contended that people should be judged solely by their public deeds.[59] In the preface to the *History*, Dunlap invoked the former argument:

> To publish the biography of the living is objected to by some. They say, if truth is told, the feelings may be wounded; and if mere eulogium is aimed at, truth will be wounded, the public deceived, and that which pretends to be history, will become a tissue of adulatory falsehood. But of public men—and every artist is a public man—the public have a right to demand the truth. . . . Every artist wishes, and ought to wish, that public attention should be called to him. It is for him so to conduct himself, both as an artist

58. "Dunlap's History of the Arts," *North American Review* 41 (July 1835): 147. In a letter to the New York newspaper *The Evening Star*, rebutting the portraits of himself and his father Charles Willson Peale in the *History*, Rembrandt Peale remarked, "I lament that the public must be amused with the envies, jealousies, and misunderstandings, of artists, and hope to be excused, in vindication of my character and of truth, that I now lay down my humble pencil to take up the dangerous pen, too often the slippery instrument of scandal and error" (Peale, "To William Dunlap," *The Evening Star*, December 31, 1834, n.p.).

59. See Scott E. Casper, *Constructing American Lives: Biography and Culture in Nineteenth-Century America* (Chapel Hill: University of North Carolina Press, 1999), chap. 1. Casper observes that though U.S. periodicals favored Johnson's encouragement of biographers to examine their subjects' private lives, most full-length biographies published in the early nineteenth century traced only their public deeds (Casper, pp. 38–40).

and a man, that his works and his actions may defy scrutiny, and his reputation may be increased by a knowledge of the truth.[60]

By taking the moral high ground, Dunlap attempted to forestall charges of malice.

Unlike the reviewer for Boston's *North American Review*, the correspondent for the New York-based *Knickerbocker* approved of the fact that "the author has not bound himself down to the dry details of the history of the arts of design in this country," continuing that "a singular aptness in the arrangement of facts and incidents, and an *unexpectedness* in the introduction of pleasing occurrences and amusing anecdote, form a striking feature of the volumes."[61] The *New-York Mirror* also applauded Dunlap's anecdotal approach, describing the *History* as

> an admirable fire-side companion: open it where you will, you find an abundance of choice morsels; roving, with most agreeable variety, 'from grave to gay, from lively to severe.' You may read it through at once, or keep it on your table or beneath the pillow of your sofa, and take it up whenever you have a spare half hour; and when you have turned the last leaf of the second volume, you will be strongly tempted to wish that you could forget it every word, and begin again with all the zest of novelty hanging fresh about its pages.[62]

These differences of critical opinion regarding the *History* not only disclose a regional divide, but also parallel debates within the diverse constituencies of the publishing industry. A correspondent for the *American Quarterly Review*, published in Philadelphia, seemed to distrust the unspoken alliance between Dunlap and the general public detected by the critic for the *North American Review*. Asserting that "heart easing mirth, is after all, the lady who possesses the greatest attractions for the mass," the *American Quarterly* reviewer observed that Dunlap "contrives to keep his readers in such good humour, for the most part, by the amusement which his

60. Dunlap, *History*, vol. 1, p. iii. Criticism over his profile of John Trumbull ultimately forced Dunlap to defend his approach as a biographer publicly; see the Pennsylvania Academy's copy of *The National Academy of Design. William Dunlap, Vice President of the National Academy of Design, and Colonel Trumbull, President of the American Academy of Fine Arts, New York* (Philadelphia, 1835), available through the Archives of American Art, Smithsonian Institution, roll P38, frames 51–57. The anonymous author of this pamphlet was undoubtedly Dunlap; appendix A in this volume provides a summary of its contents.

61. "*History of the Rise and Progress* . . . ," *Knickerbocker* 4 (December 1834): 491.

62. "*A History of the Rise and Progress* . . . ," *New-York Mirror*, November 1, 1834, p. 139. The description of the various ways in which a reader could consume the *History* also belongs to a larger contemporary debate. Isabelle Lehuu chronicles the collision between the traditional authority of the printed word and new reading practices encouraged by the expanded marketplace in her study *Carnival on the Page: Popular Print Media in Antebellum America* (Chapel Hill: University of North Carolina Press, 2000); see esp. chap. 6. Lehuu's discussion of the way that critics of the new print culture unfavorably contrasted a sampling approach to books with more established habits of reading intensively helps to illuminate the cultural positions staked out by reviewers of Dunlap's *History*.

pages afford, that it would be almost impossible for them to deal severely with his authorship."[63] This censure echoes contemporary condemnations of novels. In contrast, the critic for the *New-York Mirror* praised the wide scope of Dunlap's account, remarking of the *History*: "To the artist, of course, it will prove invaluable; but a very large proportion of the matters it contains address themselves with equally pleasant and happy effect to the scholar, the man of business in his hours of relaxation, the student of human nature, the literary idler, and even to the belle, when wearied with conquest and admiration—to such as read merely for amusement as well as to the seeker after knowledge."[64] Of course this passage could also serve as a profile of the *Mirror*'s desired readership. The variation in critical responses may therefore be related to the different audiences solicited for a weekly magazine such as the *Mirror* and for more sober publications such as the *American Quarterly Review* or *North American Review*.[65] The reviews thus divide according to their correspondents' opinions about the growing commercial might of the middle-class reading public.[66]

The diverse critical responses to the *History* also highlight inconsistencies in the relationship Dunlap established with his readers. Dunlap believed that a clear hierarchy should govern artistic culture. Artists, mindful of their professional position, would address an educated elite, raising the level of public taste indirectly through the example of their artworks. The *History* fulfilled a similar didactic mission by measuring the lives of artists against a moral standard. Critics of the book, however, suggested that Dunlap had sensationalized his subject beyond the bounds justified by public instruction in order to attract readers. Earlier in his life, Dunlap had faced a similar dilemma over an audience when he served as the manager for a New York theater. Ironically, Dunlap himself had publicly deplored the detrimental effect popular taste had on the quality of the plays he was able to produce.[67] In both

63. "*History of the Rise and Progress . . . ,*" *American Quarterly Review.*

64. "*A History of the Rise and Progress . . . ,*" *New-York Mirror.*

65. Harlow W. Sheidley discusses the ways in which the Boston elite employed the *North American Review* to promote their sectional and ideological values in *Sectional Nationalism: Massachusetts Conservative Leaders and the Transformation of America, 1815–1836* (Boston: Northeastern University Press, 1998), pp. 97–117. She observes, "As well as serving nationalist and sectional purposes, the *North American Review* was also a major weapon in the elite's war of containment waged against the cultural democracy implicit in the expansion of knowledge and the rapid spread of print" (p. 97).

66. Isabelle Lehuu observes that even "the cultural arbiters who resisted the popularization and commercialization of letters and advocated a return to a more orderly and unified print culture were themselves using the new genres of printed matter to warn their audience against sinful behavior" (Lehuu, p. 32).

67. See David Grimsted, "William Dunlap: The Corruption of an Enlightened Age," in his *Melodrama Unveiled: American Theater and Culture 1800–1850* (Chicago: University of Chicago Press, 1968).

cases a changing cultural market brought uncertainties about artistic standards. Dunlap's attempt to position the *History* within the expanding publishing market meant that American art and artists became implicated in critical debates about the popularizing trend in American writing. Dunlap privileged the role of the historian over traditional elites to mediate between artists and the public, but some observers believed his attempts to reach a larger audience compromised his intended role as a cultural authority.

The published reviews of the *History* provide an additional window onto the struggle over the responsibilities of the historian. Differences of opinion about the value of the *History* reflect the two conflicting models of information diffusion it imitated–the chronicle versus the narrative. Statements about the lack of discrimination found in its contents highlight the principal limitation of an antiquarian chronicle: lack of narrative continuity. A reviewer for the *New England Magazine* observed of the *History*: "We doubt the possibility of making so large a work, consisting of such an infinite variety of facts, many of them of but little consequence, a generally readable book; and that is the thing now wanted to stimulate the interest of the public in the humanizing art."[68] Though Dunlap employed the techniques of storytelling to make individual biographical sketches vivid, he provided no connecting tissue between these discrete units. The only elements that tie the book together are chronology and the title's promise that American art had indeed risen and progressed.

As indicated in many of the reviews, the narrative model also had serious deficiencies. By developing stories that centered primarily on artists' lives, the *History* left discussion of their artistic merits far behind. In the words of the *American Quarterly Review*, "There is little of the dignity of history in its gossiping chapters, and much more information is communicated about the men than the artists. Greater pains are taken to amuse us with traits and eccentricities of personal character, than to acquaint us with professional peculiarities. The original critical portions are for the most part meagre and unsatisfactory."[69] In other words, the love of a good story got in the way of any substantive, professional criticism. It is revealing of our own times that most modern historians have embraced an antiquarian use of the *History*, mining the book for factual nuggets while ignoring its narrative features or moral judgments. This view of the *History* serves as a reminder that uses of the

68. "*History of the Rise and Progress* . . . ," *New-England Magazine*.
69. "*History of the Rise and Progress* . . . ," *American Quarterly Review*.

book are as sensitive to cultural currents as are changing interpretations of the artists profiled in its pages.

In the end, much of the fear expressed about the deleterious effect of the *History* on an impressionable reading public seems misplaced, as the book never reached a large popular audience. Although Dunlap employed innovative techniques to promote his account, the *History* did not come close to best-seller status.[70] Yet the book's limited commercial success cannot be blamed simply on the limitations of the publishing market. The best index for popular interest in a book is its sales figures, and the *History*'s failure to inspire a second edition until 1918 suggests that many nineteenth-century readers, artists and nonartists alike, did not see their own cultural concerns embodied in the *History*. The conditions were not ripe for these readers to view the book as a means of furthering either their professional or their social ambitions.

70. Frank Luther Mott defined a best-seller as a book that sold a total number of copies equal to or greater than 1% of the contemporary U.S. population at the time of its publication. With only 1000 copies printed, the *History* fell far short of the 125,000 required to qualify as a best-seller in 1834 (Mott, *Golden Multitudes: The Story of Best Sellers in the United States* [New York: Macmillan, 1947], pp. 305–6).

EPILOGUE

Visualizing the *History*:
The Dunlap Benefit

In 1838, a correspondent for the *New-York Mirror* sounded a familiar lament about the conditions impeding the development of an American art tradition:

It has ever been a question, with those who have given the subject any serious reflection, whether an American school of painting could be permanently established in this country. The encouragement given to our artists is so very diffuse, and the construction of our government so very peculiar, that the probability of our forming a National Gallery of the works of the best masters, which shall be accessible to all, and which shall be the foundation of a truly original and talented school of paintings is about as remote and problematical as the idea of our establishing a standing army of a million of men.[1]

Despite his misgivings, the author went on to suggest a potential model for such a permanent national collection: an independent exhibition that had recently opened at the Stuyvesant Institute in New York City (figure 24). Featuring more than two hundred paintings, this "rich treat to the publick" and "ornament to the city" had been organized as a benefit for William Dunlap.[2] Occurring four years after the publication of the *History*, the Dunlap benefit provides a timely index of the book's influence. It is possible to view this long-forgotten exhibition as the illustrations missing from the *History* text since in many ways the event was a recreation of Dunlap's account. The benefit also embodied many of the contradictions found at the heart of the book's vision of American art.

Given Dunlap's long-standing involvement with the visual arts, an exhibition of paintings seemed an appropriate fundraising effort to help extricate him from dire financial straits in the late 1830s. According to a statement reproduced in the

1. "Dunlap Exhibition," *New-York Mirror*, December 1, 1838, p. 182. Dunlap's close affiliation with the *Mirror* provides one compelling reason for the magazine's fervent endorsements of the Dunlap benefit exhibition.

2. "William Dunlap, Esq.," *New-York Mirror*, October 20, 1838, p. 134.

CATALOGUE

DESCRIPTIVE, BIOGRAPHICAL AND HISTORICAL,

OF THE EXHIBITION OF

SELECT PAINTINGS.

BY MODERN ARTISTS,

PRINCIPALLY AMERICAN, AND LIVING

UNDER THE DIRECTION OF A COMMITTEE OF AMATEURS.

THE PAINTINGS BORROWED FOR THIS PARTICULAR PURPOSE

FROM FRIENDS TO THE ARTS.

AT THE

STUYVESANT INSTITUTE,

For four weeks only from the day of Opening,

Nov. 19, 1838.

NEW-YORK:

PRINTED BY G. P. SCOTT.

1838.

FIGURE 24. Title page, *Catalogue Descriptive, Biographical and Historical, of the Exhibition of Select Paintings, By Modern Artists, Principally American, and Living, Under the Direction of a Committee of Amateurs*, 1838. Courtesy of the Pennsylvania Academy of the Fine Arts, Philadelphia. Archives.

catalogue, the benefit's organizing committee—headed by the New York writer and former congressman Gulian Verplanck—planned to use the admission proceeds to subsidize Dunlap as he completed a two-volume history of New York state (to be entitled *History of the New Netherlands, Province of New York, and State of New York, to the Adoption of the Federal Constitution*). Five years earlier, a benefit theatrical performance had celebrated Dunlap's contributions to American drama. The $2,500 that this earlier tribute netted Dunlap had allowed him to conduct research for his

history of American art and defray its publishing costs.[3] Promotional material now urged the New York public to support the benefit exhibition, held in rented rooms at the Stuyvesant Institute building at Broadway and Bond Streets, in recognition of Dunlap's "great and lasting services to the arts, history, and literature of our state and country."[4] Named in honor of the Dutch colonial governor, the Stuyvesant Institute of the City of New York had been incorporated in 1836, according to city records, "for the diffusion of useful knowledge by popular lectures, the establishment of a library, a museum or cabinet of natural history, and a reading room."[5] The Institute housed not only the Dunlap exhibition but also George Catlin's "Indian Gallery" in both 1837 and 1839 (it is unclear whether the Institute ever opened its projected museum).[6]

Made up of paintings from a number of distinguished local collections as well as from artists' studios, the Dunlap benefit was a novel addition to the offerings of the New York winter season of 1838. Independent exhibitions were not an unusual phenomenon during the first half of the nineteenth century, but the benefit was distinctive in its scope, scale, and purpose. Independent displays of the period tended to fall into two categories: small, traveling exhibitions organized by European or American artists to showcase their recent work, or collections of so-called Old Master paintings assembled and offered to the public for sale by art dealers. In contrast, the large exhibition at the Stuyvesant Institute offered, in the words of its catalogue, an "exhibition of select paintings, by modern artists, principally American, and living," organized solely for the relief of one artist.[7] Although benefit performances were a standard practice in the contemporary American theater, benefit exhibitions were rare. Between 1835 and 1845, the Artists' Fund Society in Philadelphia sponsored wide-ranging exhibitions that earmarked part of their

3. See Dunlap, *Diary*, pp. 633–65, and "Correspondence of the Dunlap Benefit," *Knickerbocker* 1 (May 1833): 323–29. Philip Hone and George Pope Morris, among others, served on the committees for both benefits.

4. *Catalogue Descriptive, Biographical and Historical, of the Exhibition of Select Paintings, By Modern Artists, Principally American, and Living, Under the Direction of a Committee of Amateurs* (New York: G. P. Scott, 1838), p. 2. This catalogue is accessible through the Archives of American Art, Smithsonian Institution; see James R. Lambdin Collection, Pennsylvania Academy of the Fine Arts, roll P40, frames 907–20.

5. I. N. Phelps Stokes, *The Iconography of Manhattan Island, 1498–1909* (New York: Arno Press, 1967 [orig. pub., New York, 1926]), p. 1741.

6. See *New-York Mirror*, December 9, 1837, p. 191, and June 22, 1839, p. 414, and the Stuyvesant Institute papers, New-York Historical Society. Claude-Marie Dubufe's *The Temptation of Adam and Eve* and *The Expulsion from Paradise* (figures 22 and 23) were also exhibited there in 1837; see *New-York Mirror*, October 7, 1837, p. 112. A number of the men directing the Stuyvesant Institute—Samuel Ward and John W. Francis, for example—also had a hand in the Dunlap benefit.

7. *Catalogue Descriptive*, title page.

receipts for aid to artists (or their families) suffering from illness or poverty, but these events were not dedicated to any particular artist.[8] Conversely, the posthumous exhibition of Gilbert Stuart's paintings held at the Boston Athenaeum in 1828 and the Washington Allston retrospective installed at Harding's Gallery in 1839, while benefiting Stuart's family and Allston financially, showcased the productions of only one artist. The Dunlap benefit featured more than sixty-five painters.[9]

One look at the catalogue for the benefit reveals that the *History* provided the framework for the exhibition. Biographical information adapted from Dunlap's book accompanied many of the individual entries and, as did the *History*, the display invited its audience to marvel at the rapid rise of an American art tradition. Portraits by John Singleton Copley and Gilbert Stuart, for example, provided a historical perspective by highlighting two of the first American artists to attain international recognition (by 1838, Copley had been dead twenty-three years and Stuart ten).[10] Other artworks on view indicated the growing number of contemporary painters and the range of their chosen subjects. Though portraits did dominate the exhibition— ranging from Stuart's *James Monroe*, 1818–20 (figure 25) to Charles C. Ingham's blend of portraiture and genre in *Amelia Palmer*, c. 1829 (figure 26)—the display also recorded American forays into landscape, genre, and history painting.[11] A representation of the American landscape such as Thomas Cole's *The Oxbow*, 1836 (figure 27), complemented such scenes of American life as William Sidney Mount's *Farmers Nooning* (figure 28) of the same year. Washington Allston's biblical composition *Re-*

8. See Lillian B. Miller, *Patrons and Patriotism: The Encouragement of the Fine Arts in the United States, 1790–1860* (Chicago: University of Chicago Press, 1966), p. 109. Miller points out that in donating funds to struggling artists, the Artists' Fund Society was following the lead of the city's earlier Society of Artists of the United States (est. 1810). According to Neil Harris, New York artists established a local Artists' Fund Society in 1855; see *The Artist in American Society: The Formative Years, 1790–1860* (New York: George Braziller, 1966), pp. 256, 263, 270–71. Some artists of the era also received institutional support during their old age. For example, Yale College granted John Trumbull an annuity in exchange for his painting collection, and the Pennsylvania Academy set up a fund to assist Thomas Sully in 1867 in recognition of his service to the Academy.

9. The exhibition included works by each of the three artists discussed in the previous chapter who criticized the *History* publicly—John Trumbull, Washington Allston, and John Vanderlyn. All of these paintings appear to have been lent by private collectors rather than by the artists themselves.

10. The committee had called for such works specifically, writing that "fine specimens of the works of deceased native Americans, as Copley, West, and Stuart, would be peculiarly appropriate" (*Catalogue Descriptive*, p. 2). West was the only one of the three who was not represented.

11. A statement in the catalogue advised visitors that the five presidential portraits by Gilbert Stuart on view were available for sale (*Catalogue Descriptive*, "Appendix"). Probably these were the portraits commissioned from Stuart by the Boston framemaker John Doggett; see Richard McLanathan, *Gilbert Stuart* (New York: Harry N. Abrams in association with the National Museum of American Art, 1986), pp. 133 and 146. McLanathan notes that only the portrait of *James Monroe* survives (p. 133). The vagueness of many of the titles in the catalogue makes it difficult to identify all of the works exhibited.

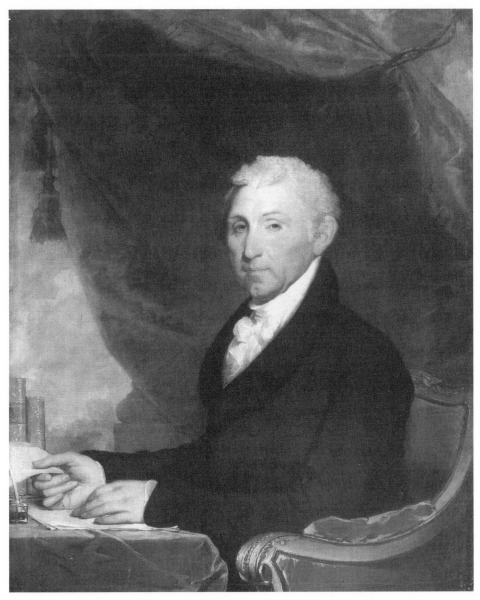

FIGURE 25. Gilbert Stuart, *James Monroe*, 1818–20. Oil on canvas, 40 ¼ × 32 in. Metropolitan Museum of Art. Bequest of Seth Low, 1916 (29.89).

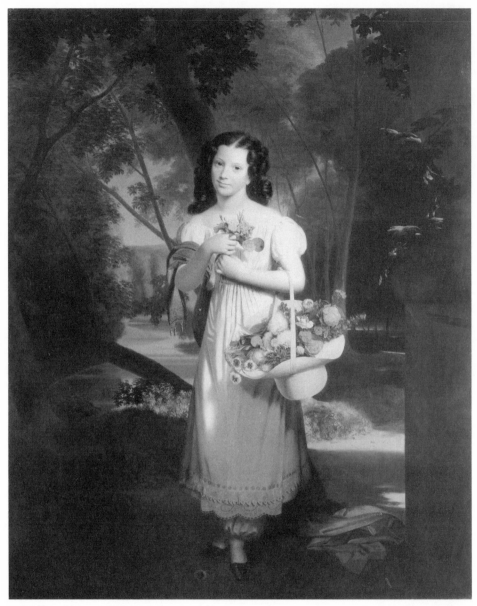

FIGURE 26. Charles Cromwell Ingham, *Amelia Palmer*, c. 1829. Oil on canvas, 67 ⅞ × 53 ½ in. Metropolitan Museum of Art. Gift of Courtlandt Palmer, 1950 (50.220.1).

OPPOSITE PAGE:

(*Top*) FIGURE 27. Thomas Cole, *View from Mount Holyoke, Northampton, Massachusetts, after a Thunderstorm* (*The Oxbow*), 1836. Oil on canvas, 51 ½ × 76 in. Metropolitan Museum of Art. Gift of Mrs. Russell Sage, 1908 (08.228).

(*Bottom*) FIGURE 28. William Sidney Mount, *Farmers Nooning*, 1836. Oil on canvas, 20 ¼ × 24 ½ in. The Long Island Museum of American Art, History and Carriages. Gift of Frederick Sturges, 1954.

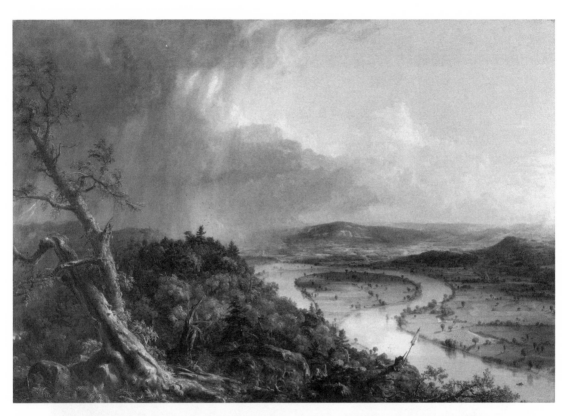

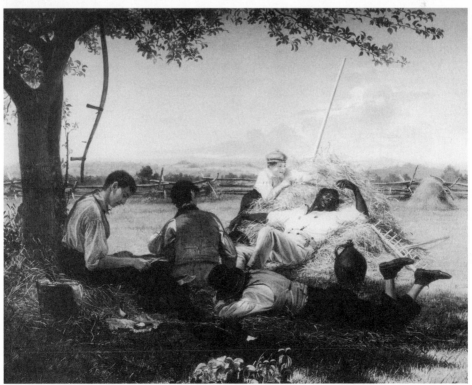

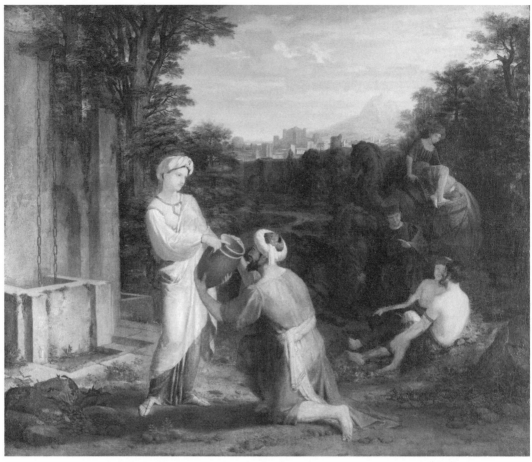

FIGURE 29. Washington Allston, *Rebecca at the Well*, 1816. Oil on canvas, 75.57 × 90.17 cm. Courtesy of the Fogg Art Museum, Harvard University Art Museums. Loan from the Washington Allston Trust. © President and Fellows of Harvard College.

becca at the Well, 1816 (figure 29), and Robert Weir's *Landing of Hendrick Hudson*, c. 1835 (private collection), indicated activity within the venerable category of history painting.[12] In addition to such established artists as Allston, the exhibition featured the work of emerging talents. *The Peddler*, 1836 (figure 30), demonstrated Asher B. Durand's recent shift from engraving to painting, and George Flagg's *Match Girl*, 1834 (figure 31), represented the work of a new generation of artists.

12. Weir painted two versions of this subject, one c. 1835 (private collection) and one c. 1838 (now in the Joslyn Art Museum, Omaha). It appears that the earlier version was the one exhibited at the Dunlap benefit. According to William Truettner, the 1835 painting was first owned by Gulian Verplanck, who lent it to the benefit; see Truettner, "Prelude to Expansion: Repainting the Past," in *The West as America: Reinterpreting Images of the Frontier, 1820–1920*, ed. William H. Truettner (Washington, D. C.: Smithsonian Institution Press for the National Museum of American Art, 1991), pp. 77–79 and n. 51.

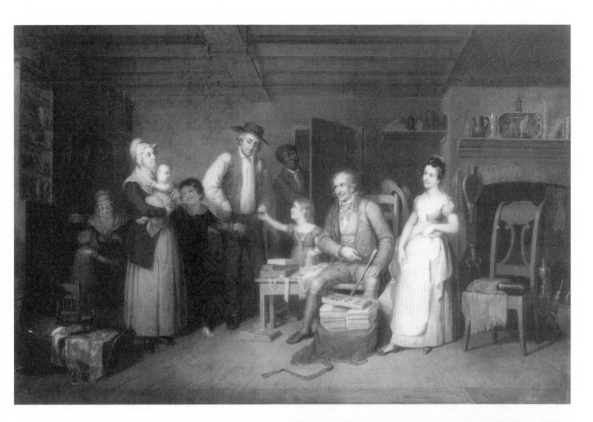

FIGURE 30. Asher B. Durand, *The Peddler (The Peddler Displaying His Wares)*, 1836. Oil on canvas, 24 × 34 in. © Collection of the New-York Historical Society.

FIGURE 31. George Whiting Flagg, *The Match Girl*, 1834. Oil on canvas, 30 × 25 in. © Collection of the New-York Historical Society.

Not only did the Dunlap benefit demonstrate the vitality of the contemporary art world, its catalogue revealed that prominent collectors were beginning to take an interest in the acquisition of American works.[13] Readers of the *History* could have detected this trend earlier by perusing the book's listing of artworks owned by Philip Hone of New York and Robert Gilmor of Baltimore. Dunlap had noted approvingly, "Notwithstanding the gratitude due to those who bring us the works of the old masters, I cannot but feel, as a *living artist*, that the collectors of the pictures and statues executed by their contemporaries, and those who otherwise give them encouragement and employment, are more entitled to praise than any purchaser of the works of by-gone days."[14] It must have been a source of pride, therefore, that the vast majority of the works on display at the Dunlap benefit were lent from private collections. Referring to the contemporary practice of publishing the name of an artwork's owner in exhibition catalogues, one local newspaper made the practical observation that "When an artist exhibits the proof of his skill and all those efforts are shown while still in his possession [that is, unsold], as is sometimes unfortunately the case, it is only a proof that his taste is not popular or that he is deficient in art, but when we see a number of specimens collected from the cabinets of those who have sought for and paid the price demanded by the artist, we are assured of his merit and popularity."[15] Many of New York's most distinguished art patrons—including Hone, Edmund Simpson, and Samuel Ward—served on the benefit's organizing committee, and contributed works to the exhibition. In addition, the widow of the noted collector Luman Reed lent four works including Cole's *Italian Scene Composition*, 1833 (figure 32), and Mount's *Truant Gamblers*, 1835 (figure 33).[16] Promotions for the benefit reminded New Yorkers that "many of the rarest pictures are private property, and can seldom be seen but by friends of the owners," and encouraged the public to make use of the temporary opportunity to see so many "choice" paintings.[17]

13. The catalogue reveals as well that American works had made their way into local institutional collections including those of the New York Hospital, Columbia College, and the New York Common Council.

14. Dunlap, *History*, vol. 2, p. 465.

15. New York *Evening Post*, November 27, 1838, n.p. This passage referred specifically to Thomas Cole.

16. Reed, who died in 1836, had opened a public gallery in his home during the early 1830s. His collection, including both American and European works, reopened in 1844 as the New-York Gallery of the Fine Arts (later absorbed by the New-York Historical Society). For information on Reed and his collection, see Ella M. Foshay, *Mr. Luman Reed's Picture Gallery: A Pioneer Collection of American Art* (New York: Harry N. Abrams in association with the New-York Historical Society, 1990). Alan Wallach profiled a number of these New York collectors in "Thomas Cole and the Aristocracy," *Arts Magazine* 56 (November 1981): 94–106.

17. "William Dunlap," *New-York American*, November 17, 1838, n.p.

Although similar in its scale to the annual exhibitions of the National Academy of Design, the Dunlap benefit received more critical praise than the Academy's display had earlier that year.[18] During the spring, the Academy's thirteenth exhibition had presented 337 art works to the public. Despite the general popularity of this event, the press had found fault with the Academy's offerings. Noting the conspicuous absence of such prominent artists as Washington Allston, Samuel Morse, Thomas Sully, and Thomas Doughty, one critic warned the National Academy that "without works of older and abler heads, the desire of young artists to produce a flashy effect by superficial means, and the approbation which such works will receive from the publick, will immediately become visible in future exhibitions."[19] Many of the artists missing at the National Academy's 1838 exhibition were represented at the Dunlap benefit, probably because of the greater flexibility of the benefit's exhibition policies. The National Academy required that all exhibiting artists be living and affiliated with the institution, and that their works be original compositions not displayed previously at the Academy; the Dunlap exhibition committee did not impose the same strictures.[20] The benefit thus made it possible for viewers to see such familiar favorites as Asher Durand's copies of Gilbert Stuart's famous portraits of George and Martha Washington, 1835 (figures 34 and 35), as well as canvases fresh from an artist's studio, such as Thomas Cole's paired allegories *Past* and *Present*, 1838 (figures 36 and 37), which were added to the exhibition at the last minute and drew rave critical reviews.[21] In addition, the Dunlap exhibition included several historical and contemporary works by European artists, allowing for a "comparison with the works of other times and other men, which is so eminently useful in forming a correct taste."[22] The criticism of the National Academy's 1838 annual reveals a general concern that the energy surrounding the establishment of the Academy was dis-

18. Once the American Academy of the Fine Arts discontinued its annual exhibitions after 1835, the National Academy offered artists the only regular, institutional venue in New York for displaying their work.

19. "National Academy of Design," *New-York Mirror*, May 26, 1838, p. 382.

20. Eliot Clark, *History of the National Academy of Design, 1825–1953* (New York: Columbia University Press, 1954), p. 16. Many of the works exhibited at the Dunlap benefit had been shown earlier at the National Academy.

21. The entry for *George Washington* states, "The faithfulness of this copy, and that of Mrs. Washington, has induced the Committee to depart from the rule they had laid down in respect to copies" (*Catalogue Descriptive*, p. 10). According to an advertisement in the *American*, both Robert Weir and Asher B. Durand also sent newly completed works to the Dunlap benefit; see "The Dunlap Gallery," *New-York American*, December 14, 1838, n.p.

22. "Dunlap Exhibition," *New-York Mirror*, December 1, 1838, p. 182.

sipating as a new generation succeeded its founders; in contrast, the Dunlap benefit's blend of artworks from the past and present offered the reassuring evidence of artistic continuity. By providing the benefit exhibition with a sense of context, Dunlap's *History* gave ideological purpose to its potentially confusing array of artworks.

Despite its remarkable assemblage of paintings, a close examination of the Dunlap benefit reveals the fault lines underlying its glowing press coverage and, by extension, the *History*'s overly optimistic vision of the American art world. For example, the ambitious nature of the exhibition obscures the fact that contemporary artists felt perpetually thwarted by an undependable public audience. In fact, despite repeated promotion in local newspapers and magazines, poor receipts forced the exhibition committee to extend the run of the Dunlap benefit; although it eventually brought in close to $1,000 in profit, the exhibition had raised only $209 after being

FIGURE 32. Thomas Cole, *Italian Scene Composition*, 1833. Oil on canvas, 27 ½ × 54 ½ in. © Collection of the New-York Historical Society.

FIGURE 33. William Sidney Mount, *Truant Gamblers (Undutiful Boys)*, 1835. Oil on canvas, 24 × 30 in. © Collection of the New-York Historical Society.

open for four weeks.[23] In addition, although American artists had branched out into a variety of painting genres, portraiture remained the only dependable source of income for many. For example, though the exhibition contained five of his works, the National Academy's president Samuel Morse had effectively given up his painting career in frustration the year before.[24] Morse had been unsuccessful in his attempt to establish himself as a history painter after his return from studying abroad in 1815. He had recently been passed over for the coveted government commission to fill the remaining panels in the U.S. Capitol Building, and the public had proved

23. "The Dunlap Gallery," *New-York American*, December 14, 1838, n.p., and *New-York Mirror*, January 12, 1839, p. 231. In comparison to the seven-week run of the Dunlap benefit, the National Academy of Design's 1838 exhibition raised $4,699.23 in nearly eleven weeks; see Thomas S. Cummings, *Historic Annals of the National Academy of Design* (New York: Da Capo Press, 1969 [orig. pub., Philadelphia, 1865]), p. 356.

24. At the time of the benefit exhibition, two of these five paintings were still in Morse's possession. Morse stopped painting in 1837—the same year as his last submissions to the National Academy's annual exhibitions.

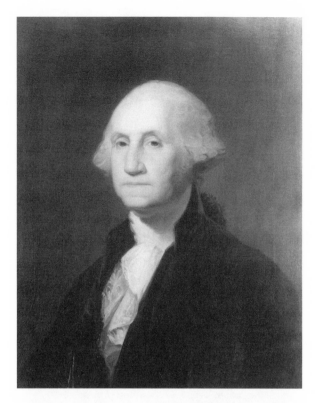

FIGURE 34. Asher B. Durand, *George Washington* (after Gilbert Stuart), 1835. Oil on canvas, 30 × 25 ¼ in. © Collection of the New-York Historical Society.

FIGURE 35. Asher B. Durand, *Mrs. George Washington* (after Gilbert Stuart), 1835. Oil on canvas, 27 × 22 in. © Collection of the New-York Historical Society.

FIGURE 36. Thomas Cole, *Past*, 1838. Oil on canvas, 40 ½ × 61 ½ in. Mead Art Museum, Amherst College (AC 1950.189).

FIGURE 37. Thomas Cole, *Present*, 1838. Oil on canvas, 40 ¾ × 61 ⅝ in. Mead Art Museum, Amherst College (AC 1950.190).

unresponsive to such labor-intensive works as his *Gallery of the Louvre*, 1832 (Terra Museum of American Art).[25]

The circumstances of the Dunlap benefit disclose the persistence of another less quantifiable, but still threatening, problem for American artists: their tenuous professional position. Though the benefit certainly had the support of the National Academy of Design—nineteen of its twenty-six academicians were represented in the exhibition—the event did not take place under its auspices. Founded in order to provide a locus for professional activities, the National Academy, so championed by the *History*, would seem to have been the most appropriate organization to sponsor a benefit for an esteemed artist-colleague.[26] Instead, a self-described "Committee of Amateurs" supervised the event. Although this group did include some professional artists, Cole and Durand among them, the majority were better known as patrons or supporters rather than practitioners of art.[27] This fact suggests that despite their advances, American artists continued to depend on nonprofessionals for legitimization.

One symptom of the disparity between the priorities of the exhibition committee and those of professional artists of the period was the random selection of European works that appeared in the Dunlap exhibition. Reflecting the diverse compositions of contemporary art collections, these entries included a portrait of Peter Stuyvesant attributed to a "Flemish Master," a portrait of an English nobleman by Joshua Reynolds, and a number of paintings by contemporary French artists.[28] The display

25. See Harold E. Dickson, "Artists as Showmen," *American Art Journal* 5 (May 1973): 13–15.

26. A letter to Thomas Cole reveals that Dunlap originally believed the National Academy would sponsor the exhibition (and demonstrates the extent of Dunlap's involvement in organizing the benefit); see "William Dunlap to Thomas Cole," October 11, 1838, Thomas Cole Papers, New York State Library (Albany), Manuscripts and Special Collections, available through the Archives of American Art, Smithsonian Institution, roll ALC-1 (Letters to Cole, 1838). The *New-York Mirror* offered the following reason for the change in the benefit's venue: "It has been suggested that the National Academy of Design should take this matter in hand, and perform an act of real munificence. . . . But we fear the constitution of this institution will present obstacles which its officers cannot overcome, particularly in admitting works by other than *living artists*" ("William Dunlap, Esq.," *New-York Mirror*, October 20, 1838, p. 134). Despite this disclaimer, the financial clout of the lenders and organizing committee probably had more to do with the lay sponsorship of the exhibition than the National Academy's regulations did.

27. Committee members included William Cullen Bryant, the poet and editor of the *Evening Post*; John W. Francis, a physician and fixture of the New York cultural scene; Myndert Van Schaick, a merchant; and the lawyer David C. Colden. On the weaknesses of early American art institutions, see Alan Wallach, "Long-Term Visions, Short-Term Failures: Art Institutions in the United States, 1800–1860," in *Exhibiting Contradiction: Essays on the Art Museum in the United States* (Amherst: University of Massachusetts Press, 1998), pp. 9–21.

28. The catalogue lists works attributed to Claude-Marie Dubufe (1790–1864); Jean-Augustin Franquelin (1798–1839); and Jean-Charles-Nicaise Perrin (1754–1831). An early notice announcing the benefit

of the Stuyvesant portrait, possibly the painting now in the New-York Historical Society (figure 38), provides a good example of the exhibition's mixed messages. In addition to paying tribute to the man for whom the Institute building was named, the benefit's organizers undoubtedly viewed the portrait as evidence of the long and distinguished history of New York art collections, and as a means of securing the support of a Stuyvesant descendant, who lent seven paintings by American artists.[29] U.S. artists, however, were currently facing strong competition from spurious "Old Masters" flooding the New York market and would probably have begrudged any additional attention paid by the public or by the critics to the European works in the benefit.[30] Artists had founded the National Academy of Design in 1826 expressly to break free from what they saw as the inappropriate control of the American Academy of the Fine Arts by its gentleman-stockholders and to protest the Academy's insensitivity to contemporary artists. The composition of the benefit exhibition and of its organizing committee suggests that less had changed in the intervening twelve years than the artists (or Dunlap himself) might have cared to admit.

The limited geographical reach of the Dunlap benefit reveals the difficulties surrounding the development of a truly national gallery as dreamed of by the *Mirror* correspondent. Despite the growing cultural prominence of New York, local attachments still defined the American art world during the late 1830s. For example, although its name might have suggested otherwise, the National Academy still primarily served New York artists. Until 1863, artists could not be elected to the ranks of associate or full academician at the National Academy unless they were residents of New York City.[31] The Dunlap exhibition displayed ample evidence of this parochialism. The press instructed New Yorkers that it was their *civic* duty to support

exhibition suggests that the organizers initially anticipated more British paintings would be included: "It is known that there are works in this city, in private collections, of West, Copely [sic], Reynolds, Lawrence, Beechy, Newton, Raeburn, Gainsborough, Alston [sic], Leslie, Stewart [sic], Sully, Moreland, Turner, Bonnington [sic], and a host of other artists, ancient and modern." "William Dunlap, Esq.," *New-York Mirror*, October 20, 1838, p. 134.

29. This was Peter Gerard Stuyvesant (1778–1847); see *Catalogue of American Portraits in the New-York Historical Society* (New Haven: Yale University Press for the New-York Historical Society, 1974), vol. 2, pp. 783–84. In addition to the five paintings listed in the catalogue, Stuyvesant was also the owner of Cole's *Past* and *Present* (figures 36 and 37), which were late additions to the exhibition (see Wallach, "Thomas Cole and the Aristocracy," p. 100).

30. David Alan Brown traced the correlation between the American reputation of one Old Master and the history of collecting in the United States in *Raphael and America* (Washington, D.C.: National Gallery of Art, 1983).

31. Clark, p. 245. During its early history, nonresident artists could be affiliated with the National Academy only as honorary members (although they were able to exhibit in the Academy's annuals).

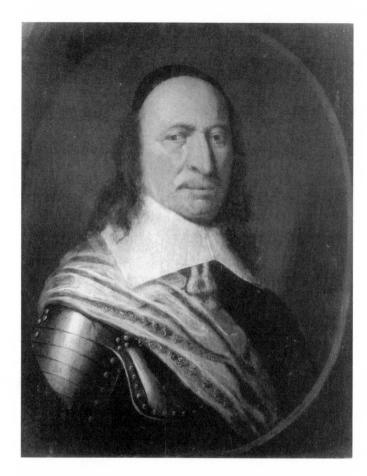

FIGURE 38.
Henri Couturier (attrib.),
Peter Stuyvesant, c. 1660.
Oil on wood, 22 ½ ×
17 ½ in. © Collection of
the New-York Historical
Society.

the exhibition. One notice published by the exhibition committee expressed their confidence in the "taste and patriotism of the citizens of New York to enable them to carry fully into effect the objects of the owners of [this] collection . . . honorable alike to the taste of this metropolis and the talents of our artists."[32] All aspects of the exhibition supported this local identification. Its contents were drawn from New York collections and from local artists. Various civic luminaries—prominent politicians, journalists, and businessmen—served on its organizing committee, and the portraits in the exhibition recorded several generations of distinguished New Yorkers. The event was held in a building that had been constructed specifically to serve and educate a municipal audience. And the exhibition was designed to reward Dunlap for his many contributions to the city and to support him financially while

32. "The Dunlap Gallery," *New-York American*, December 14, 1838, n.p.

he completed his history of New York state.[33] The actual conditions of the American art world, therefore, undercut attempts by Dunlap and other writers to establish a national outlook for American art.

Although the paintings in the Dunlap exhibition did not become the basis of a

33. Press notices of this book—whose two volumes were eventually published in 1839 and 1840—also display a regional chauvinism. A column in the *Mirror* remarked, "The History of New-York will then, we hesitate not to say, be found more interesting than that of any state in the Union; and in venturing the remark, we by no means forget the noble materials that Virginia and Massachusetts afford to the philosophick and statesman-like commentator, or the varied incident with which some of their modern sisters can enrich the pages of the romantick annalist. There are peculiar features in the early history of New-York, which, though similar to others in the records of all the old colonies, in her alone are blended in one striking historical picture" ("Dunlap's History of New-York," *New-York Mirror*, January 13, 1838, p. 231).

FIGURE 39. Francis Davignon, lithograph after *Distribution of the American Art-Union Prizes, at the Broadway Tabernacle, Broadway, New York, 24th December, 1847* by Tompkins H. Matteson. © Collection of the New-York Historical Society.

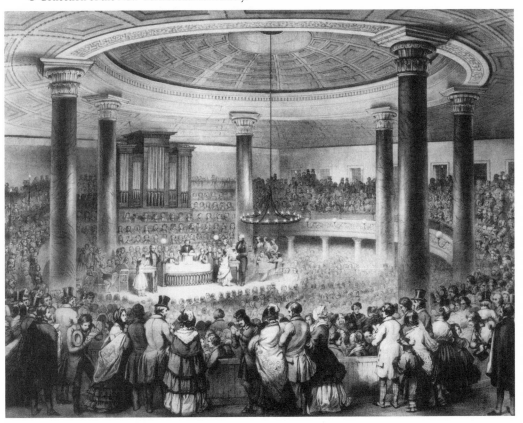

national collection, the event does represent an early, public-spirited attempt to respond to the rising interest in contemporary American art. Many of the men who served as organizers of the benefit or lent paintings to the exhibition would assemble two years later to found the Apollo Association—renamed the American Art-Union in 1844—an organization that would ultimately cultivate broad support for American artists and help to promote a national art tradition.[34] The Association used funds generated by membership dues to buy the works of American artists that would be exhibited to the public and given away in an annual lottery (see figure 39).[35] At its height the Art-Union had a membership of nearly 19,000 individuals drawn from all regions of the country, maintained a free gallery in New York City, published a newsletter, and bought and distributed hundreds of art works. The Art-Union was entirely unforeseen by Dunlap, and its appearance demonstrates the inadequacies of his vague vision of a self-regulating art market in which artists and patrons would interact as equals. Ironically, the exhibition held in Dunlap's honor predicted correctly that private initiative—rather than governmental or professional efforts, as Dunlap had hoped—would act as the best stimulant to American art. Given William Dunlap's entrepreneurial aspirations and the speculative nature of the *History*, this outcome seems strangely appropriate.

34. I am indebted to Patricia Hills for alerting me to the overlap between the membership of the Dunlap exhibition committee and the directors of the American Art-Union.

35. On the American Art-Union, see Charles E. Baker, "The American Art-Union," in *American Academy of Fine Arts and American Art-Union. Introduction, 1816–1852*, ed. Mary Bartlett Cowdrey (New York: New-York Historical Society, 1953), pp. 95–240; Miller, *Patrons and Patriotism*, chap. 14; Maybelle Mann, *The American Art-Union* (Otisville, N.Y.: ALM Assoc., 1977); Rachel N. Klein, "Art and Authority in Antebellum New York City: The Rise and Fall of the American Art-Union," *Journal of American History* 81 (March 1995): 1534–61; and Patricia Hills, "The American Art-Union as Patron for Expansionist Ideology in the 1840s," in *Art in Bourgeois Society, 1790–1850*, ed. Andrew Hemingway and William Vaughan (Cambridge: Cambridge University Press, 1998), pp. 314–39.

APPENDIX A

Annotated Bibliography of William Dunlap's Published Writings on the Visual Arts

The following entries are arranged chronologically. Each item is followed by the source of its attribution and a brief summary of its contents. Unless otherwise noted, all publications originated in New York. See the notes for chapter 2 herein for reference to published promotions for the *History*.

The Monthly Recorder (April–August 1813).

ATTRIBUTION: Short-lived magazine edited by Dunlap; see *History*, vol. 1, pp. 272–73.

CONTENT: Eclectic monthly included several articles on the visual arts as well as chronologies of current events, book and theater reviews, poetry, and biographical sketches.

NOTE: Later bound together as *A Record, Literary and Political, of Five Months in the Year 1813* (New York: David Carlisle, n.d.).

"Communication," *New York Daily Advertiser*, May 31, 1819, n.p.

ATTRIBUTION: Signed "W.D."

CONTENT: Offers an interpretation of a bronze bas-relief sculpture recently donated to the American Academy of the Fine Arts. Dunlap was serving as the Academy's Keeper and Librarian at the time.

"Death on the Pale Horse," *New-York Review and Athenaeum Magazine* 1 (November 1825): 489.

ATTRIBUTION: This article is related to the two-part series of December 1825 and January 1826 listed below that was attributed to Dunlap by William Cullen Bryant in his marked copy of the magazine found in the Berg Collection at the New York Public Library. James T. Callow first drew attention to Bryant's attribution in *Kindred Spirits: Knickerbocker Writers and American Artists, 1807–1855* (Chapel Hill: University of North Carolina Press, 1967), p. 10, n. 12.

CONTENT: Describes Dunlap's large exhibition painting *Death on the Pale Horse* on view in New York.

[An Artist], "To the editors of the *American*," *New-York American*, November 15, 1825, n.p.

ATTRIBUTION: Carrie Rebora, "The American Academy of the Fine Arts, 1802–1842," Ph.D. diss., City University of New York, 1990, p. 638, and Ellwood C. Parry III, *The Art of Thomas Cole: Ambition and Imagination* (Newark: University of Delaware Press, 1988), pp. 24–26.

CONTENT: Gives the story of the discovery of Thomas Cole. Along with John Trumbull and Asher B. Durand, Dunlap was one of Cole's earliest patrons.

NOTE: Article was reprinted in the *Evening Post*, November 22, 1825, n.p.

"A Review of the Gallery of the American Academy of Fine Arts, as now opened for the
Exhibition of Dunlap's Painting of 'Death on the Pale Horse,' " *New-York Review and
Athenaeum Magazine* 2 (December 1825): 71–78.

> ATTRIBUTION: Attributed to Dunlap by William Cullen Bryant in his marked copy of the *New-York
> Review* found in the Berg Collection, New York Public Library [see above].
> CONTENT: Includes a tribute to the American Academy as well as a review of its eleventh annual
> exhibition.

"A Review of the Gallery of the American Academy of Fine Arts, as now opened for the
Exhibition of Dunlap's Painting of 'Death on the Pale Horse' (continued.)," *New-York
Review and Athenaeum Magazine* 2 (January 1826): 152–59.

> ATTRIBUTION: See previous entry.
> CONTENT: Review includes a note about contemporary efforts to negotiate a union between the Amer-
> ican Academy and the New York Drawing Association.

"To the Stockholders of the American Academy of the Fine Arts," *Daily Advertiser*, January
10, 1826, n.p.

> ATTRIBUTION: Thomas S. Cummings in his *Historic Annals of the National Academy of Design* (Phila-
> delphia: George W. Childs, 1865), p. 25, cited by Rebora, "American Academy," p. 326, n. 114.
> CONTENT: Anonymous notice outlines the discussions taking place between the American Academy
> and the New York Drawing Association and warns that if the Association's slate of nominees to the
> Academy's board of directors is not elected, its member artists will sever all ties with the Academy.

"Fine Arts," *New-York Review and Athenaeum Magazine* 2 (February 1826): 244.

> ATTRIBUTION: Rebora, "American Academy," p. 328, n. 131.
> CONTENT: Announces that the proposed union between the American Academy and the artists of the
> New York Drawing Association has failed and that the latter have founded their own academy. Also
> notes that Dunlap's painting *Death on the Pale Horse* has been removed from the American Academy in
> order to make way for Jacques-Louis David's *Coronation of Napoleon*.

["Boydell"], "Letter I. To the Editors of the *Morning Courier*, *Morning Courier*, January 10,
1828, n.p.

> "Letter II . . ." January 14, 1828, n.p.
> "Letter III . . ." January 19, 1828, n.p.
> "Letter IV . . ." January 24, 1828, n.p.
> "Letter V . . ." February 1, 1828, n.p.
> "Letter VI . . ." February 8, 1828, n.p.
> "Letter VII . . ." February 11, 1828, n.p.
> ATTRIBUTION: Rebora, "American Academy," pp. 297–98, and Sarah Elizabeth Williams, "William
> Dunlap and the Professionalization of the Arts in the Early Republic," Ph.D. diss., Brown University,
> 1974, pp. 179–80, suggest that Dunlap was the author of this series (see chapter 2 herein).
> CONTENT: Articles enumerate the artists' dissatisfactions with the American Academy of the Fine Arts
> and trace the events leading up to the founding of the National Academy of Design. Written in response
> to a published attack on the National Academy that appeared in the *North American Review* 26 (January
> 1828): 207–24.
> NOTE: Series reprinted in Cummings, pp. 67–75.

Address to the Students of the National Academy of Design, At the Delivery of the Premiums, Monday, the 18th of April, 1831 (New York: Clayton & Van Norden, 1831).

ATTRIBUTION: Signed "By Wm. Dunlap, N.A. Professor of Historical Painting."
CONTENT: Dunlap was functioning as the acting president of the National Academy when he delivered this address in Samuel Morse's absence. Extolling the high calling of the artist, the speech charges the Academy's students with upholding and further promoting the dignity of their profession. Includes lengthy argument that artists in a democratic republic should be considered the equal of their patrons (see chapter 4 herein).
NOTE: Available through the Archives of American Art, Smithsonian Institution; in several collections including roll P38, frames 198-210 (Pennsylvania Academy of the Fine Arts).

"Greenough's Chanting Cherubs," *New-York Mirror*, June 30, 1832, p. 411.

ATTRIBUTION: Signed "D" (see *History*, vol. 2, pp. 418–20).
CONTENT: Praise for sculptural group by Horatio Greenough owned by James Fenimore Cooper that was being exhibited. Includes plea for the public's support of American fine arts.

"Two Distinguished Artists," *Evening Post*, December 6, 1832, n.p.

ATTRIBUTION: Dunlap, *Diary*, p. 635; cited in Ellwood C. Parry III, "On Return from Arcadia in 1832," in *The Italian Presence in American Art, 1760–1860*, ed. Irma B. Jaffe (New York: Fordham University Press, 1989), pp. 106–7.
CONTENT: Notes the recent arrival from Europe of Samuel Morse and Thomas Cole. Discusses works executed by the painters while abroad and celebrates the general state of American art.

Conflicting Opinions, Or, Doctors Differ (New York, 1833).

ATTRIBUTION: Dunlap, *Diary*, p. 659.
CONTENT: In this pamphlet, Dunlap juxtaposed excerpts from his 1831 address to the students of the National Academy of Design with John Trumbull's recent speech to the directors of the American Academy of the Fine Arts. The contrasting quotations present Dunlap as a republican champion of American artists and Trumbull as maintaining feudal ideas about artistic patronage (see chapter 4 herein).
NOTE: Available through the Archives of American Art, Smithsonian Institution, roll P38, frames 170–72 (Pennsylvania Academy of the Fine Arts).

"Biographical Sketch of the Late Gilbert Stuart," *Knickerbocker* 1 (April 1833): 195–202.

ATTRIBUTION: Signed "William Dunlap, Esq." See also Dunlap, *Diary*, p. 664.
CONTENT: Dunlap received $25 for this profile of Stuart (*Diary*, p. 666). Written before he had completed research on Stuart for the *History* (for example, gives Stuart's death date incorrectly as 1830). Like Dunlap's subsequent biographies of the painter, this article emphasizes Stuart's ebullient personality, his skill in eliciting a portrait likeness, and his generosity towards fellow artists.

"Scraps and Miscellanies. Thomas Dowse," *Knickerbocker* 1 (May 1833): 281–82.

ATTRIBUTION: Signed "William Dunlap, Esq."
CONTENT: Reports that Dowse, a Boston area "leather-dresser," won fifty-two watercolor copies after Old Masters and complementary sets of the engravings which resulted from them in a lottery held by the British Institution. Defends the practice of art lotteries and intimates, somewhat condescendingly, that only in the United States would a laboring man appreciate such works.

"National Academy of Design. The Eighth Annual Exhibition," *New-York Mirror*, May 11, 1833, p. 355.

> "National Academy of Design," May 18, 1833, p. 366.
> "Second Notice," May 25, 1833, p. 371.
> "Third Notice," June 1, 1833, pp. 378–79.
> "Fourth Notice," June 8, 1833, p. 387.
> "Fifth Notice," June 15, 1833, p. 398.
> "Sixth Notice," June 22, 1833, p. 406.
> "Seventh Notice," June 29, 1833, p. 410.
> "Eighth and Last Notice," July 6, 1833, p. 6.
> ATTRIBUTION: Dunlap, *Diary*, pp. 679 and 682–83. Articles of May 18 and June 22 signed "D."
> CONTENT: After an introductory article which explains the aims of the National Academy, this series reviews its eighth annual exhibition by documenting each of the 218 entries (see chapter 2 herein). Most of the artworks exhibited receive only a brief description or a phrase of analysis. Not uncritical but mostly complimentary to the artists (particularly encouraging to young students of the Academy).

"American Academy of the Fine Arts," *New-York Mirror*, June 15, 1833, p. 398.

> ATTRIBUTION: Dunlap, *Diary*, p. 687.
> CONTENT: Caustic review of the American Academy's fifteenth annual exhibition (see chapter 2 herein). Unlike the series on the National Academy, does not survey all of the entries. Although Dunlap detects some new life at the Academy, questions the overall quality of the display. Also mentions the Academy's practice of recycling artworks from previous annuals. Clearly, a partisan attack.

"Mr. Morse's New Picture of the Gallery of the Louvre," *Evening Star*, October 15, 1833, n.p.

> ATTRIBUTION: Dunlap, *Diary*, pp. 749–50.
> CONTENT: Praises Samuel Morse's painting currently on view in New York City.
> NOTE: Dunlap may also be the author of a similar article published in the *New-York Mirror*, November 2, 1833, p. 142.

"Gilbert Charles Stuart," *The National Portrait Gallery of Distinguished Americans*, vol. 1, ed. James Herring and James B. Longacre (New York: Monson Bancroft, 1834).

> ATTRIBUTION: Dunlap, *Diary*, pp. 739–40, and John Jay Smith, "A Literary Secret," *American Historical Record* 3 (November 1874): 485–88.
> CONTENT: A condensation of the profile of Stuart published in the *History*. Amplifies information provided in the earlier *Knickerbocker* article and further develops the moral lessons to be derived from Stuart's personal weaknesses.
> NOTE: Dunlap also contributed a biography of his friend, the author Charles Brockden Brown, to this collection. The *National Portrait Gallery* was published "under the superintendence" of the American Academy of the Fine Arts.

History of the Rise and Progress of the Arts of Design in the United States, 2 vols. (New York: George P. Scott & Co., 1834).

"Mr. Cole's Picture," *New-York Mirror*, April 5, 1834, p. 318.

> ATTRIBUTION: Dunlap, *Diary*, p. 773, and Williams, p. 270.
> CONTENT: A notice of Thomas Cole's painting *The Angel Appearing to the Shepherds* (1833–34; Chrysler

Museum, Norfolk, Va.) then on exhibition at the American Academy of the Fine Arts. Review provides a description of the painting and, while detecting some faults, praises Cole's imaginative conception of the scene.

"To the Editor of the *New York American*," *New-York American*, December 16, 1834, n.p.

ATTRIBUTION: Signed "Wm. Dunlap."

CONTENT: Dunlap's answer to John Trumbull's letter to the editor of the *American* of December 13, 1834, in which Trumbull pointed out a factual error in the *History* biography of him (see chapter 5 herein). Dunlap responds politely and promises to provide a correction in any forthcoming edition of the book.

The National Academy of Design. William Dunlap, Vice President of the National Academy of Design, and Colonel Trumbull, President of the American Academy of Fine Arts, New York (Philadelphia, 1835).

ATTRIBUTION: Given Dunlap's tendency to publish his more polemical pieces anonymously and based on the example of the previously published comparison of his and Trumbull's writings (*Conflicting Opinions*, see above), it seems reasonable to credit him with the authorship of this pamphlet. It is also possible that it was published, with Dunlap's assistance, by an ally of his such as the future historian of the National Academy of Design, Thomas Cummings.

CONTENT: Provides a lengthy defense of Dunlap's scathing profile of John Trumbull in the *History*. Supports Dunlap's contention that the various circumstances of Trumbull's life are a fair subject of inquiry given the artist's role as a public figure and blames Trumbull for the demise of the American Academy of the Fine Arts. Also summarizes the general state of the visual arts in the United States (unpromising because of lack of patronage, not want of talent).

NOTE: Available through the Archives of American Art, Smithsonian Institution, roll P38, frames 51–57 (G. R. Lambdin Collection, Pennsylvania Academy of the Fine Arts).

"To Rembrandt Peale, Esq.," *Evening Star,* January 2, 1835, n.p.

ATTRIBUTION: Signed "Wm. Dunlap."

CONTENT: Written in response to Peale's letter to the editor of December 31, 1834, in which Peale disputed aspects of his *History* profile. Dunlap blandly acknowledges Peale's communication but does not promise any corrections to the text.

"The Studio of Cole," *New-York Mirror*, April 18, 1835, p. 330.

ATTRIBUTION: Angela Miller, *The Empire of the Eye: Landscape Representation and American Cultural Politics, 1825–75* (Ithaca, N.Y.: Cornell University Press, 1993), p. 93, n. 78.

CONTENT: Reports that Thomas Cole is working on the series that would become the *Course of Empire* in his New York studio. As in his other writings about Cole, Dunlap emphasizes the poetic quality of Cole's paintings, comparing the *Course of Empire* to landscapes by Claude Lorrain.

"To the Editors of the *New-York Mirror*," *New-York Mirror,* October 24, 1835, p. 131.

ATTRIBUTION: Signed "William Dunlap."

CONTENT: Written at the prompting of yet another disgruntled artist—in this case, Washington Allston (see chapter 5 herein). Dunlap reproduces a letter he received from Allston that corrected a passage in the *History* (Allston disputed a quotation attributed to him). Dunlap seems mystified by Allston's vehemence but is deferential in his response.

"On the Influence of the Arts of Design; And the True Modes of Encouraging and Perfecting Them," *American Monthly Magazine* n.s. 1 (February 1836): 113–23.

> ATTRIBUTION: Signed "William Dunlap."
> CONTENT: The text of a lecture Dunlap delivered for the American Lyceum in 1835 (see *Diary*, p. 815). Defends the visual arts as essential and civilizing forces in all aspects of human life. Through a historical overview, declares religious and political liberty the necessary preconditions for any flowering of the arts and predicts a bright artistic future for the United States. Recommends promoting the visual arts through the establishment of schools, administered solely by artists, and through the development of public art collections that help to educate taste. Still making the case against the lay administration of the American Academy and defending artists' right to self-determination.
> NOTE: Appeared the month after Thomas Cole's "Essay on American Scenery," *American Monthly Magazine* n.s. 1 (January 1836): 1–12, also based on a Lyceum speech.

"The *Death on the Pale Horse*," *New-York American*, April 15, 1836, n.p.

> ATTRIBUTION: Signed "W.D.," and Rebora, "American Academy," p. 487 n. 36.
> CONTENT: Notice of the American tour of Benjamin West's painting that the Pennsylvania Academy had recently purchased. Provides a description of the work and attests to its moral value.
> NOTE: According to Rebora, Dunlap was hired to supervise the exhibition of the painting in New York ("American Academy," pp. 466–68).

"Painting and the Drama," *New-York Mirror*, September 24, 1836, p. 102.

> ATTRIBUTION: Signed "William Dunlap."
> CONTENT: Presents new "antiquarian" information found during the course of his research on colonial New York. In addition to correcting an error in his history of the American theater, reproduces a 1753 advertisement he discovered promoting the portraitist Lawrence Kilburn. Views this notice as one measure of the subsequent improvement of artists' professional standing.

"The Fine Arts," *New-York Mirror*, February 25, 1837, p. 280.

> ATTRIBUTION: Signed "W.D."
> CONTENT: One of Dunlap's rare considerations of American architecture, a topic he concedes is generally neglected. Reports a recent renovation has not only improved the appearance of the Record Office building in New York, but also made it "fire-proof."

"Mr. Catlin's Lectures," *New-York Mirror*, October 14, 1837, p. 126.

> ATTRIBUTION: Signed "William Dunlap."
> CONTENT: Praise for George Catlin's lectures and exhibitions showcasing Native American culture. Although labeling the native population "savages and barbarians," Dunlap argues that both Catlin's paintings of Indian life and the collected Indian artifacts on display should be considered works of art. Follows Catlin's lead in presenting Native Americans as a doomed population.

APPENDIX B
Chronology of the Publication of Dunlap's *History*

Adapted from the record of Dunlap's activities in his *Diary*.

November 1, 1832	First mention of *History* in *Diary* [*History of American Theatre* published on October 26, 1832].
November 8, 1832	Writes to Washington Allston, Charles Bird King, and John Frazee (first requests for information).
March 12, 1833	Begins writing, starting with profile of Benjamin West.
June 18–June 25, 1833	Makes research trip to Philadelphia, meeting with Thomas Sully and John Neagle, among others.
September 15, 1833	Writes subscription proposals for the *History*.
November 24, 1833	Decides that George Pope Morris, editor of the *New-York Mirror*, will print his book.
January 24, 1834	Original date of publication.
February 26, 1834	Dunlap undergoes surgery to remove a kidney stone.
June 1, 1834	Printing begins.
July 15, 1834	Sends first batch of proofs to Charles Robert Leslie in London in the hopes of finding a British publisher.
July 23, 1834	Begins index for the book.
August 4–6, 1834	Makes research trip to New Haven.
October 5, 1834	Records having 321 subscribers to *History*.
November 5, 1834	Sends last of manuscript and index to the printers.
November 14, 1834	Date printing to be completed.
November 27, 1834	Records 550 subscribers.
December 5, 1834	Writes advertisements of *History*'s publication subsequently submitted to New York magazines and newspapers.

APPENDIX C

Published Reviews of Dunlap's *History* in Contemporary Magazines

Arranged chronologically and includes place of publication. For references to published excerpts of the *History*, consult the notes to chapter 2.

"*A History of the Rise and Progress of the Arts of Design in the United States*. By William Dunlap." *New-York Mirror*, November 1, 1834, p. 139. [New York]

"Dunlap's *History of the Arts of Design*." *North American Magazine* 5 (December 1834): 130–40. [Philadelphia]

"*History of the Rise and Progress of the Arts of Design in the United States*. By William Dunlap." *Knickerbocker* 4 (December 1834): 491–95. [New York]

"*History of the Rise and Progress of the Arts of Design in the United States*. By William Dunlap." *American Quarterly Review* 17 (March 1835): 143–77. [Philadelphia]

"*History of the Rise and Progress of the Arts of Design in the United States*. By William Dunlap." *New England Magazine* 8 (March 1835): 239–40. [Boston]

"Dunlap's History of the Arts." *North American Review* 41 (July 1835): 146–70. [Boston]

INDEX

Note: References to illustrations are given as "*f*" following the page number.

Maura Lyons was born in Waterbury, Connecticut, and raised in New England. She earned a B.A. in government from Georgetown University and an M.A. and Ph.D. in art history from Boston University. She was the recipient of a Henry Luce Foundation/American Council of Learned Societies Dissertation Fellowship in American Art for 1997–98. She is currently assistant professor of art history at Drake University in Des Moines, Iowa. *William Dunlap and the Construction of an American Art History* is her first book.